TURNER
INSPIRED

IN THE LIGHT OF
CLAUDE

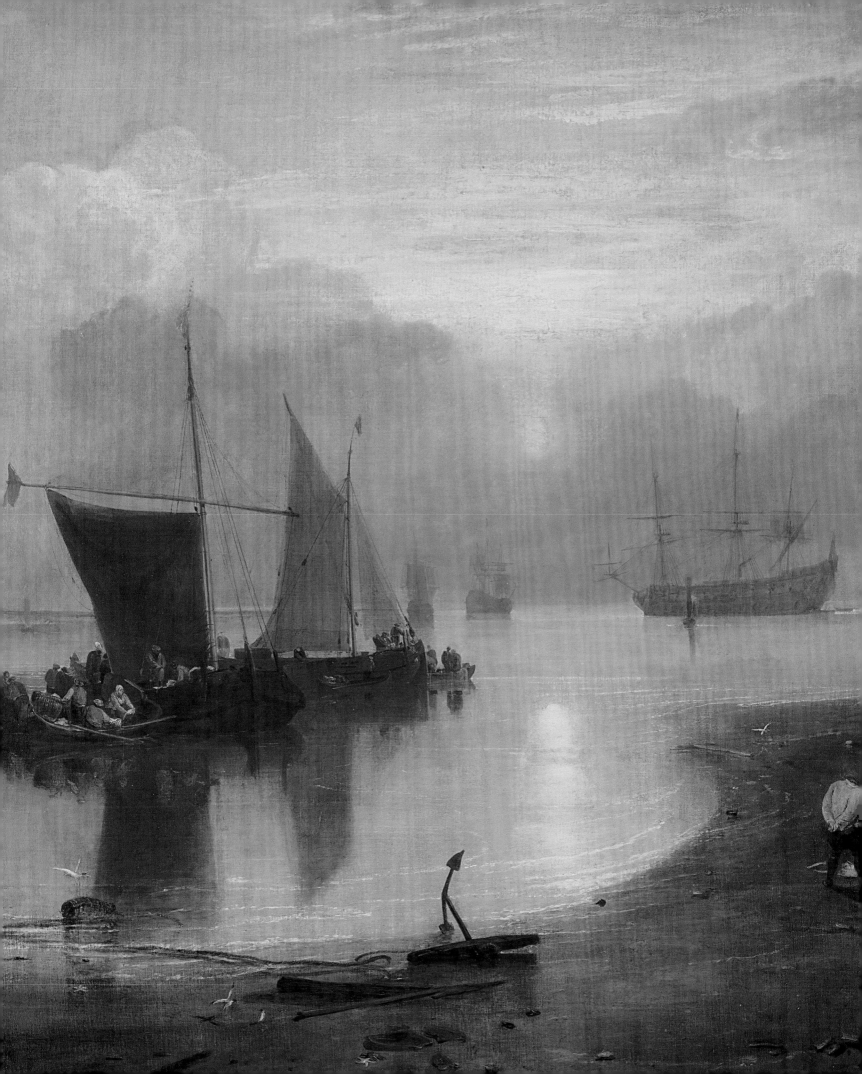

TURNER
INSPIRED

IN THE LIGHT OF
CLAUDE

IAN WARRELL

WITH CONTRIBUTIONS BY
PHILIPPA SIMPSON, ALAN CROOKHAM
AND NICOLA MOORBY

NATIONAL GALLERY COMPANY, LONDON

DISTRIBUTED BY YALE UNIVERSITY PRESS

This book was published to mark the exhibition
Turner Inspired: In the Light of Claude
The National Gallery, London, 14 March – 5 June 2012

A National Gallery exhibition created in collaboration with
Tate Britain

First published in Great Britain in 2012 by
National Gallery Company Limited
St Vincent House, 30 Orange Street, London WC2H 7HH
www.nationalgallery.org.uk

ISBN: 978 1 85709 537 1
1032370

British Library Cataloguing-in-Publication Data.
A catalogue record is available from the British Library.
Library of Congress Control Number: 2011940404

Managing Editor Jan Green
Project Editor Giselle Sonnenschein
Editor Lise Connellan
Picture Researcher Suzanne Bosman

Production Jane Hyne and Penny Le Tissier
Design Joe Ewart for Society

Reproduction by DL Repro, London
Printed by Pureprint, England

FSC
www.fsc.org
MIX
Paper from
responsible sources
FSC® C022913

All measurements give height before width

NM Nicola Moorby
PS Philippa Simpson
IW Ian Warrell

Front cover: J.M.W. Turner, *Keelmen heaving in Coals by Night*
(plate 55), 1835, detail

Page 2: J.M.W. Turner, *Sun rising through Vapour: Fishermen
cleaning and selling Fish* (plate 21), before 1807, detail

Page 12: Claude, *Landscape with Narcissus and Echo* (plate 7),
1644, detail

Page 24: J.M.W. Turner, *Thomson's Aeolian Harp* (plate 14), 1809,
detail

Page 50: Detail of a letter from Jabez Tepper to Thomas Uwins
regarding the deposit of Turner's paintings at the National
Gallery pending the outcome of court proceedings,
29 July 1854 (fig. 35, p. 54)

Pages 66-7: J.M.W. Turner, *Dido building Carthage, or The Rise
of the Carthaginian Empire* (plate 22), 1815, detail

Page 68: J.M.W. Turner, *Lake Geneva and Mount Blanc* (plate 6),
about 1804, detail

Page 80: J.M.W. Turner, *Crossing the Brook* (plate 27), exhibited
1815, detail

Page 98: Claude, *A View of the Roman Campagna from Tivoli*,
Evening (plate 37), about 1644–5

Page 112: J.M.W. Turner, *Keelmen heaving in Coals by Night* (plate
55), 1835, detail

Page 128: J.M.W. Turner, *Venice: The Giudecca Canal, looking
towards Fusina at Sunset* (plate 57), 1840, detail

CONTENTS

DIRECTOR'S FOREWORD

The National Gallery was in many respects the offspring of the British Institution, an association of art collectors and connoisseurs that began to acquire major paintings (one by Benjamin West and another by Paolo Veronese) in anticipation of the Government's decision to establish a national collection. Royal Academicians suspected the Institution's supporters of promoting interest in old art rather than encouraging living artists (although clearly it strove to do both) and of rewarding a servile attitude towards the past. Some of this distrust lingered throughout the early decades of the National Gallery's existence. Awareness of any conflict in the interests and values of these two institutions must have been sharpened by the fact that the National Gallery's first proper home – William Wilkins's building, which opened in 1838 – was originally divided between it and the Royal Academy.

Turner's ambitions as an artist reflected these tensions. A veneration for the past, and a craving to be part of history, coexisted with restless commercial acumen and a competitive self-confidence. His determination to insert his own, modern art into the national collection of Old Masters was at once an endorsement and a subversion of the ideals of the Gallery's first Trustees. Turner's relations with the National Gallery were coloured by his attitude towards Claude, then the Old Master best represented in the collection. Although he revered and imitated this artist, he also certainly intended to surpass him.

The story of the Turner Bequest is also an important episode in the history of the National Gallery – a sorry one in many respects, maddening to many of the artist's admirers, a nightmare for any curator. But the solution that was eventually reached with the establishment of the Clore Gallery at Tate Britain is highly satisfactory. It is generous of Sir Nicholas Serota, Director of Tate, and Penelope Curtis, Director of Tate Britain (our closest relative among national institutions), to have agreed to lend so much to *Turner Inspired: In the Light of Claude* and to have allowed the National Gallery to borrow the services of Ian Warrell, Curator of 18th- and 19th-Century British Art, and an eminent Turner scholar, who has curated the exhibition. It has been a pleasure to collaborate in this way.

NICHOLAS PENNY
The National Gallery, London

CLAUDE GELLÉE, LE LORRAIN

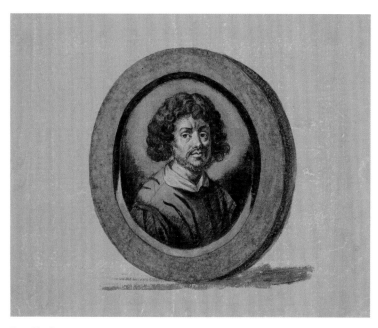

Fig. 1 Claude
Portrait of Claude from *Liber Veritatis*, about 1636–40
Pen and brown ink and brown wash on paper, 26.5 x 32.3 cm
The British Museum, London

1604/5? Claude Gellée is born at Chamagne, near Nancy, in the Duchy of Lorraine (hence his nickname 'le Lorrain' in later life). He was the third of the seven children of Jean Gellée and Anne Padose. No record of the precise year of his birth has been found: a long tradition, stemming from the date on his tombstone, suggests it occurred in 1600, but recent scholars favour sometime around 1604–5.

1615/17 After the death of his parents, before his twelfth birthday, goes to stay with an elder brother in Freiburg im Breisgau.

c.1617 Travels to Rome where he intended to work as a pastry chef. One account proposes that he was employed by the artist Agostino Tassi (about 1580–1644) as a *garzone* (studio assistant).

1618/20 Based in Naples for two years, working for the German landscape painter Goffredo Wals (about 1590/95–late 1630s), formerly an assistant of Agostino Tassi.

1623 His address at this date is recorded as being in the Via della Croce, Rome.

1625 April: departs for Nancy to work under contract with the court painter Claude Déruet (about 1588–1660) on the decoration of the ceiling in the Carmelite church (now destroyed).

1627 Returns to Italy over the winter, travelling by sea from Marseilles. Back in Rome by Easter. Established in a house in Via Margutta, near the Piazza di Spagna, where he is joined from 1628 by the Dutch painter Herman van Swanevelt (about 1600–1655). Starts going on sketching expeditions with Joachim von Sandrart (1606–1688) and other artists, including Nicolas Poussin (1594–1665).

1629 First signed and dated work: *Landscape with Cattle and Peasants* (Philadelphia Museum of Art).

1630 First of his dated drawings and etchings. Around this period he is employed in painting mural decorations for the Palazzo Muti-Papazzurri (now Balestra-Altieri) and the Palazzo Crescenzi, and begins to undertake his celebrated port scenes.

1632 *A View in Rome* (NG 1319)

1633 Joins the Accademia di San Luca, the official guild of painters and guilders. Employs Gian Domenico Desiderii as an assistant (until about 1657–8).

1635	Trip to Tivoli (about 30 km east of Rome).
c.1635–6	Begins an album known as the *Liber Veritatis* (Book of Truth) as a means of recording his compositions, the names of those who commission or acquire them, and the locations to which they are sent. The purpose, initially, is to prevent forgery of his work.
1636	Probably travels to Naples.
c.1636–7	*Landscape with a Goatherd and Goats* (NG 58)
c.1638–9	Visits the port of Santa Marinella (about 50 km north-west of Rome) to survey the harbour for a picture commissioned by Urban VIII, one of a series of paintings for the Pope that helps to establish Claude's reputation across Europe.
c.1640	By this date Claude is the most commercially successful landscape painter in Europe. His patrons, who frequently specified his subject matter, include several popes, cardinals and princes, the King of Spain and the French Ambassador. Even among this élite, his prices were sometimes considered high.
1640–7	Claude's sketches indicate further trips to the Roman Campagna, and the towns of Tivoli and Subiaco (about 50 km east of Rome).
1641	*Seaport with the Embarkation of Saint Ursula* (NG 30)
1644	*A Seaport* (NG 5)
1646	*Landscape with Hagar and the Angel* (NG 61)
1648	*Landscape with the Marriage of Isaac and Rebecca,* one of 'The Bouillon Claudes' (NG 12)
	Seaport with the Embarkation of the Queen of Sheba, one of 'The Bouillon Claudes' (NG 14)
1650	Moves from Via Margutta to the neighbouring street of Via Paolina (now Via del Babuino), remaining in the quarter inhabited by foreign artists.
1653	Birth of Agnese, a child of unknown parents, who is presumed to be the illegitimate daughter of Claude, who adopted her later in the 1650s.

1654	Declines the offer of becoming the 'first rector' of the Accademia di San Luca.
	Landscape with the Adoration of the Golden Calf (Staatliche Kunsthalle Karlsruhe)
	Landscape with Jacob, Laban and his Daughters (Petworth House, Sussex)
1658	*Landscape with David at the Cave of Adullam* (NG 6)
1662	*Landscape with the Father of Psyche sacrificing at the Temple of Apollo* (Anglesey Abbey, Cambridgeshire)
1662	Claude's nephew, Jean, joins his household. In the late 1670s Claude is joined by another nephew, Joseph. Collectors, such as Cardinal Leopoldo de' Medici, seek to acquire Claude's earlier work, considering his recent work less strong.
1663	February: suffers ill health, leading him to make his will (to which he adds a codicil in 1670, and two more in 1682). Commences work on a series of paintings for Prince Lorenzo Onofrio Colonna, one of the most important patrons of his later years.
1664	*Landscape with Psyche outside the Palace of Cupid ('The Enchanted Castle')* (NG 6471)
1675	*Landscape with the Arrival of Aeneas before the City of Pallanteum* (Anglesey Abbey, Cambridgeshire)
1682	23 November: Claude dies. Buried in his local church of Santissima Trinità dei Monti, above the Piazza di Spagna. His remains were moved in 1836 to San Luigi dei Francesi, France's National Church in Rome.

JOSEPH MALLORD WILLIAM TURNER

Fig. 2 John Thomas Smith
Portrait of J.M.W. Turner, about 1829
Watercolour over pencil on paper, 22.2 x 18.2 cm
The British Museum, London

1775	23 April: Turner is born at 21 Maiden Lane, Covent Garden, London. His father, William, is a barber and wig-maker.
1789	December: admitted to the Royal Academy Schools after a period of training with the architect Thomas Hardwick (1752–1829), and the draughtsman Thomas Malton Jr (1748–1804).
1790	Exhibits his first work at the Royal Academy, a watercolour view of Lambeth Palace.
1791	First significant sketching tour. Between this year and 1801 he makes five trips to Wales, and two to Scotland and the north of England.
1796	Exhibits his first oil painting, *Fishermen at Sea* (Tate, London).
1799	November: becomes an Associate of the Royal Academy. By this date he admits to having too many commissions, the most substantial of which come from members of the aristocracy or the landed gentry. Moves to 64 Harley Street.
1802	Elected a full member of the Royal Academy.
	Summer: during a pause in Anglo-French hostilities he makes his first tour of France and the Alps, including time spent studying the paintings in the Musée du Louvre, Paris.
1803	*Calais Pier, with French Poissards preparing for Sea: an English Packet arriving* (NG 472)
1804	15 April: death of his mother, Mary, in an asylum for the insane.
	18 April: opening of the first exhibition in Turner's newly completed gallery in Queen Anne Street (adjoining his Harley Street home).
1805	Rents a property at Isleworth, to the west of London, where he undertakes *plein-air* sketching. In 1813 he builds his own villa further upriver at Twickenham, called Sandycombe Lodge, which he retains until 1826.
1807	Publication of the first part of the *Liber Studiorum* (see pp. 88–9).
1808	First visit to Farnley Hall, near Leeds, the home of Walter Fawkes (1769–1825), a landowner and sometime politician, and Turner's most important patron.

1811	Delivers his first series of six lectures as Professor of Perspective at the Royal Academy (repeated erratically until 1828).
1815	*Dido building Carthage, or The Rise of the Carthaginian Empire* (NG 498)
1817	Resumes travelling to the Continent almost every year. Over the next thirty years he was to visit France, Switzerland, Germany, Denmark, Luxembourg and Italy, in addition to extensive tours of England and Scotland.
1819–20	First stay in Rome. Travels there via Venice, Ferrara, Bologna, Ancona, and returns to England at the beginning of 1820 via Florence, Parma and Milan. Makes excursions from Rome to Tivoli, Lake Albano, Naples and the Amalfi coast. Elected an honorary member of the Accademia di San Luca.
1827	Resumes his visits to Petworth House in West Sussex. Begins work on a series of landscapes for Lord Egremont's dining room.
1828	Second stay in Rome, where he stages an exhibition of his current work.
1829	*Ulysses deriding Polyphemus – Homer's Odyssey* (NG 508) Visits Paris, and possibly meets Eugène Delacroix (1798–1863). Death of his father. Drafting of his first will.
1830	Publication of an edition of the poem *Italy* by Samuel Rogers (1763–1855), for which Turner provides vignette illustrations. Its huge popularity results in commissions for illustrated editions of works by Lord Byron, Sir Walter Scott and Thomas Campbell. During the ensuing decade, critical responses to Turner's work stress his eccentricity and his heightened use of colour.
1835	Travels to Denmark, Germany, Bohemia and the Netherlands; sees the new art gallery in Berlin.
1839	*The Fighting Temeraire tugged to her last berth to be broken up, 1838* (NG 524)
1840	Last visit to Venice.
1843	John Ruskin publishes the first volume of *Modern Painters*, a defence of Turner's work.
1844	*Rain, Steam, and Speed – The Great Western Railway* (NG 538)
1845	Last trip to the Continent includes a visit to King Louis-Philippe at the Château d'Eu, near Le Tréport.
1850	Last exhibits at the Royal Academy (see p. 47).
1851	19 December: Turner dies at 119 Cheyne Walk, Chelsea, under the assumed name of Admiral Booth (adopting the surname of his mistress, Sophia). 30 December: buried in St Paul's Cathedral.

TAKING IN THE VIEW

THE RECEPTION OF CLAUDE IN EARLY NINETEENTH-CENTURY LONDON

PHILIPPA SIMPSON

When the mind of man is in that delightful state of repose, of which Claude's pictures are the image – , when he feels that mild and equal sunshine of the soul, which warms and cheers, but neither inflames nor irritates, – his heart seems to dilate with happiness, he is disposed to every act of kindness and benevolence, to love and cherish all around him.[1]
Uvedale Price, 1796

By the end of the eighteenth century the popularity of Claude Gellée (also known as 'Lorrain') among British collectors and connoisseurs was unparalleled. His ability to paint grand landscapes, giving 'dignity to a low subject', was a well-established trope of art criticism, and his works a necessary inclusion in any collection of note.[2] As Alastair Laing has pointed out, at least thirty of the 195 paintings by Claude in the artist's own record of drawings (the so-called *Liber Veritatis*) were in British collections before the French Revolution.[3] This is the case for half of the dozen paintings by him in the National Gallery today, including some of the most celebrated, such as '*The Enchanted Castle*' (plate 61) and the *Embarkation of Saint Ursula* (NG 30).[4] No fewer than eight had been acquired by Thomas Coke, Earl of Leicester (plates 28 and 53), and four by Frederick, Prince of Wales. The depth of interest in the artist is further, and perhaps more remarkably, attested by the enthusiastic collecting of his drawings. Few, if any, major British collector neglected these, and Lord Leicester and Prince Frederick were especially keen. Most importantly, the *Liber Veritatis* with all its finished drawings was bought by the second Duke of Devonshire in around 1720.[5]

Prints after Claude's paintings (available in the early eighteenth century) gave an idea of his compositions,[6] and Richard Earlom's remarkable prints after the *Liber Veritatis* published in 1774–7 were very good indications of the beauties of Claude's drawings and in particular of the aerial perspective he achieved (see plates 16 and 17).[7] It is significant that these publications coincided with striking developments in British watercolour drawing. Naturally, familiarity with Claude's original paintings and drawings was confined to collectors, connoisseurs and artists, most of whom had also travelled on the Grand Tour and admired the artist's work in the Palais Royal (property of the Duc d'Orléans) and the French Royal Collection in Paris and in the great palatial collections in Rome. This situation changed dramatically following the French Revolution and the French

invasion of Italy. It was already clear that British collectors had a special taste for Claude and were prepared to pay gigantic sums for his work.[8] Unsurprisingly, therefore, many of his greatest paintings found their way to London from France and Italy (and especially Paris and Rome). It was notorious that great British collections were less accessible to artists and art lovers than those of the Continent, but the exhibitions of the paintings when they were for sale, then in loan exhibitions organised by the British Institution (at first for the benefit of artists), and eventually in the National Gallery, meant that an awareness of Claude's achievement was available to a far greater public in London than at any earlier period. It has indeed been pointed out by Francis Haskell that the exhibitions in London organised in 1793 by the dealer Thomas Slade of the Dutch, Flemish and German paintings sold by the Duc d'Orléans in the previous year and by the dealer and art historian Michael Bryan in 1798–9 – acting for the syndicate of noblemen who had purchased the Italian, French and Spanish portion of the Orléans collection – constitute the first ever extended public displays of Old Master paintings in London.[9] It is noteworthy that works by Claude appeared in many of the sales, suggesting some confusion over how best to categorise this painter from Lorraine who worked in Rome and whose style owed so much to both artistic traditions. Indeed, this ambiguity contributed in large part to the appeal of his pictures, which were seen to combine the 'botanical nicety' found in Dutch landscape painting, with the grandeur of conception associated with the Italian School.[10] As Bryan himself put it, he 'soars above the servile representation of ordinary nature, and transports his spectators into the regions of poetry and enchantment'.[11] The taste for this generalised form of painting was such that an instrument was invented to help artists and amateurs in emulating the style – the so-called 'Claude glass'. This small convex mirror reflected the view, simplifying masses and colours, which could then be rendered in paint.

The rage for Claude's landscapes may be said to have reached its peak around 1799. Not only was the second half of the Orléans collection on display, but a great stir was being caused by the arrival of paintings bought from a palace in Rome during the city's occupation by the French army – the so-called 'Altieri Claudes' (plates 1 and 2). These quickly became icons of Claude's elevated landscape style, and almost twenty years after its arrival in 1799, one of the pictures – *Landscape with the Father of Psyche sacrificing at the Temple of Apollo* (fig. 3) – was said to have been long

Fig. 3 Claude
Landscape with the Father of Psyche sacrificing at the Temple of Apollo, 1662
Detail of plate 1

considered 'the best landscape in the kingdom'.[12] It was not, however, the introduction of classical narratives in landscapes such as this that marked them out for early nineteenth-century viewers – then, as now, it was generally accepted that Claude's figures were 'very indifferent'[13] – indeed, one reviewer found their inclusion 'derogates entirely from the dignity of the scene'.[14] Rather, the status of his works rested upon an overall quality of effect, that seems to have defied definition but been impossible to mistake; thus the Altieri Claude was praised for 'a brilliancy so happily blended and subdued by an almost visible atmosphere, that the whole is splendour, the whole is repose'.[15]

Works by Claude continued to be seen regularly in sale rooms across London into the nineteenth century. A number of his works, including *Pastoral Landscape* (fig. 4), appeared at the display of pictures belonging to Noel Desenfans, an erstwhile grammar teacher turned art collector and advisor to the King of Poland. This collection had been assembled for the King, who abdicated in 1795, leaving Desenfans in the possession of a varied but valuable group of Old Master works, which he exhibited for an extended period in 1802. During this same year, thanks to a short-lived peace treaty, viewers also had the opportunity to travel once again to France and, while there, to visit the newly established Musée du Louvre, the largest and most

Fig. 4 Claude
Pastoral Landscape, 1646–7
Oil on canvas , 102.6 x 132.7
The Putnam Foundation, Timken Museum of Art, San Diego

impressive gallery in the world. But while overwhelmed by the matchless treasures to be seen in Paris, visitors felt that in one respect at least, collections at home had the upper hand, asserting that of pictures by Claude 'England has more to boast of'.[16]

Certainly the market for Claude's works had become particularly strong. In a letter written to his agent in Italy in 1804, the energetic dealer William Buchanan stated that 'fine Claudes of any size are always desirable purchases', particularly those that are 'high finished, with a full pencil [brush], and sparkling … when they can be had, large or small, they are treasures'.[17] This demand was reflected in the prices commanded by Claude's works.

In 1803, John Julius Angerstein reportedly bought two of his pictures – *Seaport with the Embarkation of the Queen of Sheba* and *Landscape with the Marriage of Isaac and Rebecca* (plates 20 and 48) – for £8,000, making them each worth a little more than Sebastiano del Piombo's *Raising of Lazarus* (NG 1), for which he had paid 3,000 guineas at the Orléans sale in 1799. Nevertheless, Claude's popularity continued unabated, and by 1813 Bryan felt able to claim that 'we possess more of his capital works than the rest of Europe'.[18]

The growing visibility of Claude's work would have struck not only collectors and their friends, as a trend towards opening private collections,

Fig. 5 Claude
Coast Scene with Ezekiel mourning over the Destruction of Tyre; plate in *Liber Veritatis*, 1667
Pen and brown ink with grey wash, heightened with white, on paper, 19.5 x 25.6 cm
The British Museum, London

precipitated by the highly publicised imports flooding into the capital, gave an increasingly broad public the chance to see his works. In 1806, the renowned Stafford Collection at Cleveland House, near St James's Park, was made accessible for one afternoon a week to select visitors and also to artists, who were invited to study from the pictures. Largely compiled during the previous decade, this collection contained a number of star works from the Orléans sale as well as other recent imports, including Claude's *Coast Scene with Ezekiel mourning over the Destruction of Tyre* (see fig. 5). Placed in a gallery with works by Raphael and Titian, this picture and others by the artist were here classified definitively as Italian, a statement symbolising their status within the canon of great Continental art.

In the earliest catalogue of the Stafford Collection, Claude's pictures were said to be 'calculated to arrest and gratify every class of persons', and this universal appeal may account for their ubiquity in collections across the country.[19] Unlike the grand historical compositions of many Italian paintings, which demanded a thorough knowledge of biblical and classical narratives, Claude's attractive landscapes could be enjoyed for their aesthetic virtues, without compromising the viewer's claim to high taste. This combination of accessibility and aspiration is evoked in a poem by William Gilpin, an artist and influential author on theories of the Picturesque, the beautiful and the Sublime. First, Gilpin described the immediacy with which Claude's works strike the viewer:

Fig. 6 **Claude**
Landscape with Apollo and the Muses, 1652
Oil on canvas , 186 x 290 cm
The National Gallery of Scotland, Edinburgh

> … *thy pencil, Claude, the season marks;*
> *Thou makest us pant beneath your summer noon;*
> *And shiver in thy cool autumnal eve.*

But Gilpin also saw in these pictures, and their 'power of furnishing images *analogous to the various feelings and sensations of the mind*', the potential for a more consequential engagement of the viewer. 'If the landscape painter can call up such representations,' he argued, 'where would be the harm in saying that landscape, as well as history-paintings, has its ethics!' [20]

This notion of a morally invested mode of landscape painting (found also in the extract by Uvedale Price cited at the start of this chapter) had important implications for British art. Cut off from the Continent by the wars with France, British painters were turning increasingly to local views as their subject matter. In the attempt to give historical authority and intellectual weight to this practice, Claude was to become an important model, and this was nowhere more effectively, or systematically, achieved

than at the British Institution (see fig. 13). Established in 1805 by a group of collectors and connoisseurs, this initiative was designed to 'encourage the talents of the artists of the United Kingdom',[21] an ambition achieved both by offering an alternative exhibition space to the Royal Academy and by filling the galleries while theirs were closed with loans of Old Master works from private collections. Young artists were encouraged to engage in a close study of the works at these private exhibitions; to 'converse with the Old Masters and not with your common acquaintances' as the keeper of the gallery put it.[22] Prizes were awarded for the best pictures painted as a companion piece to one of the lent works, and while artists were advised not to copy from their models there is no doubt that much time was spent doing just that. This scheme offered some compensation for a notable gap in the programme at the Academy – where students had access only to sculpture casts, prints and drawings – and it provided an unprecedented opportunity for the close observation of works by canonical artists, particularly those most favoured by the Directors. Paintings by Claude appeared at virtually every exhibition (or 'school' as these events were

described) and in the first few years British painters had the chance to study some of his greatest landscapes, including his *Sermon on the Mount* (The Frick Collection, New York) and *Landscape with Apollo and the Muses* (fig. 6), which was selected by one commentator, along with Titian's *Venus and Adonis* (National Gallery of Art, Washington) as one of the two best examples on display.[23]

Attendance at the schools was high, but many artists struggled to reconcile the prescribed emulation of the Old Masters with that appearance of originality that would win them recognition, both literally and critically. In 1814, J.M.W. Turner took it upon himself to tackle these issues head on, submitting for the painting competition *Appulia in Search of Appulus, vide Ovid* (fig. 7), an almost direct copy of Claude's *Landscape with Jacob, Laban and his Daughters* (fig. 10), which had been lent by Lord Egremont, a Director of the Institution, the previous year. In reproducing this famous work almost exactly (see details on pp. 20–1), Turner had hoped to draw attention to the type of servile imitation he saw being promoted at the British Institution, and to challenge the taste for derivative art. Furthermore, it has been argued that the subject matter of the painting itself may be read as a pointed, if obscure, reference to the dangers of copying, as the story tells of a shepherd who was punished for mimicking a group of nymphs.[24] In a final snub to the Directors, Turner even missed the deadline for submission.

It is testament to the impossibility of the situation that Turner found his work being praised for precisely the values he had sought to undermine:

> *Mr Turner's landscape … has one recommendation, that must always enhance the value of this most able artist's productions; that the composition is taken verbatim from Lord Egremont's picture of Jacob and Laban … the beautiful arrangement is Claude's, the powerful execution is his own … we would almost wish that this gentleman would always work in the trammels of Claude. All the taste and all the imagination being borrowed, his eye, hand and memory, are equal to anything.*[25]

It must have struck the artist as ironic, if not extremely frustrating, that this review was intended as encouragement.

The year after Turner exhibited *Appulia*, the British Institution embarked on a new venture – a series of public loan exhibitions of Old Master works,

the first ever to be seen in London. The first comprised paintings from the Northern School, and was followed in 1816 by a major show of Italian works, recorded in a watercolour by James and F.P. Stephanoff (fig. 13), which shows at the centre of one of the main walls the legendary Altieri Claude, *Landscape with the Father of Psyche sacrificing at the Temple of Apollo* (plate 1). Positioned opposite Titian's *Bacchus and Ariadne* (NG 35), this work was clearly presented as an important masterpiece, and Claude as a major name in the history of European art. It is no surprise, then, that in choosing works to be retained for the school that year, the Directors placed at the top of the list one of Claude's best known pictures: the *Landscape with Jacob, Laban and his Daughters* that had been so spectacularly imitated by Turner just two years earlier.

At the same time as the first of these exhibitions opened, artists were also granted access to an alternative place of study, at the newly established picture gallery in Dulwich, south London, built around the unsold collection of Noel Desenfans. On Desenfans's death, these pictures had passed to his friend, the artist Francis Bourgeois, who bequeathed them to Dulwich College, where a gallery was specially built to house them. At this site (which was to open to general visitors in 1817, making it the first public art gallery in the country), artists were invited to study the works, among them a number by or after Claude, including the *Classical Seaport at Sunset* (now thought to be by an imitator; Dulwich Picture Gallery). Furthermore, the Royal Academy was offered the chance to borrow works from the collection to form, finally, a painting school of their own. Claude's pictures were included at many of the early schools, and when the Academy decided to branch out and borrow works from collectors, Lord Egremont's *Landscape with Jacob, Laban and his Daughters* was once again the first to be requested (unsuccessfully, in the event, as it had already been promised to the British Institution).[26]

The desire to promote Claude as a model was founded on the needs of both the market and the Academy. As collectors incorporated his light suffused landscapes easily into their domestic galleries, so a new generation of British landscape painters looked increasingly to his pictures as examples of how a reverential study of nature might produce a mode of painting that transcended the limits of its genre. For both groups, the combination of natural detail and ethereal effect witnessed in Claude's paintings proved irresistible. These qualities are beautifully traced in an unusual piece of writing by the artist James Northcote, entitled 'The Dream of a Painter', in which the artist imagines

Fig. 7 J.M.W. Turner
Appulia in Search of Appulus, vide Ovid, 1814
Oil on canvas, 148.5 x 241 cm
Tate, London

Fig. 8
Detail of fig. 7

Fig. 9
Detail of fig. 10

Apparently working almost entirely from memory,
Turner's version of Claude's landscape reveals how
closely he had studied the details of the earlier picture.
He shows ruins instead of classical temples, and the
overall tone of his painting is darker. But this latter
quality may be attributed to the original appearance of
the Claude canvas, before its varnish was removed in
the late twentieth century.

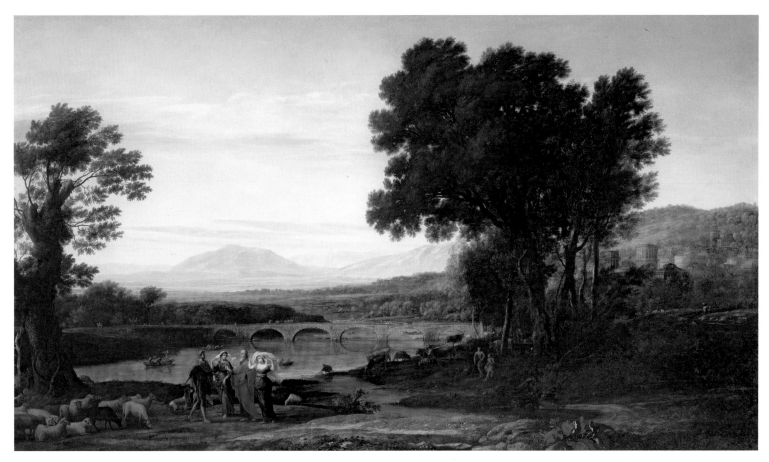

Fig. 10 **Claude**
Landscape with Jacob, Laban and his Daughters, 1654
Oil on canvas, 143.5 x 251.5 cm
Petworth House, Sussex

Fig. 11
Detail of fig. 7

Fig. 12
Detail of fig. 10

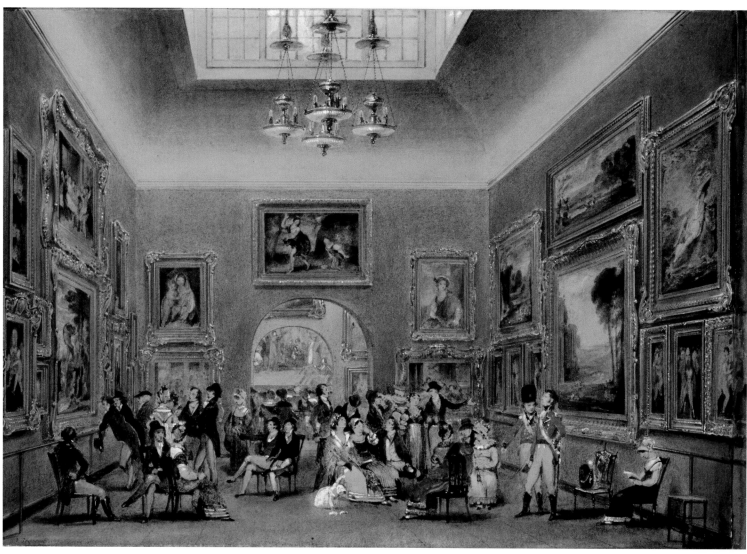

Fig. 13 James and F. P. Stephanoff
The British Institution, London, interior view 1816, 1817
Watercolour on paper, 21 x 29 cm
Victoria and Albert Museum, London

himself led by a guide through a series of scenes and encounters, in which the great masters of the past are revealed to him:

> ... *we alighted on a most delicious rural spot ... The atmosphere was clear and perfectly calm: and now the rising sun gradually illumined the fine landscape, and began to discover to our view the distant country of immense extent ... the only object which appeared to fill this natural, grand and simple scene, was a rustic, who entered, not far from the place where we stood ... after advancing a few paces, he stood still, and with an air of rapture seemed to contemplate the rising sun; he next fell on his knees, directed his eyes towards Heaven, crossed himself, and then went on with eager looks, as if to make choice of the most advantageous spot from which to make his studies as a painter. 'This,' said my conductor, 'is ... Claude Gelee of Lorain.'* [27]

In this romantic vision of the (divine) inspiration of the unrefined artist, Northcote powerfully evokes the aura that surrounded Claude's name in the early nineteenth century. Even the repetition of compositions and techniques in his work, which today may be seen as formulaic, came to stand as evidence of his superiority. 'Perfection,' wrote the critic William Hazlitt, 'is one thing. I confess I think that Claude knew this, and felt that his were the finest landscapes in the world – that ever had been, or would ever be.' [28]

NOTES

1 Uvedale Price, *An essay on the picturesque: as compared with the sublime and the beautiful; and, on the use of studying pictures, for the purpose of improving real landscape*, London 1796, p. 145.

2 Jonathan Richardson, *An Essay on the Theory of Painting*, London 1715, p. 161.

3 Alastair Laing, *In Trust for the Nation*, exh. cat., National Gallery, London 1995, p. 100.

4 Humphrey Wine, *National Gallery Catalogues: The Seventeenth-Century French Paintings*, London 2001, p. XIV and entries for NG 19, 30, 58, 61, 1018, 1319, 6471.

5 J.J.L. Whiteley, *Claude Lorrain: Drawings from the Collections of the British Museum and the Ashmolean Museum*, exh. cat., British Museum, London 1998, especially his introductory text on 'English Collectors of Claude's Drawings', pp. 10–14.

6 Richardson, op. cit.

7 For Richard Earlom (and also prints after Claude published by Bond and Knapton in 1740–8), see Timothy Clayton, *The English Print 1688–1802*, New Haven and London 1997, p. 157.

8 Matthew Pilkington, ed., Henry Fuseli, *A Dictionary of Painters from the revival of the art to the present period*, London 1805, p. 214.

9 Francis Haskell, *The Ephemeral Museum: Old Master Paintings and the Rise of the Art Exhibition*, London and New Haven 2000, pp. 22–9, who supplies a full account of the exhibitions.

10 *The Literary Gazette,* no. XVII, 17 May 1817, p. 263.

11 Michael Bryan, *Biographical and Critical Dictionary of Painters and Engravers*, London 1816, p. 675.

12 *Repository of Arts*, vol. II, no. VII, 1 July 1816, p. 45.

13 Pilkington, op. cit.

14 *Monthly Magazine*, part 1, vol. XXV, 30 July 1808, p. 621.

15 *Catalogue of an exhibition ... of the finest specimens of the old masters in the cabinets and galleries of the United Kingdom, painted in watercolour ...* , London 1812, p. 22.

16 Charles Long and Abraham Hume recorded in Joseph Farington, *Diary*, V, pp. 1851–2: 13 September 1802.

17 Quoted in Hugh Brigstocke, *William Buchanan and the Nineteenth Century Art Trade: 100 Letters to his Agents in London and Italy*, New Haven 1982, p. 205: letter dated 20 March 1804.

18 Bryan, op. cit., p. 676.

19 John Britton, *Catalogue Raisonné of the pictures belonging to the most honourable Marquis of Stafford, in the gallery of Cleveland House*, London 1808, p. 55.

20 William Gilpin, *Three essays: On picturesque beauty; On picturesque travel; and On sketching landscape: with a poem on landscape painting*, 3rd edn, London 1808, pp. 112, 165.

21 *By-Laws of the British Institution,* 1805, By-Law 1.

22 Address made by Valentine Green to the students on the opening of the 1812 British Institution school, recorded in the *Examiner*, 1 November 1812, p. 701.

23 *Monthly Magazine*, part 3, vol. XXVI, 1 October 1808, p. 263.

24 Kathleen Nicholson, 'Turner's "Appulia in Search of Appulus" and the Dialectics of Landscape Tradition', *Burlington Magazine*, vol. 122, no. 931, October 1980, pp. 679–81.

25 *Morning Chronicle,* 5 February 1814.

26 RAA, RAA/PC/1/4, RA Council minutes, V, 12 July 1816, p. 299.

27 James Northcote, 'The Dream of a Painter', in *Memoirs of Sir Joshua Reynolds*, Philadelphia 1817, pp. 14–15.

28 William Hazlitt, 'Whether Genius is conscious of its Powers?', in *The Plain Speaker: Opinions on Books, Men, and Things*, vol. I, London 1826, p. 290.

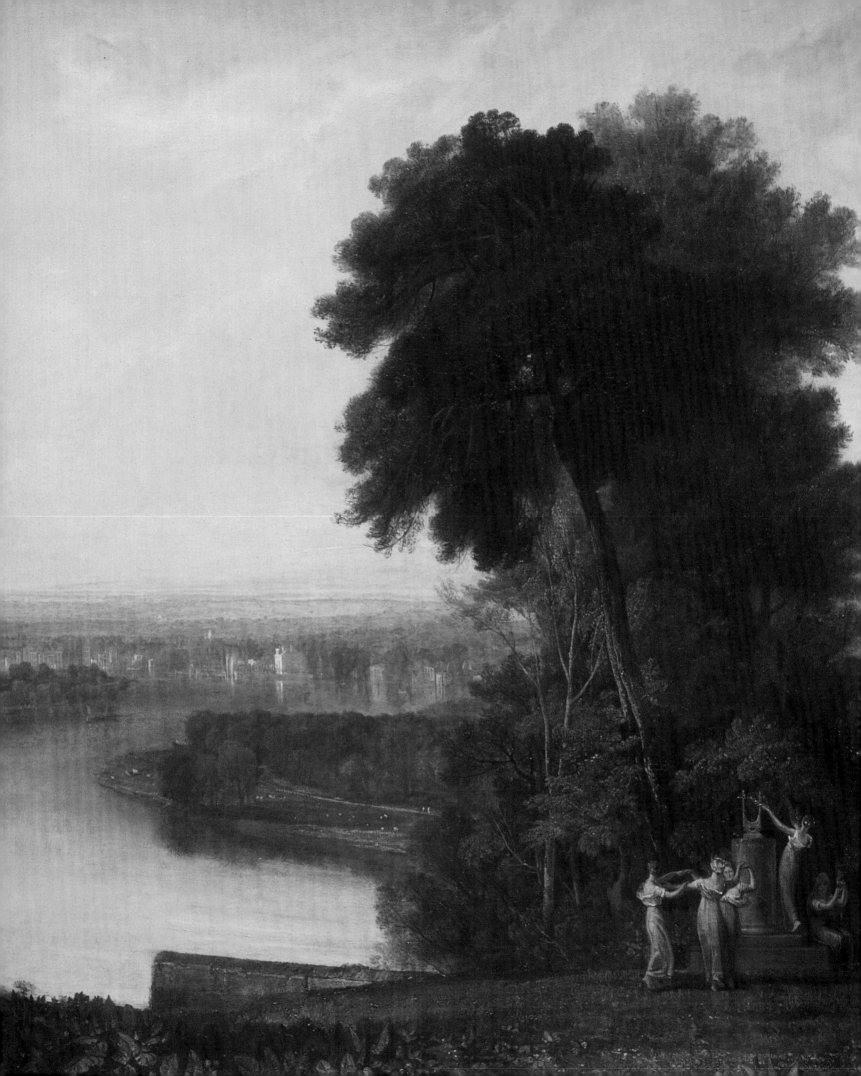

'THE LAND OF BLISS'

TURNER'S PURSUIT OF THE LIGHT AND LANDSCAPES OF CLAUDE

IAN WARRELL

At the beginning of January 1829 Joseph Mallord William Turner left Rome after working there during the previous three months. He was aged fifty-three, and it was his second extended stay in the city in less than a decade. As on his previous tour, one of the chief aims of his time in and around Rome was to study the scenery that had inspired the seventeenth-century painter Claude. Along with many of his contemporaries, Turner viewed Claude's paintings as a distillation of all he expected to find in this hallowed landscape: whether this was the wide, open vistas of the Campagna; the shady paths under towering pine trees; the crystalline sparkle of fountains and waterfalls; or the fantasy of an unchanged bucolic life. And above all, there was the soothing balm of Italian sunshine.

As he made his way northwards, Turner attempted to summarise what his recent experiences had meant for him. This took the form of a poem, written in the back of one of his sketchbooks. The text was evidently written hastily and with feeling, at times becoming illegible. In essence, it was a tribute to the fertile Italian landscape – 'The land of bliss' – he was leaving behind.[1] He wrote with the eye of a British landscape painter, assessing the potential of Italy as his subject, and contrasting it with the materials of his native soil (with its notoriously variable climate). The point he was keenest to make was of the continuing relevance to the depiction of landscape – in either country – of the artist he invariably described as 'Aerial Claude' (out of respect for his recreation of light on canvas). Turner had asserted his admiration for Claude even more emphatically during his time in Rome: he had exhibited two new landscape paintings – a paired landscape and harbour scene (plates 46 and 47) – in a palace on the Via del Quirinale, both of which alluded to the earlier artist by reworking Claude's compositions in his own manner. This proved to be a highly controversial gesture because few of those who saw the exhibited paintings would have failed to recognise that Turner was laying claim to the status that Claude had enjoyed, both in his own lifetime and subsequently, as perhaps the greatest and most highly prized European landscape painter. The exhibition of these Claude-inspired paintings also gave public expression to a developing private desire. Turner articulated this for the first time a year later in his first will, which aimed at linking himself with Claude for posterity through the proposed gift of two of his masterworks to the new National Gallery, where he hoped that they were to be shown alongside a pair by Claude. This arrangement continues in essence more than a hundred and fifty years later (see fig. 44, pp. 62–3).

This second journey to Italy took place at roughly the middle of Turner's working life, a stage of maturity by which point most artists have thrown off the artistic influences that shape their formative years. Turner, however, continued to draw rapaciously from other artists, absorbing and revising their imagery with a magpie-like attraction to the most eye-catching effects. But his relationship with the art of the past was a complicated one that can rarely be boiled down to one of simple influence.[2] In the case of Claude – his most constant reference point among the Old Masters – Turner maintained an intimate artistic dialogue throughout his career. Writing in 2009, Kathleen Nicholson outlined the essence of this dialogue, making the critical observation that its precise character veers between 'indebtedness, emulation, homage, or pastiche', and sometimes combinations of these responses. Expanding this line, she proposed that underlying Turner's adherence to Claude's example was his desire to 'raise the affective power of landscape painting – to give the portrayal of nature the same power to move the heart and mind expected of the depiction of significant human actions in history painting'.[3] This important point recognises the degree to which Turner's appreciation of Claude was bound up in his ambition to transform attitudes towards landscape painting among his peers, and explains his need to co-opt the popular master of the genre, who had done so much to establish the legitimacy of landscape almost two hundred years earlier.

In fact, the parallels between the paintings of the two artists were already so well established in Turner's own lifetime that the resemblance had become something of a cliché; so much so that he was habitually referred to in contemporary art journals as the 'modern Claude', or 'the British Claude', and critics enthused that his classical subjects succeeded chiefly because his mind was 'saturated with Claude Lorrain'.[4]

With our privileged ability to survey the full range of Turner's output, the relationship between the two artists seems at times one of umbilical continuity and at others like encountering one side of a romantic correspondence: Turner's regular tributes to Claude thread through his work like letters to a distant beloved. Indeed, it is possible to conclude that to some degree Claude and his paintings epitomised for Turner his love of Art itself. But in his attempts to emulate Claude, there is also a more primal, essentially Oedipal desire to surpass and remake the Claudian legacy in his own image. Exactly what this meant for Turner clearly changed over the course of his working life, reflecting the development of his own interests and abilities, but also the gains in his knowledge of Claude's art.

Fig. 14 Richard Wilson
Tivoli, the Cascatelle and the 'Villa of Maecenas', about 1752
Oil on canvas, 73.3 x 97.2 cm
Dulwich Picture Gallery, London

But to return to the beginnings of this intriguing relationship, its most crucial foundation stone was the fact that Claude had always been an artist that the British had taken to their hearts. The late Michael Kitson estimated that more than half of the 300 or so paintings by Claude could be found in British collections by 1820, many of which appeared fortuitously on the London art market just as Turner was embarking on his career.[5] Claude's drawings are also more than usually well represented in British institutions, a circumstance attributable both to the direct appeal of his studies from nature, but also to the connection implicitly felt and made with the British tradition of landscape.

The languid mood of elegiac pastoral found in so many of Claude's landscapes also had a profound influence on the development of the parks and gardens of the British landed gentry and nobility during the eighteenth century. At Blenheim, Harewood, Petworth and countless other country estates, the designer Lancelot 'Capability' Brown (1716–1783) undertook massive transformations, redirecting streams to form lakes, and uprooting and transplanting trees, to create the more idealised yet simultaneously more 'natural' landscapes of a Claudian painting. Perhaps the best example of this phenomenon can be found in the gardens of Stourhead in Wiltshire, formed on a similar model by Henry Hoare II (1705–1785), where an Arcadian setting is explicitly evoked through the judicious positioning of the kinds of classical temples that mark the distances of Claude's images (see plate 44). Towards the later part of the eighteenth century, however, different aesthetic criteria were increasingly in vogue, such as the Sublime, or the Picturesque, both of which offered contrasts to the prevailing appeal of calm pastoral.[6]

This lively interest in Nature proved a fecund soil from which a native school of landscape artists – and poets – was already sprouting. By 1784 Horace Walpole was protesting that 'Enough has been done to establish such a school of landscape, as cannot be found on the rest of the globe. If we have the seeds of a Claud [sic] or a Gasper amongst us, he must come forth. If wood, water, groves, vallies, glades can inspire poet or painter, this is the country, this is the age to produce them.'[7] If in retrospect Walpole's rhetorical flourish seems to call forth the kind of landscape painting realised by Turner and contemporaries like John Constable within the next thirty years, he was here unfairly overlooking the existing achievements of the Welsh painter Richard Wilson (1713/14–1782), who had been creating his own version of Claudian landscape since the 1750s (fig. 14). Moreover, Wilson was to prove an important model for Turner, suggesting ways in which Claude's ordering of a scene could be transplanted to a British setting.

But the crucial point in Walpole's exhortation was the premise that any achievement in landscape painting must emanate from, and be measured alongside, the achievements of Claude. He was certainly not alone in believing this, or in his patriotic ambition for British artists to be seen as the inheritors of such a distinguished mantle. At the newly established Royal Academy, in the 1770s, Sir Joshua Reynolds instilled in his students an admiration for Claude founded on a belief that the earlier painter's example offered a way of imbuing landscape art with the same kind of intellectual framework expected in the higher genre of history painting. According to Reynolds's precepts, the idealised perfection achieved in Claude's scenes arose only partly from his direct observation of nature, and was more importantly indebted to his skilful selection and composition of 'the various draughts which he had previously made from various beautiful scenes and prospects'.[8]

Turner could perhaps have absorbed these ideas directly from Reynolds at the start of his training at the Academy. But they were, in any case, well established in British aesthetic theory by the 1790s. He was just as likely to have encountered these notions from Alexander Cozens, the father of the watercolourist John Robert, whose works Turner studied during this decade. In a passage that develops Reynolds's idea, Cozens Sr had professed the view that 'Composing landscapes by invention, is not the art of imitating individual nature; it is more; it is forming artificial representations of landscape on the general principles of nature, founded in unity of character, which is true simplicity.'[9] These were principles that Turner absorbed and

reiterated when he came to give lectures himself, as Professor of Perspective, from 1811 onwards. In preparing these during the preceding years, Claude's example seems to have been never very far from his thoughts. His annotations to John Opie's *Lectures on Painting* include the following observations: 'He that has that ruling enthusiasm which accompanies abilities cannot look superficially. Every glance is a glance for study … Each tree and blade of grass or flower is not to him the individual tree, grass or flower but what [it] is in relation to the whole, its contrast and its use, and how far practicable.'[10] These remarks, made around 1809, were reformulated a couple of years later in Turner's perspective lecture on 'Backgrounds', as part of his analysis of Claude's art: 'We must consider how he could have attained such powers but by continual study of parts of nature. Parts, for, had he not so studied, we should have found him sooner pleased with simple subjects of nature, and [would] not [have], as we now have, pictures made up of bits, but pictures of bits.'[11] More than the works of any other artist, Claude's paintings demonstrated for Turner a means of infusing the delineation of a specific place with a profoundly imaginative response that could rival any other genre of painting. Indeed, as he had said earlier in the same lecture, 'To select, combine, and concentrate that which is beautiful in nature and admirable in art is as much the business of the landscape painter in his line as in the other departments of art.'[12]

For the most part, Turner was temperamentally opposed to reductive formulas and systems when it came to picture-making. Yet throughout his career he stubbornly remained loyal to the landscape formulas that Claude had adopted and which he thereafter repeated in elegant variations. These were: the presentation of a topographical view (though this is not so common in Claude's work); the pastoral landscape with cattle or figures; the view over a river valley; the distant town or landmark framed by trees; the coastal scene; and the well-known harbour, or seaport, subjects. Turner's first encounter with the full range of Claude's works would have been through Richard Earlom's mezzotints of the *Liber Veritatis*, the first two volumes of which were published in 1777 (see plates 16 and 17). This set of prints reproduced the book of drawings described by Claude as the *Libro di verità* (Book of Truth), or *Libro d'invenzioni* (Book of Invention), which Claude had steadily filled with his designs from the mid-1630s onwards, initially as a means of documenting the compositions and first owners of his paintings, and thereby protecting his reputation from the attribution to him of fake works. The book had been in England since the late 1720s, and was

acquired by the Duke of Devonshire, who kept it among his collection at Chatsworth. Individual pictures had also been engraved over the years, so Turner's first introduction to Claude could quite possibly have been mediated through the process of monochrome reproduction, although it would not have been long in the 1790s before opportunities arose for him to see genuine paintings in the homes of the wealthy men who collected his own work. During Turner's lifetime there was a common, no doubt snobbish, perception that he was a little too eager to make money. But given his astute skills for positioning himself in a competitive market, it is clear that he would have been very aware of the premium his patrons placed on Claude, both as a matter of taste and commercial value, and this would surely have reaffirmed his own admiration for this type of landscape painting.

As well as being invaluable as a compendium of Claude's images, the *Liber Veritatis* offered Turner an insight into his life and working practices. Earlom's publication was prefaced by a biographical outline by the publisher and entrepreneur John Boydell, based on a brief account by Joachim von Sandrart (1606–1688), whose direct acquaintance with Claude was limited to the early part of his time in Rome. From these six pages Turner would have learned about Claude's relatively modest origins in Lorraine, which in the seventeenth century was an independent province on the north-eastern borders of France. Having lost his parents by the time he was of an age to support himself, Claude travelled to Rome, apparently initially working as a pastry cook, and then as a servant to the artist Agostino Tassi. Turner would have empathised with the account of Claude's indefatigable labour and 'unremitting industry' as the foundation of his success, because he invariably claimed this characteristic as part of his own ethos.[13] In fact, the account of Claude's domestic arrangements, which were all geared to enable him to work without distractions, aided in all his endeavours by a member of his family, could just as easily serve as a description of Turner's own mode of practice in later life.[14] Addressing the nature of Claude's art, Boydell's *Liber Veritatis* narrative went on to emphasise the originality of his method of studying nature at first hand, through taking long walks in the country close to Rome, as well as on excursions to outlying towns, and especially at Tivoli, which was identified as his favourite spot. The 'judicious combinations of the most beautiful objects of nature' that Claude created earned him the highest levels of patronage, most notably from three popes and 'many of the principal Nobility of Rome', in addition to 'crowned heads' from distant realms.[15] More critically, thinking no doubt of the heroic landscapes of Poussin,

Boydell proposed that there was perhaps only a modest element of invention in Claude's countless evocations of an elusive rural retreat, and that the figures in his classical narratives were timid in scale and conception. Despite these shortcomings, Boydell acknowledged that Claude's most significant contribution was his ability to reproduce, with painstaking exactitude, the spectrum of aerial perspective: 'He attained even the proper knowledge of a Philosopher, rather than a Painter, and could discourse with as much exactness as if he had been well versed in physics, on the causes of the differences of the same view, in point of its colouring at different times; on the morning dews and evening vapours, and on the several various reflections and refractions of light.'[16]

This account of the forging of Claude's philosophical (or scientific) mindset must have appealed to the Romantic generation, with its suggestion that his discoveries were untutored, founded on his engagement with nature at first hand. He was living in an era in which beliefs that had been passed down the centuries since the ancients were at last being questioned by precise observations. The astronomer Galileo Galilei (1564–1642), for example, was advocating the Copernican notion of heliocentrism, the idea of the earth revolving round the sun. This threatened to overturn the flawed orthodoxy that it was actually the sun that moved from east to west in a regular, twenty-four-hour cycle, something that was fiercely maintained by the Church authorities. Curiously, given this context, Claude decided to structure many of his images with the sun as the focal point at the centre. Even so, since Claude's patrons included several influential figures high up in the Church, it is doubtful that his decision was in any way a provocative reflection of Galileo's controversial thesis. Nonetheless, Claude seems to have been the first artist to compose paintings that focus so crucially on the sun and its light.[17]

The sketchy outline of Claude's life in the *Liber Veritatis*, combined with the images themselves, provided plenty for the youthful Turner to mull over as he aspired to gain similar recognition himself. In his twenty-fourth year, in 1799, when he exhibited views of the castles of Harlech and Caernarvon (plate 5), his debt to Claudian prototypes was readily apparent and quickly recognised by reviewers, though one of them also detected a more individual talent at work.[18] At this point, Turner had not yet fully developed a means of fusing his respect for the longer tradition of idealised landscape with the practicalities of representing contemporary Britain. This was a dilemma that continued to challenge him during the first decade or so of the nineteenth

Fig. 15 J.M.W. Turner
London Autumnal Morning, 1801
Oil on canvas, 60.3 x 99.1 cm
Private collection

century. Another self-conscious early attempt was his 1801 autumnal view of London from Clapham (fig. 15). Here he bathed the Thames Valley in a warm vaporous light, as if it was the Roman Campagna, directing the eye past a herd of indolent cattle into the distance with the aid of framing pine trees and Italianate buildings. Though the original colouring (now somewhat faded) did much to unify the scene, it did not prevent the distant monuments of the London skyline from feeling like part of a second image, unconnected to the foreground.

One more detail Turner would have acquired from the text in the *Liber Veritatis* was the value Claude placed upon making studies of specific subject types, such as animals and figures. Perhaps inspired by a knowledge of this process, Turner devoted individual sketchbooks exclusively to studies of figures, or to cows. These are much more than diligent exercises, and were recorded by an eye appreciative of the contrasting earth tones of a group of cows. As well as savouring the visual interplay between their forms, Turner

recognised that by introducing grazing cattle he could create a sense of timelessness, connecting the scenery he was depicting to the west of London with the pastoral mood that defines so many of Claude's paintings.

The kind of *plein-air* sketching that underlies these judiciously observed studies was becoming widespread among some of his contemporaries. Artists such as William Havell, John Varley, Peter De Wint and Constable were all working in oils directly from the motif during this decade, driven by a desire for a closer approximation to nature in their studio productions. Foremost in articulating his aims, Constable, who had criticised the lifeless bravura of the exhibits at the Royal Academy, instead proposed that there was 'room enough for a natural painture'.[19] Like Turner, he hoped to achieve this through a synthesis of his first-hand observations with acquired knowledge from Claude and other masters. The essential difference was that Turner's idea of naturalism was more instinctive, and less grounded in painstaking exactitude.

Fig. 16 J.M.W. Turner
Thomson's Aeolian Harp, 1809
Detail of plate 14

During the first decade of the nineteenth century the urge towards a kind of naturalistic pastoral became one of the two subject types that dominated Turner's output, the other being marine painting. This last category was an obvious response to the naval conflicts of the Revolutionary and Napoleonic era (1792–1815) that contested British sovereignty at sea, threatening the very independence of the nation. But the lively dramas Turner created from the churning waters and scudding clouds over the Thames estuary are the complete antithesis of the idyllic reveries he painted of the upper stretches of the river, where everyday life remained tranquil and undisturbed. A sense of poetic wonder characterises these pictures, something that Turner deliberately heightened as a result of his concurrent interest in elegiac poetry, whether that of Virgil and Ovid, or comparatively recent writers like Alexander Pope and James Thomson, both of whom had lived near Richmond. In 1803, following his mad dash to the Alps during the Peace of Amiens, Turner had made his first attempt to overlay the Thames setting at Richmond with the kind of bucolic revelry more typical of Claude's evocations of the Campagna (plate 13). Though the resulting picture purported to represent the Saône close to Mâcon, many of Turner's audience would have recognised that the sparkling curve of river snaking through the image corresponded to the way the Thames is seen from the celebrated vantage point of Richmond Hill.[20] The same glorious sweep of landscape appeared again six years later in the painting *Thomson's Aeolian Harp* (plate 14), this time undisguised, though still embellished with classical ruins and peopled with the kind of elegant, if elongated, figures Claude also adopts in his foregrounds (fig. 16).[21] It was

accompanied when first exhibited by Turner's longest published attempt at poetry, his verses emanating from his affection for the author of *The Seasons* and a desire to preserve the fame of another creative mind.[22]

By this date Turner was himself a resident in the area. Following the distinguished example of Sir Joshua Reynolds, he began to seek the Richmond neighbourhood as a regular retreat from London. He spent much of the summer of 1805 exploring the Thames from there towards Oxford. He very rarely painted directly from nature, but this year he undertook *plein-air* studies as he went along. The sketchbooks he filled during his excursions also reveal the impact of the *Seaport* paintings by Claude recently acquired by John Julius Angerstein (see plate 20), as Turner pursued his own variations on mythical narratives of embarkation.[23] These 'studies for pictures', as he termed them, were interspersed among topographical or classicised versions of the banks of the Thames, as if Turner was oscillating imaginatively between different eras, fired by the potential of the riverside as a kind of unspoilt Arcadia. In effect he had appropriated the Thames to his own lyrical ends in much the same way that Claude had commandeered the Roman Campagna as a stage for the re-enactment of classical mythology. This layering of direct experience with idealised fantasy indicates the extent to which Turner's familiarity with numerous works by Claude permeated his fundamental approach to any landscape setting. It is also striking that his more elevated response is not distinct from the overriding move towards a more naturalistic approach, but that the two run in tandem, informing each other.

Fig. 17 J.M.W. Turner
Beeston Castle, about 1809
Watercolour and pencil on paper, 21 x 33 cm
National Museums Northern Ireland, Ulster Museum

Beyond the Thames Valley, Turner surveyed other parts of Britain with his new apprehension of the essence of Claudian landscape. In some images, such as the watercolour view of Beeston Castle in Cheshire (fig. 17), the balance between the underlying prototype and Turner's delineation of the specifics of the place are in perfect alignment. Instead of cavorting nymphs and shepherds, the viewer encounters stooped labourers clearing the woods below the distant castle, which appears on the brow of a hill, in place of a classical temple. The idyllic qualities Turner introduced to his view of Linlithgow (plate 24), on the other hand, are perhaps not as well integrated; the purpose of the framing trees is too blatant, even though the overall effect is serene and shares the imperceptible shifts of golden tone that characterise one of Claude's pictures.

If Claude's example can be detected so readily in Turner's paintings and watercolours of this period, it also informed two didactic projects that began in the mid-1800s and that continued to influence the course of his aesthetic

taste on into the 1820s. The first of these was the series of mezzotints published from 1807 as Turner's *Liber Studiorum* (or 'Book of Studies'), which to some extent took Claude's *Liber Veritatis* as its starting point, recording existing paintings, but then developing into a much more wide-ranging manifesto of Turner's own aims as a painter of landscape.[24] To emphasise his diversity, Turner devised six categories into which he divided his images. These reflected his principal achievements as a painter of Marine, Mountainous, Historical or Architectural subjects. But, more significantly, he also specified two types of Pastoral subject: firstly the rudimentary form, which reflected his recent advances in this genre; and another that he labelled 'E.P.', to denote a more 'Elevated' or possibly 'Epic' type of pastoral, its scenes inhabited by Claudian peasants and goddesses, rather than British yeomen, even though some images confer a classical character to a British setting (plates 18 and 19). The images were published in parts over many years, without any accompanying text. As a result, the distinction Turner created between the two types of pastoral, and the precise meaning of 'E.P.', remains

unknown. Scholars have speculated that Turner was highlighting that, as a modern artist, he was fully able to match his great predecessor, and that he could also surpass Claude's example, a point that was to become highly contentious during the second decade of the nineteenth century.

Turner gave further testament to his appreciation of Claude in another sphere when, in January 1811, he at last began to deliver his lectures on perspective to the students of the Royal Academy. The last of these lectures, focusing on 'Backgrounds, Introduction of Architecture and Landscape', included his fullest tribute to Claude, and the 'comprehensive qualities and powers' of his art. As already mentioned earlier, he gave due emphasis to Claude's ability to compose and unite in his pictures the 'bits' he had studied from nature, though Turner was hardly unique in singling out this tendency. Much more personal was his impassioned appreciation of the visual appeal of Claude's pictures:

> *Pure as Italian air, calm, beautiful and serene, spring forward the works and with them the name of Claude Lorrain. The golden orient or the amber-coloured ether, the mid-day ethereal vault and fleecy skies, resplendent valleys, campagnas rich with all the cheerful blush of fertilisation, trees possessing every hue and tone of summer's evident heat, rich, harmonious, true and clear, replete with all the aerial qualities of distance, aerial lights, aerial colour ...*[25]

As Turner rattled through his litany of the 'bits' of Claude that especially appealed to him, his listeners would have comprehended how these collectively came together as harmonious 'Compositions'. Just as significant here is the emphasis on the subtly different light effects that were evidently, for Turner, the defining triumph of Claude's art. While this was also a well-established notion, Turner's analysis was that of a fellow practitioner, who fully comprehended the difficulties overcome in recreating the nuances of a specific hour, and carrying them throughout the whole image. In addressing this achievement, Turner had very early on adopted Claude's revolutionary positioning of the sun at the heart of many of his images, an effect that remarkably few other artists had been bold enough to attempt. The luminosity the effect required was something that Turner at first found possible only when working in watercolour, as in his 1799 view of Caernarvon (plate 5), where the supporting white paper contributes to the sunlight's brilliance. In attempting to approximate more closely to what were then believed to be Claude's methods, by 1803 he was experimenting by painting with distemper on an unprimed

canvas (plate 13).[26] But the rich colours diminished as they sank into the canvas, causing Turner soon afterwards to begin to adopt a light ground when painting in oils. This radical departure gave his pictures a noticeably different look from his earlier paintings, which had followed the more traditional process of working from dark grounds up to white highlights. It also permitted him to approach in oils the same dazzling effects that were so crucial to the success of his watercolours. This is evident in some of his views of the Thames, such as *Abingdon* (1806, Tate), or *Pope's Villa, at Twickenham* (1808, private collection), where the clouds coalesce more organically as the products of vapour over which light passes. Turner created this kind of effect with much less effort in his watercolours. For example, in his depiction (fig. 18) of the story of Chryses, the Trojan priest of Apollo, the clouds emerge towards the top of the sheet, their collective mass providing a useful counterpoint to the rock arch on the other half of the image, and in the process frame the sun to underscore its significance to the main narrative.

The natural feature of the arch by the sea derives from paintings by Claude (see plate 53), and it is significant that another of the exhibits Turner sent to the Royal Academy the same year as *Chryses* also indicated his intention that his works were understood as paraphrases of Claudian models. This second picture was *Mercury and Herse* (fig. 19), a rare instance of Turner making use of an upright format. Among the examples he could have known of Claude's upright compositions perhaps the most relevant was the *Landscape with Hagar and the Angel* (plate 40), then owned by the prominent connoisseur Sir George Beaumont, though Turner would also have been aware from the *Liber Veritatis* of the four large canvases commissioned from Claude by Philip IV of Spain, each of which blended a religious narrative with recognisable landmarks in the vicinity of Rome. Both *Chryses* and *Mercury and Herse* were responses to the tales in Ovid's *Metamorphoses*, a text he was aware Claude had drawn on frequently for inspiration. Around 1804–6 Turner had proposed many subjects from Ovid and other mythological sources for himself in his preliminary designs, but it was not until 1811 that he regularly began to exhibit subjects taken from classical texts. This was the year in which he had already emphatically endorsed Claude's works for those attending his Academy lectures, but the decision to approximate to Claude's example so closely in the annual exhibition may have been partly a pragmatic attempt to secure a different kind of patron. Many significant collectors preferred Old Master pictures to anything contemporary. So it was notable that the most prominent admirer of *Mercury and Herse* was the Prince Regent, afterwards

Fig. 18 J.M.W. Turner
Chryses, exhibited 1811
Watercolour on paper, 66 x 100.4 cm
Private collection

George IV, who praised Turner at the Academy dinner for having created 'landscapes which Claude would have admired'.[27] Despite fevered speculation that he intended to acquire the painting for the sort of figure more usually paid for a modest Old Master, it ultimately failed to become part of the royal collection. The incident nonetheless would have served to further provoke those of a conservative mind, who considered Turner's prominence as a landscape painter unmerited when considered alongside the earlier artists he aspired to equal. Chief among these was Beaumont, who from at least 1806 steadily challenged the growing perception of 'Turner as being superior to Claude, – Poussin, or any other'.[28] Unhappy to witness the erosion of the artistic certainties he cherished, Beaumont incited others to disparage Turner's increasingly naturalistic approach. He particularly disliked the radical brightness of Turner's images, which derived from the white preparatory grounds on which they were painted (instead of working from dark and adding the lighter parts last). As a result he castigated Turner and those who imitated him as 'White Painters'.

This private campaign, evidently damaging to picture sales, erupted into the public sphere of the London exhibitions a few years later when, early in 1814, Turner retaliated by submitting to the annual British Institution competition his painting *Appulia in Search of Appulus, vide Ovid,* a full-scale version of a renowned Claude landscape belonging to Lord Egremont (figs 7 and 10, pp. 20–1). Both Beaumont and Egremont were Directors of the British Institution, which aimed to encourage young artists to produce pictures deemed appropriate to form the companions of Old Masters. Like their fellow Directors, they regularly lent pictures from their collections for aspiring students to copy. Though Turner knew the benefits of this kind of exercise all too well, he and other artists resented the limits this conservative notion of modern art imposed on them and their hopes of patronage. By replicating one of the most beautiful paintings by Claude in Britain, he sought to deride

those like Beaumont who refused to consider the possibility that earlier formulas could be reutilised to serve new ends and to reinvigorate contemporary practice.[29] The full subtleties of his protest are unlikely to have been understood, since it failed in any tangible way to change the outlook of these guardians of taste. But few on the judging panel at the Institution would have missed his desire to undermine their doctrine. However, while Turner sought to subvert the ways in which Old Master paintings were being used, there were many artists who were inclined to accept the prevailing dictates at face value, such as John Glover, yet another contender for the title 'the English Claude'.[30]

Curious as it may seem today, Claude's legacy was increasingly disputed ground, and Turner made his boldest claim to it the following year with two landmark paintings: *Dido building Carthage* (plate 22) and *Crossing the Brook* (plate 27). These works addressed different aspects of Claude's achievement. The Carthaginian scene derives from his harbour subjects, lit with refulgent sunlight, and was a palpable rethinking of the Claude canvas Angerstein had acquired a decade earlier (plate 20), then among the most expensive works of art to have passed through the London market.

Accompanying it, *Crossing the Brook* represented an even more concerted attempt to create a harmonious relationship between the demands of an idealised landscape format and Turner's own imperative to introduce the particularity that informed the oil sketches he had made directly from nature during a tour of Devon. While the essence of the view has been supplemented with an Italianate refinement, Turner nevertheless retained the local mine workings, illustrating his desire to create landscapes that are simultaneously transcendent and grounded in the specifics of an actual place. Turner was particularly successful in propagating this more purposeful type of landscape in his contemporary topographical watercolours, whether recording the

Fig. 19 J.M.W. Turner
Mercury and Herse, exhibited 1811
Oil on canvas, 190.5 x 160 cm
Private collection

Fig. 20 J.M.W. Turner
A Beginning, from the *Como and Venice* sketchbook, 1819
Watercolour on paper, 22.6 x 28.7 cm
Tate, London

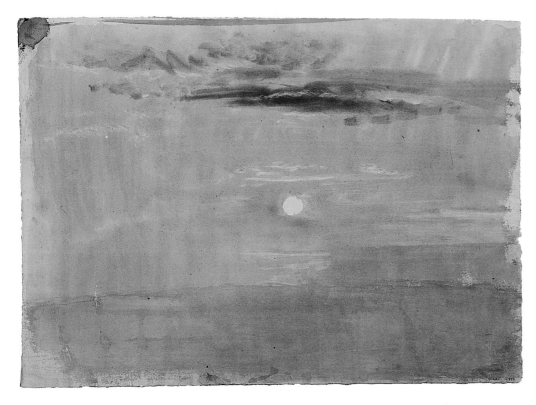

Fig. 21 J.M.W. Turner
Sunset over Water, about 1825–7
Watercolour on paper, 22.5 x 34.6 cm
Tate, London

Fig. 22 J.M.W. Turner
The Bay of Baiae, with Apollo and the Sibyl, 1823
Oil on canvas, 145.5 x 239 cm
Tate, London

coasts of southern England or the nation's rivers and rolling countryside (plate 26). His view of the *Vale of Ashburnham* (British Museum, London), for instance, includes a pair of Claudian trees that direct the eye towards the distant country home of the Earl of Ashburnham. But on this occasion they and the fallen trunks in the foreground invoke the forests that formerly covered this view, by then lost to the production of charcoal.[31]

By the later 1810s, when preparing these watercolours, Turner habitually worked in batches, laying down the foundations of his designs as broadly painted, parallel bands of colour, the blue for the sky diluted imperceptibly to nothing as it met the earth tone below it (fig. 20). This process was partly a matter of convenience, enabling him to work on several images at the same time. But its essential character surely also stemmed from his continued scrutiny of the way Claude prepared the skies in his paintings. Back in 1799, when he had examined the prized canvases known as the 'Altieri Claudes' under the guidance of Benjamin West (see plates 1 and 2), he was presumably party to the latter's perceptive analysis: 'Claude began his pictures by laying in *simple gradations* of flat colours from the Horizon to the top of the Sky, and from the Horizon to the foreground, witht. [= without] putting clouds *into* the sky or specific forms into the Landscape till He had fully settled those gradations.'[32] Once again, the *Liber Veritatis* version of Sandrart's biography would have provided further confirmation that this was Claude's practice: 'It was his principal delight to mark the almost insensible gradations of objects towards the horizon, and those delicate and fine tints of Nature which

none but the most diligent observer can imitate.'[33] As well as practising this effect in his watercolour 'beginnings', Turner frequently rehearsed the more challenging art of putting the sun at the centre of an image (fig. 21). By 1820 he had become deeply preoccupied by the latest colour theories, which sought to revise Sir Isaac Newton's colour spectrum.[34]

In 1819, with the Napoleonic Wars already four years in the past, Turner's yearning to see for himself the actual light and landscapes that had inspired Claude could no longer be contained, and he at last set out for Italy. Sir Thomas Lawrence, who was already in Rome, judged that the Campagna was the perfect subject for Turner: 'The country and scenes around me thus impress themselves upon me; and that Turner is always associated with them; Claude, though frequently, not so often.'[35] For Turner, the trip was effectively a pilgrimage during which he looked intently for echoes of the pictures he knew so well in the reality of modern Italy, duly noting the 'first bit of Claude', as he passed Osimo on the road from Ancona, and conducting his own studies at Tivoli in the spirit of his predecessor.[36] He would have known that, as well as making pen and ink studies of individual features, Claude had apparently attempted to capture the precise tints of what he found in nature, presumably in oil colours, so that he could refer to them back in his studio. Knowledge of this sketching practice, which had also been undertaken by Poussin along the Tiber, inspired many visiting artists to pursue their own nature studies in oils while in Italy.[37] But it seems that Turner decided to record his own observations almost exclusively in pencil, with occasional

bursts of watercolour. This was a process he had honed over the years, and which was essentially founded on the Claudian principle of setting down 'bits' that, individually or in combination, he was afterwards able to resolve into pictures. This was certainly the case for the three major oil paintings he exhibited in the years after this first trip to Italy, each of which sprouted from bodies of detailed and incidental notes.[38] Of these, *The Bay of Baiae, with Apollo and the Sibyl* (fig. 22) is arguably the most successful, offering a scintillating evocation of Italian sunshine crowning the azure depths along the Mediterranean shore. In a setting where the ruins of the ancient world are integrated into the present, and where a shepherd continues the timeless process of herding his flock, it does not seem all that incongruous to introduce Apollo and the Cumaean Sibyl. Their encounter, as described by Ovid and other classical writers, is indeed entirely appropriate to the location, which was the Sibyl's legendary home. And the setting sun neatly underscores the theme of the chaste Sibyl's waning beauty. This visual feast, of course, also functioned as a further updating of Claude's coastal subjects, three of which also adopted the same narrative.

In the years after his first experience of Italy, Turner continued to refresh his passion for Claude's imagery. In addition to the canvases he had studied while in Rome, in 1821 he returned to the Louvre to pay better attention to its impressive collection of the master's works, which he appears to have neglected or overlooked nearly twenty years earlier (plate 8). But perhaps just as significant was the arrival at the British Museum in 1824 of a large group of nature studies by Claude (see fig. 23). These had been seen by Constable, when still on the market, before their acquisition by Richard Payne Knight (who left them to the Museum).[39] Though himself as much of an admirer of Claude as Turner, Constable described the sketches as being 'just like papers used and otherwise mauled, & purloined from a Water Closet'.[40] If this was partly a response to their physical condition, Constable was also aggrieved that such things could sell for so much more than his own pictures. Simultaneously, it also suggests that Claude's works could still surprise and inspire in terms of their boldness and originality.[41]

As for Turner, it is probable that he would have seen drawings by Claude long before this. But around 1824 he once again chose to work in monochrome in his private studies. This fed into his work in mezzotint around this date, but quite possibly was a response to the new insights he could have gained from the drawings in the Payne Knight group (fig. 24).[42] Taken in tandem with his recent first-hand enquiry into how Claude worked in the Roman Campagna, Turner now benefited from a deeper understanding of the distinction between Claude's direct encounters with nature (as preserved in his fragmentary studies) and his production of the consummate ideal landscapes. During the eight years before he returned to Rome in 1828, his Claudian studies intensified and took the form of playful variations on sketches he had made in Italy and France, transforming this material so successfully into idealised scenes that its true nature remained undetected until recently (plate 50).[43] He also turned to well-tried idealising formats when creating a version of British scenery, demonstrating for one of his former pupils how a vague impression of a scene in Derbyshire could receive an elevated response.[44]

Turner's renewed absorption in Claude's art, evident in this concentrated outburst, had presumably been given further impetus by the establishment of the National Gallery, also in 1824, and the inclusion there of those paintings he had treasured in the collections of Angerstein and Beaumont. Above all, the inauguration of the Gallery seems to have rekindled an interest in Claude's harbour subjects, something not altogether surprising, given the quality of the three great canvases acquired from Angerstein's collection (NG 5; NG 14, plate 20; NG 30). Constable, too, championed the vitality of this group, observing that, 'Although [Claude] was a painter of fairyland, and sylvan scenery of the most romantic kind, he is nowhere seen to greater advantage than in his sea ports.'[45] Turner's admiration for the same works permeates the views he made at East Cowes Castle in the summer of 1827 (plate 45), a visit that also stimulated a third large Carthaginian subject, which he apparently conceived to accompany those he had painted in 1815 and 1817 (plates 22 and 23) as a kind of triptych.[46] But much more extraordinary as redefinitions of the vitality of the Claudian model are the four landscapes Turner created at roughly the same time for Lord Egremont at Petworth House. Each of these is structured so that the viewer squints through golden light towards the setting sun: two show engineering projects with which the Earl was associated at Chichester and Brighton; and the other two canvases depict the park outside his country house (fig. 25). Rather neatly, once the paintings were installed in the Earl's dining room, they permitted him and his guests to discern how Turner had transformed 'Capability' Brown's improved natural landscape into his own exultant kind of art.

The logical culmination of this fruitful application of idealised modes of landscape was Turner's second trip to Italy, the 'Land of Bliss'. Turner could

Fig. 23 Claude
View of the Tiber from Monte Mario, looking towards
the south [-east], about 1640–1
Brown wash on white paper, 18.5 x 26.8 cm
The British Museum, London

Fig. 24 J.M.W. Turner
Lurid Sunset, from *Old London Bridge* sketchbook,
about 1824
Watercolour on white paper, 10.3 x 16.7 cm
Tate, London

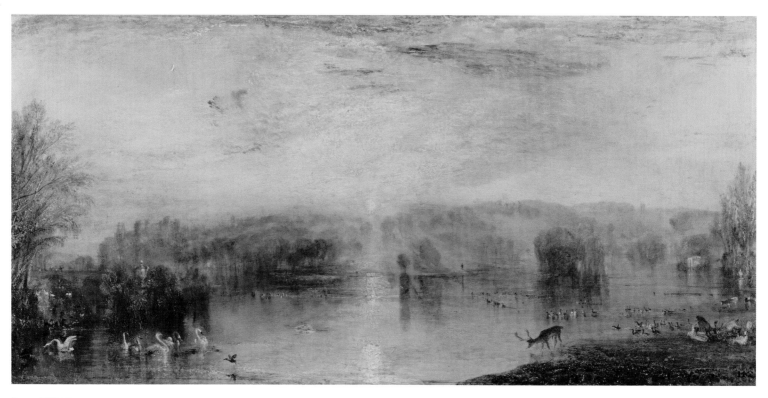

Fig. 25 J.M.W. Turner
Petworth Lake, about 1829
Oil on canvas, 63.5 x 132 cm
Tate, London (in situ at Petworth House)

not have been more 'saturated with Claude' than he was at this moment, and it is interesting that so many of his efforts in 1828 were aimed at a further demonstration of how integral he believed Claude to be to his own aesthetic direction. This explains his otherwise curious desire to paint a companion picture to Egremont's Claude as his first objective once he got to Rome.[47] He intended to undertake this fundamentally out of his deep love for the *Landscape with Jacob, Laban and his Daughters* (fig. 10, p.21). But his underlying motive was also a gesture of thanks for the support to 'modern art' that Lord Egremont had given. Evidently for Turner the conjunction of old and new was entirely resolved. Indeed, he appears not to have considered it a matter of contention (or irony) that his proposed gift of a reworking of the Claude effectively succumbed to the criteria demanded by the old British Institution competitions. However, surely this was the point. By way of making amends for his earlier impertinent appropriation of the Claude, Turner was offering a more up-to-date statement of what a modern ideal landscape should entail. Whether the gesture was appreciated by Egremont is unknown, but, perhaps significantly, the resulting painting, *Palestrina – Composition* (plate 49), never joined its inspiration at Petworth House.

The other landscapes Turner completed while in Rome were also deliberately conceived in response to works by Claude, most obviously *Regulus* (plate 47), his powerful intensification of the well-known *Seaport* in the Uffizi. (The embarkation Turner depicts is that of Regulus, the humiliated

Roman general, who had been taken hostage in Carthage, where his punishment included the removal of his eyelids.) Turner perhaps anticipated that such overt tokens of homage would be approved in the city that Claude had made his home, where contemporary artists continued to aspire to equal the works of Claude, Poussin and other seventeenth-century landscape painters. However, the overwhelming reaction to Turner's exhibition was the standard one of bemused outrage that new art has since so often generated. Not for the last time, the crudely pithy phrase 'Cacatum non est pictum' (crapped not painted) was trotted out and incorporated into satirical lampoons at Turner's expense.[48] This highlights that it was more Turner's style than his choice of subject matter that antagonised his viewers. In comparison with the polished smoothness of academic practice, Turner's canvases possessed rich textures and a bold deployment of impasto. They were also marked by a greater chromatic lustre than was the norm, something his choice of vibrant new materials further heightened. Objections to his departure from a controlled approximation of the actual colours of the natural world had increasingly characterised critical responses to his exhibits in London too. A year later, the American landscape artist Thomas Cole saw Turner's paintings for the first time and was similarly struck by their 'splendid combinations of colour when it is considered separately from the subject'. The casualty of such effects Cole felt was an apparent lack of solidity: 'Every object appears transparent or soft.'[49] In addition to this, it had not escaped critical eyes that Turner had adopted a very generalised means of describing individual

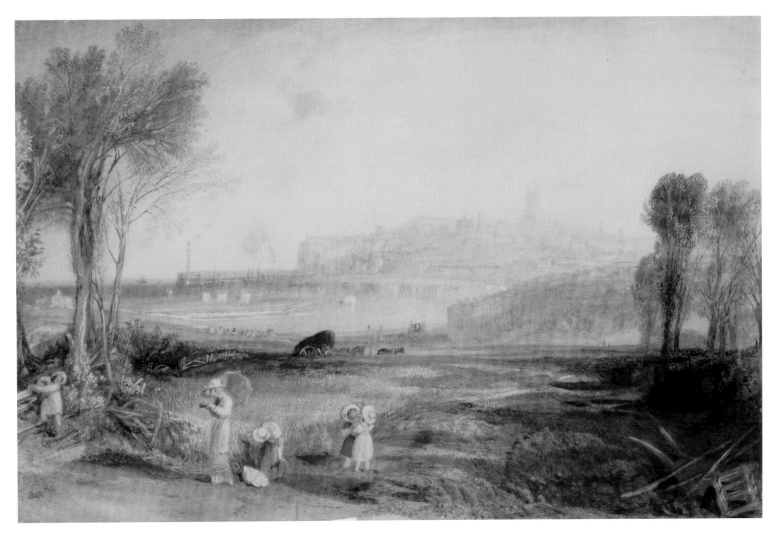

Fig. 26 J.M.W. Turner
Margate, Kent, about 1830
Watercolour and gouache on paper, 29 x 45 cm
Herbert Art Gallery and Museum, Coventry

objects, giving far less attention to their specifics than the contribution they made to the whole. It was as if, having invoked the spectre of Claude, Turner could not prevent his viewers from perceiving where he did not match the earlier artist, and not what he offered instead.

Yet if Turner felt in any way chastened by the caustic responses his works provoked, it was not apparent. Over the following years he doggedly pressed on with his own type of modern landscape, in effect evolving a sort of idealised topography. This was perfectly suited to the designs he tailored to the appetite for illustrated travel books, or volumes of poetry, such as Samuel Rogers's *Italy* (1830), or the *Life and Works of Lord Byron* (1832). For projects of this kind, he returned to the innumerable pencil sketches he had made during his travels since the 1790s, developing them in watercolour in much the same way that he sifted and collated similar impressions for an oil painting. Frequently, in their evocation of mood or structure, the images hark back to Claude, revealing Turner's desire to infuse his settings with a

numinous character that elevates them beyond the ordinary. To light on just two of many scenes where this is discernible in the long set of *Picturesque Views in England and Wales*, the watercolours of Margate (fig. 26) and Prudhoe (British Museum, London) both seduce the viewer with their recreation of gleaming sunlight, and barely hint at the mundane details of the actual locale – in the case of Margate, a long terrace of modern houses. Turner adopted a similar approach in the views he made along the rivers Loire and Seine for his three *Annual Tours* (1833–5). As at Margate, he did not neglect the urban setting, or innovations in contemporary life, such as public transport, steamboats or the new boulevards of Paris. Instead these features are deftly woven into a reinvigorated version of Claude's prototypes. One of the most successful in this respect is the view of the port of Le Havre at sunset (plate 54). Inevitably, the informed viewer thinks of Claude's *Seaports*. But the visual bustle of the harbour is suggested so adroitly and energetically that the image operates independently of its model as a vibrant account of modern life. Nevertheless, as the 1830s commenced, Turner invariably struggled to

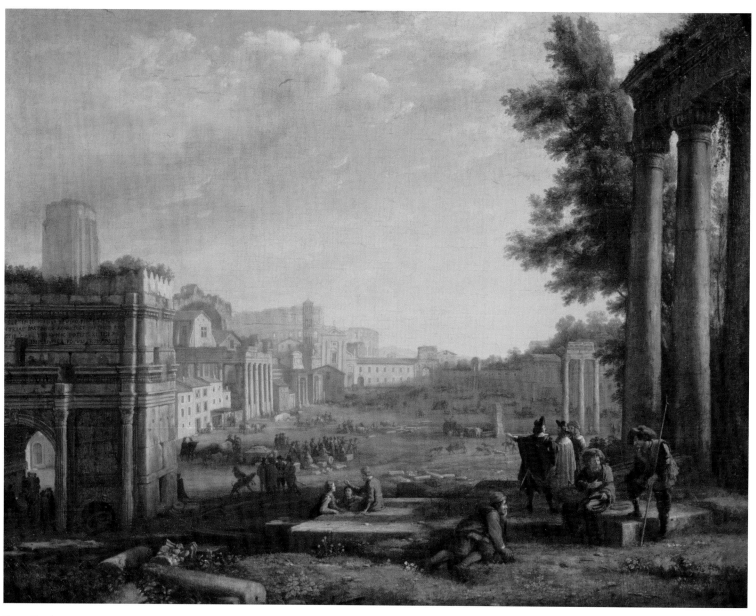

Fig. 27 **Claude**
The Roman Forum, 1636
Oil on canvas, 53 x 72 cm
Musée du Louvre, Paris

secure sales in the deeply competitive arena of the annual exhibitions at the Royal Academy, where his work was more frequently mocked than praised. Those critics who were sympathetic noted his persistence as a purveyor of works of ambition and true distinction. The *Athenaeum*, for example, lamented that, even though he was 'the noblest landscape painter of any age, Turner cannot sell one of his poetic pictures: he rolls them up, and lays them aside, after they have been the wonder of the Exhibition'.[50] This writer was probably thinking of *Ulysses deriding Polyphemus* (1829; Tate, London), *Palestrina – Composition* (plate 49), *Caligula's Palace and Bridge* (1831; Tate, London) or *Childe Harold's Pilgrimage – Italy* (1832; Tate, London), Turner's chief exhibits between 1829 and 1832, all of which remained unsold. The fate

of these works possibly reflects a shift both in critical attitudes and in the physical character of Turner's work. But more fundamentally, the nature of patronage was changing, as the confident, new middle classes sought different types of imagery. Even so, the implicit comparison Turner set up in his classical landscapes with the seventeenth-century artist no longer worked to his advantage. As in Rome in 1828, viewers applied different criteria in judging between the two. For example, when *Childe Harold's Pilgrimage – Italy* was exhibited in 1832, the critic of the *Morning Post* condemned it, proposing its colour untrue: 'We have a few Claudes in the Galleries of this country to instruct our untravelled eyes in the true features and hues of the classic land, or we might be borne down by the authoritative

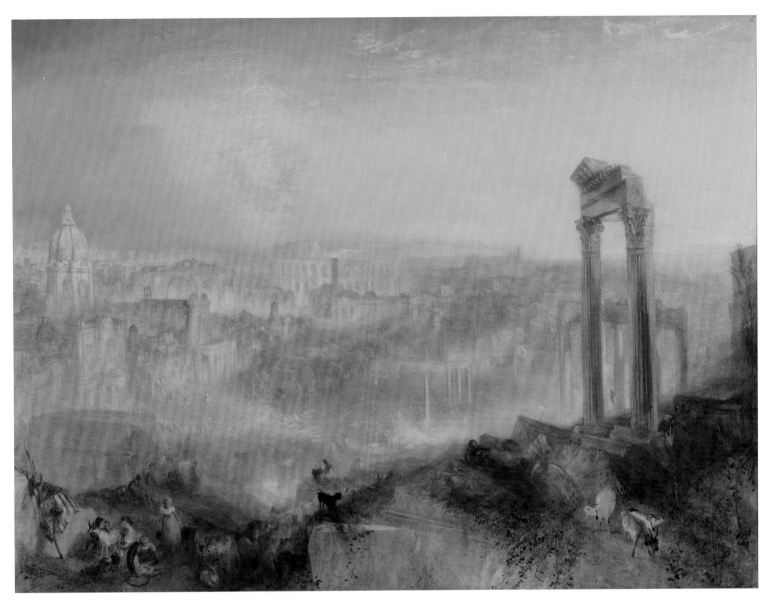

Fig. 28 J.M.W. Turner
Modern Rome – Campo Vaccino, 1839
Oil on canvas, 90.2 x 122 cm
The J. Paul Getty Museum, Los Angeles

assertion of certain pilgrims of art, who would persuade us that there are no colours beyond the Alps but the colours of the rainbow.'[51] And more hostile objections arose when *Regulus* got its first London showing a few years later: 'Turner is just the reverse of Claude; instead of the repose of beauty – the soft serenity and mellow light of an Italian scene – here all is glare, turbulence, and uneasiness.'[52] The heavily reworked *Regulus* is a more extreme case than most, with its additional layers of thickly scumbled paint intended to approximate to the invasive effect of the radiating light. But its strident effect was a long way from the qualities Turner himself had first cherished in Claude; qualities that Constable articulated so well in his phrase 'the calm sunshine of the heart'.[53] Yet, if Turner's recreation of light in his later classical subjects was vigorous and exaggerated, this tendency seems to have resulted from

the interplay he created between his subjects and the effects he depicted. These were years in which his images dealt with the blinding pain of sunlight to Regulus's lidless eyes, the stoic exile endured by Cicero, or the rape of Proserpine.[54] The series also encompassed Ovid's banishment from Rome, a moment dramatised by a baleful, miasmic sunset that seems to invade the city.[55] These pictures were, however, shown alongside much more restrained examples of Turner's response to the light of Italy, his canvases of this period often conceived to hark back to the paired morning and evening pendants of Claude. The Ovid picture, for example, was juxtaposed with a gently evocative view of modern Tivoli (plate 39). And, a year later, he showed two views of Rome, again a pairing of 'Ancient' and 'Modern' scenes, where the latter surveys the Roman Forum as the day comes

to an end (fig. 28). In contrast with Claude's earlier depiction of the same scene (fig. 27), which took the form of fairly literal topography by his standards, Turner's picture offers a profoundly poetic idea of this celebrated view. The departing sun still casts a warm glow over the dried-out husk of ancient Rome, even as the coolness of moonlight begins to take possession of the sky. As in so many of his paintings of Italy, Turner moderates the temptations of nostalgia by presenting his type of idealised landscape as something that illustrates and meditates on modern life.

As he moved into the 1840s, Turner at last found regular commercial success with his serene views of Venice and his tempestuous marine subjects, and more rarely found it expedient to draw on Claude so overtly in the composition of his pictures. This did not mean that he abandoned his master; Claude's example still percolates through the watercolours Turner produced during these years, whether painted during the course of his travels in Europe, or back in his studio. This can be seen in his delicately realised watercolour of Lake Nemi (fig. 29), its surface flooded with flickering particles of individually nuanced sunlight. The watercolour demonstrates how Claude's 'Land of Bliss', in the form of the Italian scenery he had first experienced twenty years earlier, still haunted and inspired him. It is an effortless reworking of one of Claude's pastoral subjects, where the idle pastimes of the figures induce a pleasant mood of reverie.

It will perhaps be a surprise to some to find a similar vein of pastoral in the painting that has become one of the crucial examples of Turner's surge towards a more modern type of picture-making: *Rain, Steam, and Speed – The Great Western Railway* (fig. 30).[56] Powering across the bridge over the Thames at Maidenhead, a steam locomotive bears down towards a speeding hare, its fiery hulk encroaching on the usual welcoming foreground area that Turner often used to lead the eye into his compositions.[57] The effect is deliberately destabilising, and results in the viewer seeking security elsewhere in the image. As well as the ploughman, with his team of horses, to the right of the bridge, the central area of the picture features a group of dancing figures on the banks of the river. Apparently undeterred by the passing shower, their frolicking is more suggestive of Claude's Italian peasants than the natives of the Thames Valley. The comparison was clearly intended, as Turner had claimed that this part of the river exceeded the beauties of anything he had seen in Italy.[58] Seeking a means of suggesting the peerless nature of the Thames, he had embellished his earlier Thames views with similar revellers

(fig. 16, p. 31). As on those occasions, it seems he was intending to infuse the picture with a poetic dimension that can be traced ultimately to his devotion to *The Seasons* by Thomson, an author whose works enunciated clearly for Turner the beauties of landscape in a way that ran parallel with what he took from Claude. So, though Turner is undoubtedly celebrating the thundering arrival of the modern age in his image, he does so by suggesting continuities with the past. The train may temporarily shatter the idyll it hurtles through so quickly, but it does not completely displace it.

Even while the contrasts between the appearance of Claude and Turner's paintings become more pronounced in his later works, Turner had been regularly updating his will. Though the process resulted in revisions to many details, at its core the will remained unchanged in enshrining Turner's yearning for his works to be wedded as an ensemble with the two most prestigious works of Claude. Given this obsession, it was curious that Turner stood by carelessly, allowing the pictures he planned to leave to the nation to become damaged in his steadily neglected gallery on Queen Anne Street. These paintings had never found buyers after they were first exhibited, and still adorned the walls in the early 1840s, when John Ruskin was researching the first volume of his defence of Turner: *Modern Painters* (1843). Because Ruskin sought to assemble a case for Turner as an artist who represented nature accurately, he was, at best, somewhat equivocal about Turner's essays into the realm of idealised landscape, deeming the later ones merely 'nonsense pictures'.[59] More significantly, he criticised Claude's tendency to generalise when making comparisons with Turner's ability to achieve a balance between close observation and idealised form. Some of these aspects of his text were withdrawn in subsequent editions, but a seed had been planted for Turner, who shortly afterwards started to rework a group of ten of the subjects of his *Liber Studiorum*. Almost all of these derive from images with Claudian echoes, as if Turner was creating a last tribute to his hero. He had never depicted Claude himself in a picture in the way he had portrayed other artists, such as Raphael, Rembrandt, Canaletto, van Goyen or Bellini. But these late private meditations on Claudian motifs represent a magical and transcendent demonstration of what he had learned, and why Claude had remained such a vital touchstone for so many years. Claude provided for him, as also for Constable, a refreshing source from which to 'drink at again and again'.[60] There was to be one more group of works that hark back to the most important period of Turner's dialogue with Claude. In 1850 Turner sent four canvases to the Royal Academy based on the Dido and Aeneas narrative that had

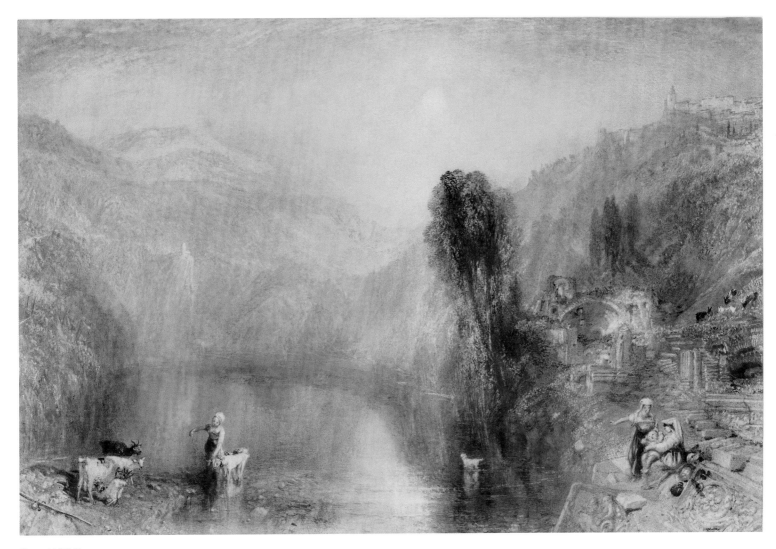

Fig. 29 J.M.W. Turner
Lake Nemi, 1839
Watercolour on paper, 34.7 x 51.5 cm
The British Museum, London

always remained a vital trigger for his classical fantasies (fig. 31).[61] Though
utterly at odds with the taste of the Academy by that date, these works were
suffused with Turner's passion for his mentor, each one literally built up over
months with glazes of ravishing colour. Collectively, they constitute a moving
final testament to the hand that had guided and spurred Turner for so long.
Without Claude's example, Turner could never have enriched the possibilities
of British landscape. Nor could he have discovered such fruitful ways of
channelling his instinctive romanticism. It has sometimes been assumed that
his motive for proposing that his works were indeed worth showing alongside
Claude was essentially a kind of blithe arrogance. But perhaps his plan should
be considered in another light. In directing others to recognise the value of
Claude to his own development, there was surely also a didactic element to
this proposition. Ultimately, Turner did not want his response to be seen as
a full stop, but as a signpost that others might follow.

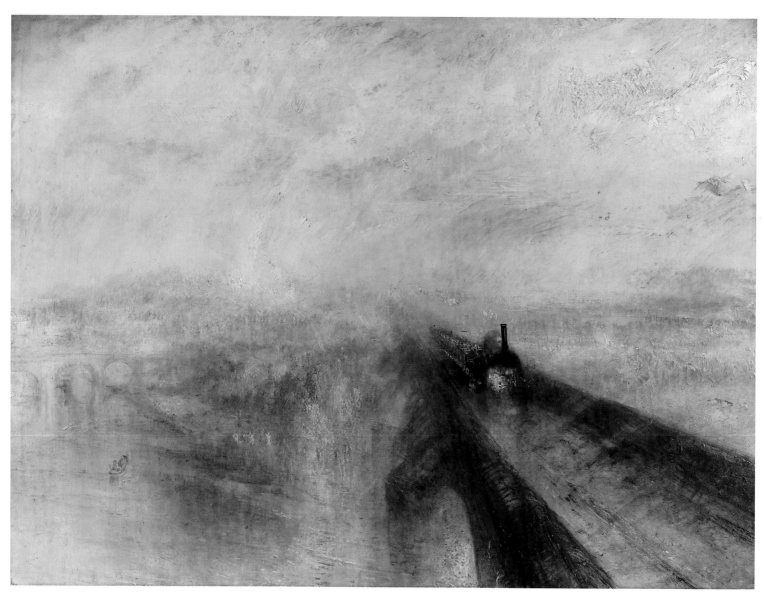

Fig. 30 J.M.W. Turner
Rain, Steam, and Speed – The Great Western Railway, 1844
Oil on canvas, 91 x 121.8 cm
The National Gallery, London

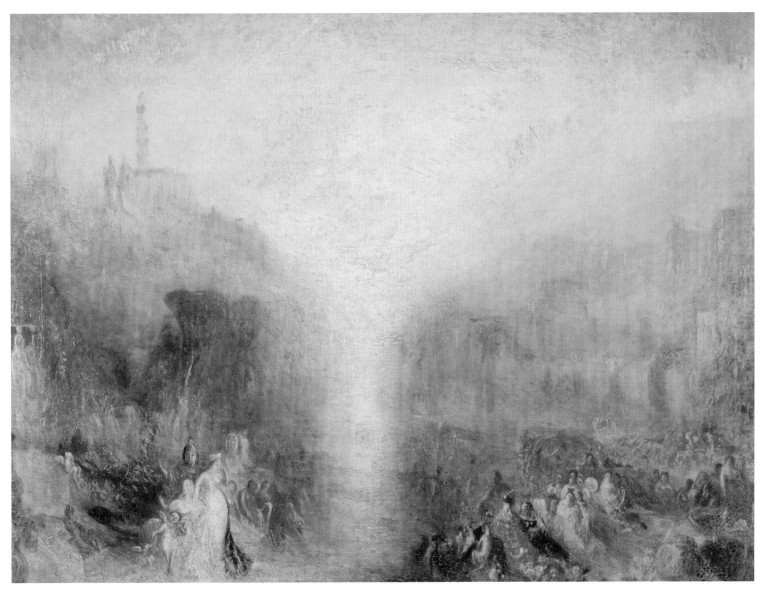

Fig. 31 J.M.W. Turner
The Visit to the Tomb, exhibited 1850
Oil on canvas, 91.4 x 121.9 cm
Tate, London

NOTES

1 *Roman and French* sketchbook, TB CCXXXVII 8-9, Tate. The text has generally been transcribed as 'Land of all bliss' (see, most recently, James Hamilton, *Turner and Italy*, exh. cat., National Galleries of Scotland, Edinburgh 2009, p. 76). However, it reads as given here, with another word added above and to the right of the text. This appears to say 'golden'. I am grateful to Nicola Moorby for corroborating this piece of Turner's handwriting.

2 See John Gage, *J.M.W. Turner: 'A Wonderful Range of Mind'*, New Haven and London 1987, pp. 97–123, 'Interpreting the Old Masters'; and David Solkin, ed., *Turner and the Masters*, exh. cat., Tate Britain, London 2009.

3 Kathleen Nicholson, 'Turner, Claude and the Essence of Landscape', in Solkin, op. cit., p. 62.

4 See for example, *Bristol Journal*, 26 April 1828; *New Times*, 10 March 1828; *New Monthly Magazine and Literary Journal*, December 1832, p. 532; *The Times*, 6 May 1815 (quoted in Martin Butlin and Evelyn Joll, *The Paintings of J.M.W. Turner*, revised edn, New Haven and London 1984, p. 95).

5 Michael Kitson, 'Claude Lorrain', in Evelyn Joll, Martin Butlin and Luke Herrmann, *The Oxford Companion to J.M.W. Turner*, Oxford 2001, pp. 48–9.

6 For a useful summary of these developments, see Malcolm Andrews, *Landscape and Western Art*, Oxford 1999.

7 Horace Walpole, *Essay on Modern Gardening*, London 1784, p. 85.

8 Sir Joshua Reynolds, Discourse IV, first given on 10 December 1771, quoted in Robert Wark, ed., *Discourses on Art*, San Marino 1959, pp. 69–70.

9 Alexander Cozens, *A New Method of Assisting the Invention in Drawing Original Compositions of Landscape*, London 1785–6.

10 See Barry Venning, 'Turner's Annotated Books: Opie's "Lectures on Painting" and Shee's "Elements of Art"', *Turner Studies*, vol. 2, no. 1, summer 1982, pp. 36–46.

11 Jerrold Ziff, '"Backgrounds: Introduction of Architecture and Landscape". A Lecture by J.M.W. Turner', *Journal of the Warburg and Courtauld Institutes*, 26 (1963), p. 144.

12 Ibid., p. 133.

13 John Boydell, *Liber Veritatis*, London 1777, pp. 5, 7; see Walter Thornbury, *The Life of J.M.W. Turner*, London 1862, vol. I, p. 409: Turner is supposed to have complained, 'No holiday ever for me.'

14 *Liber Veritatis*, op. cit., p. 8.

15 Ibid., pp. 5, 7–8.

16 Ibid., p. 10.

17 See Richard Cohen, *Chasing the Sun: The Epic Story of the Star that Gives us Life*, London 2010, pp. 427–9.

18 See the comments of the *True Briton* for 4 May 1799, quoted in Butlin and Joll 1984, op. cit., p. 7, no. 9.

19 For a discussion of Constable's famous statement of 1802, see Michael Rosenthal, *Constable: The Painter and his Landscape*, New Haven and London 1983, pp. 27ff.

20 See David Hill, *Turner on the Thames: River Journeys in the Year 1805*, New Haven and London 1993, pp. 54ff.

21 Claude's figures were criticised by some of his contemporaries, leading him famously to say that he charged for the landscapes, but gave the figures for free.

22 Andrew Wilton, *Painting and Poetry. Turner's 'Verse Book' and his Work of 1804–1812*, exh. cat., Tate Gallery, London 1990, p. 134.

23 For the provenances of these paintings, see Humphrey Wine, *National Gallery Catalogues: The Seventeenth-Century French Paintings*, London 2001. For Turner's Thameside fantasies, see Kathleen Nicholson, *Turner's Classical Landscapes: Myth and Meaning*, Princeton 1990; and Hill, op. cit.

24 For the most recent complete study of this series, see Gillian Forrester, *Turner's 'Drawing Book': The Liber Studiorum*, exh. cat., Tate Gallery, London 1996.

25 Quoted in Ziff, op. cit., p. 144.

26 See Butlin and Joll 1984, op. cit., p. 36, no. 47.

27 Quoted in Butlin and Joll 1984, op. cit., p. 81, no. 114.

28 Joseph Farington, *Diary*, 5 April 1806; quoted in Butlin and Joll 1984, op. cit., p. 45.

29 For a full discussion of this episode, see Kathleen Nicholson, 'Turner's "Appulia in Search of Appulus" and the Dialectics of Landscape Tradition', *Burlington Magazine*, vol. 122, no. 931, October 1980, pp. 679–86; and Nicholson 1990, op. cit., pp. 227ff.

30 See David Hansen, *John Glover and the Colonial Picturesque*, exh. cat., Tasmanian Museum and Art Gallery, Hobart 2003, pp. 40ff.

31 Eric Shanes, *Turner's England, 1810–38*, London 1990, p. 31.

32 Joseph Farington, *Diary*, eds Kenneth Garlick and Angus Macintyre, vol. IV, New Haven and London 1978–84, p. 1219: 8 May 1799.

33 *Liber Veritatis*, op. cit., p. 7.

34 See John Gage, *Colour and Culture: Practice and Meaning from Antiquity to Abstraction*, London 1993, pp. 203–4.

35 Quoted in Cecilia Powell, *Turner in the South: Rome, Naples, Florence*, New Haven and London 1987, p. 19.

36 See Powell 1987, op. cit., pp. 29, 72–8: *Ancona to Rome* sketchbook (TB CLXXVII 6, Tate).

37 See Peter Galassi, *Corot in Italy: Open-Air Painting and the Classical Landscape Tradition*, New Haven and London 1991; and Philip Conisbee, *In the Light of Italy: Corot and Early Open-Air Painting*, exh. cat., National Gallery of Art, Washington, Washington DC 1996.

38 *Rome from the Vatican* (1820, Tate; B&J 228); *The Bay of Baiae, with Apollo and the Sibyl* (1823, Tate; B&J 230); *Forum Romanum, for Mr Soane's Museum* (1826, Tate; B&J 233). As well as the individual entries for these in the Butlin and Joll 1984 catalogue raisonné (indicated by the B&J numbers), see Powell 1987, op. cit.; Nicholson 1990, op. cit.; and Nicola Moorby, 'Turner's Sketches for *Rome from the Vatican: Some Recent Discoveries*', *Turner Society News*, 115 (2011), pp. 4–10.

39 For the collections of Richard Payne Knight, see Michael Clarke and Nicholas Penny, eds, *The Arrogant Connoisseur: Richard Payne Knight 1751–1824*, exh. cat., Whitworth Art Gallery, Manchester, 1982.

40 R.B. Beckett, ed., *John Constable's Correspondence*, VI, Ipswich 1968, p. 150: letter, 17 January 1824.

41 Another admirer of Claude was Samuel Palmer, who may have been directed in his mysterious twilight sepia series by an appreciation of Claude's nature studies. In later life he wrote, 'Ordinary landscapes remind us of what we see in the country; Claude's of what we read in the great poets and of *their* perception of the country, thus raising our own towards the same level.' Letter of May 1875 (Raymond Lister, *The Letters of Samuel Palmer*, London 1974, vol. II, pp. 912–13).

42 Ian Warrell, *Turner et Le Lorrain*, exh. cat., Musée des Beaux-Arts, Nancy 2002, pp. 126, 194, no. 57.

43 For discussion of these works, see Butlin and Joll 1984, op. cit., pp. 176–9; Cecilia Powell, 'Roman Oil Sketches', in Evelyn Joll, Martin Butlin and Luke Herrmann, *The Oxford Companion to J.M.W. Turner*, Oxford 2001, pp. 266–8; and Warrell 2002, op. cit., pp. 132–43, 195–6.

44 *Scene in Derbyshire*, exhibited 1827, Musée du Québec (B&J 240/269). Like plate 41, this picture was painted for Julia Willoughby Gordon (see Ian Warrell, *Turner on the Loire*, exh. cat., Tate Gallery, London 1997, pp. 181–3, fig. 179). It was identified as the 1827 exhibit in Ian Warrell, 'Petworth Revisited: Turner's Paintings for the Carved Room and his Other Country House Subjects', in *Turner at Petworth*, exh. cat., Petworth House, Petworth, West Sussex 2002, p. 56. The viewpoint in the picture has not been recognised but might relate to sketches in the *Derbyshire* sketchbook of 1809.

45 R.B. Beckett, ed., *John Constable's Discourses*, Ipswich 1970, p. 52: Lecture II, The Establishment of Landscape, 1834.

46 *Dido directing the Equipment of the Fleet, or The Morning of the Carthaginian Empire* (Tate, N00506; B&J 241). Unfortunately, the condition of this work has deteriorated over the years.

47 John Gage, ed., *Collected Correspondence of J.M.W. Turner*, Oxford 1980, pp. 118–19: letter to Charles Eastlake, 23 August 1828. Turner appears to have stayed at Petworth in the weeks before his departure for Rome.

48 The satirical image is reproduced in Andrew Wilton, *Turner in his Time*, London 1987, p. 158. See the account of reactions in Rome by Joseph Anton Koch, quoted in John Gage, *Colour in Turner: Poetry and Truth*, London 1969, pp. 104–5 and 247, n. 147.

49 Ellwood C. Parry III, *The Art of Thomas Cole: Ambition and Imagination*, Newark 1988, p. 98.

50 *Athenaeum*, 11 May 1833, p. 299.

51 *Morning Post*, 29 May 1832; quoted in Butlin and Joll 1984, p. 194, no. 342.

52 *Spectator*, 11 February 1837; quoted in Butlin and Joll 1984, no. 294.

53 Beckett 1970, op. cit., p. 53.

54 *Cicero at his Villa* (1839, private collection; B&J 381); *Pluto carrying off Proserpine* (1839, National Gallery of Art, Washington, DC; B&J 380).

55 *Ancient Italy – Ovid banished from Rome* (1838, private collection, New York; B&J 375).

56 See John Gage, *Turner: Rain, Steam and Speed*, London 1972; William S. Rodner, *J.M.W. Turner: Romantic Painter of the Industrial Revolution*, Berkeley, Los Angeles and London 1997, pp. 140–60; and Judy Egerton, *National Gallery Catalogues: The British Paintings*, London 1998, pp. 316–25.

57 See Maurice Davies, *Turner as Professor: The Artist and Linear Perspective*, exh. cat., Tate Gallery, London 1992, pp. 77ff.

58 Quoted in Gage 1972, op. cit., p. 26.

59 E.T. Cook and Alexander Wedderburn, eds, *The Works of John Ruskin*, III, London 1903, pp. 241–3: *Modern Painters*, vol. 1.

60 Beckett, op. cit., VI, p. 142.

61 See Butlin and Joll 1984, pp. 273–5. The *Classical Vignette* at the Victoria and Albert Museum, dating from the late 1830s, may also be a depiction of the Dido and Aeneas narrative (A. Wilton, *The Life and Work of J.M.W. Turner*, Fribourg 1979, p. 452, no. 1312).

July 29th 1854

for the relief
of Thos W Turner
to inquire
allow me to
Room or Rooms
Trustees of the

THE
TURNER BEQUEST

AT THE NATIONAL GALLERY

ALAN CROOKHAM

In Chancery.

TRIMMER v. DANBY
TRIMMER v. TURNER
TRIMMER v. TEPPER

COPY

Will and Four Codicils

OF THE LATE

J. M. W. TURNER ESQ. R.A.

AND ALSO

COPY OF A

Cancelled Codicil.

NATIONAL GALLERY

TEPPER,
39, GREAT JAMES STREET
BEDFORD ROW.

J. Sullivan, Printer, 22, Chancery Lane.

R. N. Wornum

Fig. 32 Copy of Turner's will, annotated by R.N. Wornum, about 1852–6
Paper, 30.5 x 12 cm (folded)
National Gallery Libraries and Archive, London

J oseph Mallord William Turner died on 19 December 1851. Following his funeral at St Paul's Cathedral, his executors gathered at his house in Queen Anne Street to read the will. Any hope of a quick resolution of Turner's estate soon evaporated when a number of his cousins contested the will on the grounds that Turner was of unsound mind. As a beneficiary, the National Gallery found itself embroiled in a legal dispute that would last more than four years until an agreement was reached that in itself would have repercussions up to the end of the twentieth century.

Turner had drawn up two wills and a number of codicils. In his first will of 1829 he bequeathed to the National Gallery two paintings, *Dido building Carthage* (plate 22) and *The Decline of the Carthaginian Empire* (plate 23),[1] provided that they were accepted within a year of his death and hung between two paintings by Claude: *Landscape with the Marriage of Isaac and Rebecca* (plate 48) and *Seaport with the Embarkation of the Queen of Sheba* (plate 20). A second will of 1831 maintained these conditions but substituted *Sun rising through Vapour* (plate 21) for *The Decline of the Carthaginian Empire*. The much larger bequest of his collection of finished pictures was added in a codicil of 2 August 1848, with the stipulation that they should be housed together in a room or rooms to be annexed to the Gallery and to be called 'Turner's Gallery', this annexe to be built within five years of his death (later extended to ten years by a final codicil of 1 February 1849). Aside from these specific bequests to the National Gallery and several small legacies, Turner intended that the bulk of his estate should be used to provide for a charitable institution for the relief of impoverished artists.[2]

Although Turner's relatives failed in their initial suit and probate was granted, they pursued their case with an appeal to the Court of Chancery, arguing that Turner's bequest to establish a charitable institution was illegal. Until this appeal was resolved the executors were powerless to carry out Turner's intentions as expressed in his will, including the bequests to the National Gallery (fig. 32). As the court case stalled, the Trustees of the National Gallery became increasingly concerned about the fate of *Dido building Carthage* and *Sun rising through Vapour* as both these paintings had to be accepted within a year of Turner's death. Therefore the executors agreed to deliver these two paintings to the Trustees pending the outcome of the case in Chancery and the pictures were hung with the two Claudes in December 1852 (figs 33 and 34).

21 Cavendish Square

18 Oct 1852

My dear Sir —

I would suggest that
you should immediately
make an official application
on the part of the Trustees
of the National Gallery
to the Executors of the late
Mr Turner, & sent to Mr Drake
the Solicitor No 38 Walbrook
for the _Two_ pictures bequeathed
to them under his Will

upon that a meeting of
the Executors will be called
and the pictures will. I have
no doubt will be directed
to be given to the Trustees.
subject to the restrictions
of the Will —

The sooner this is done the
better — believe me

very sincerely Yr

P Hardwick

Tho Uwins E. RA

Figs 33 and 34 Letter from P. Hardwick to the National Gallery's
Keeper, Thomas Uwins, respecting the transfer of *Dido building
Carthage* and *Sun rising through Vapour*, 18 October 1852
Paper, 18 x 11 cm
National Gallery Libraries and Archive, London

P. Hardwick, one of Turner's executors, urged the Gallery to
ensure the removal of *Dido building Carthage* and *Sun rising
through Vapour* to Trafalgar Square in late 1852 in order to meet
Turner's condition that they be hung with the two Claudes within
a year of his death. The two paintings arrived at the Gallery in
December, shortly before the anniversary of Turner's death.

Figs 35 and 36 Letter from Jabez Tepper to Thomas Uwins regarding
the deposit of Turner's paintings at the National Gallery pending
the outcome of court proceedings, 29 July 1854
Paper, 24.5 x 20 cm
National Gallery Libraries and Archive, London

Jabez Tepper coordinated the challenge to Turner's will on behalf
of his cousins. During the period of the court case, Tepper, himself
the son of one of the cousins, corresponded with the Gallery on
various matters connected to the paintings. In this letter to the
Gallery's Keeper, Thomas Uwins, Tepper asks about the arrangements
for the deposit of Turner's pictures pending the outcome of the case
in Chancery.

Diary

1861
October
8

80 Turners hung on the walls of the Abt Room the third row for the most part taken out of their frames to admit of their being hung — Gold slips to be placed round the pictures —

9 & 10th At Kensington rearranging the Bell pictures in the last of the Turner Rooms — the two other Rooms hung with the Turner Sketches — 198 frames of Sketches 6 frames of finished drawings being brought to Trafalgar Sq

The Vernon pictures being now separated from the other collections and, with the exception of the great Hilton, all placed together in the three Vernon Rooms.

19th All the rooms now hung in Trafalgar Square.

frame of Michelangelo da Caravaggio sent to be regilt

N. P.
672 Screens brought up again into the west Room
New Rembrandt hung No 672, canvas 3ft. 3in. h by 2 ft. 7½ in. w. new frame ordered —

23 Gallery entirely hung — 82 Turners on the walls, & 18, including six drawings, on the screens — Mr Bentley & son wiping the Turners
+ Wrote to Sir Charles Eastlake at Paris —

24 Office hung — nine of the Turner pictures, in this room, it is a pity more were not excluded from the great room! —

25 Mr Wilcox removed the "Ecce Homo" copy, which was sent here to be compared with the original —

26th all glasses cleaned — inside and out —

WITHIN the last few weeks the magnificent collection of pictures bequeathed to the nation by its landscape painter has been thrown open to the public. The Turner collection has at length completed its temporary suburban sojourn, and is now safe in its proper home in Trafalgar Square. Almost simultaneously with the opening of the gallery appear the volumes in which are contained the results of Mr. Thornbury's researches into the history of the life of the painter. Thanks to Mr. Wornum, who, by the bye, is treated to a most contemptuous notice in the preface, the works of the great artist may now be seen in the National Gallery easily and well. We wish, for Mr. Thornbury's sake as well as for our own, that we could affirm honestly that his task had been completed in a manner anything like as satisfactory.

Fig. 37 R.N. Wornum's diary entry for October 1861
Bound volume, 37.5 x 26 cm (closed)
National Gallery Libraries and Archive, London

Initially displayed at Marlborough House and South Kensington, Turner's finished pictures were placed in Trafalgar Square in 1861. (Previously, only the two Turners hanging with the two Claudes had been exhibited at the National Gallery's main building.) The arrival of the paintings and the arrangements for their display were recorded by the Keeper, R.N. Wornum, in his diary. In the bottom right corner Wornum has pasted a press cutting comparing his curatorial expertise favourably with the skills of Turner's first biographer, Walter Thornbury.

It was not until 19 March 1856 that the legal proceedings in the Court of Chancery came to an end with a decree that annulled Turner's charitable legacy and distributed this part of the estate among the relatives (figs 35 and 36). It also apportioned Turner's unfinished paintings and sketches and drawings to the National Gallery as well as his finished pictures.[3] The Director of the Gallery, Charles Lock Eastlake, and its Keeper, Ralph Nicholson Wornum, were therefore confronted with a much larger addition to the national collection than either had anticipated. With space at a premium, the Gallery had already been compelled to find alternative accommodation at Marlborough House for its collection of British paintings and it was these premises that offered the only opportunity for the Gallery to put at least part of the Turner bequest immediately on display. The first twenty paintings, other than *Dido building Carthage* and *Sun rising through Vapour* which remained at Trafalgar Square, were exhibited to the public at Marlborough House on 10 November 1856. It was to be a short-lived residency. After the property was assigned to the Prince of Wales in 1859, the Trustees were once again presented with the dilemma of where to house the collection and had little choice but to accept a temporary building adjoining the South Kensington Museum (now the Victoria and Albert Museum).

While the Trustees were mindful that this arrangement should remain temporary until appropriate accommodation could be found for 'Turner's Gallery', it was unclear whether the Court of Chancery's decree had in effect supplanted the conditions stipulated in Turner's will. The matter came to the attention of the former Lord Chancellor, Lord St Leonards, who raised the issue in the House of Lords. St Leonards's endeavours resulted in a House of Lords Select Committee, which reported on the Turner bequest on 30 July 1861. The Committee recommended that, in order to meet the terms of the will, Turner's finished pictures should be exhibited at Trafalgar Square but added the caveat that such a move might only be temporary until a more considered scheme for housing the paintings could be put into effect. As the lack of display space had become no less pressing an issue in the intervening years, Wornum was instructed to remove thirty-eight Dutch and Flemish paintings from the West Room of the National Gallery to make way for the reception of 100 works by Turner, with a further nine placed in an adjoining office (Rooms 7 and 8 in today's Gallery). The operation was completed by 8 October 1861, a few months within the ten-year limit fixed by Turner's will (fig. 37).

In essence there were now three parts to the Turner bequest: the finished pictures subject to the condition that they be kept together and placed in accommodation to be known as 'Turner's Gallery'; the unfinished pictures and sketches and drawings; and the two paintings that were to be hung with the two pictures by Claude.

While Eastlake would have preferred to have received the bequest without conditions, he nonetheless oversaw the exhibition of the finished pictures and these would remain as a separate Turner Collection for the rest of their stay at the National Gallery (fig. 40).[4] The unfinished pictures and sketches and drawings remained at South Kensington or in storage until 1876, when an extension to the National Gallery enabled the reunion of the bequest at Trafalgar Square. In 1879 a selection of almost 300 of these sketches and drawings were put on display in two rooms on the ground floor of the eastern wing of the Gallery and over the coming years the number of rooms available for their display and study in this part of the building would gradually increase (see figs 38 and 39).

Eastlake also continued to hang the two Turners with the two Claudes, despite his own advocacy of a more scientific approach to display based on artistic school and period. Curatorial practice had moved in this direction since Turner had drawn up his will in 1829 (when the collection had been hung with less regard to chronology) and continued to develop along these lines throughout the nineteenth century (see fig. 41). As a result the hang of these four pictures together would become increasingly anomalous and, for some Directors, problematic. For the moment *Dido building Carthage* was placed between the two Claudes, with *Sun rising through Vapour* hanging above it.

The Turner bequest was not only to be seen in London. In 1869 the Trustees sanctioned the formation of three loan collections of Turner's sketches and drawings that could be sent out to regional museums and galleries. The success of these loans, together with the shortage of display space, may have prompted the Trustees to consider ways to lend out Turner's paintings, a move that was forbidden by the terms of the will. In 1883 the Government was persuaded to pass the National Gallery (Loan) Act, which enabled the Gallery to lend pictures that had been given or bequeathed to the nation provided that fifteen years had elapsed from the date the works entered the collection. In the case of collections that had

Fig. 38 Henry Tidmarsh
*Interior View of the National Gallery showing Two Copyists
at work in the Basement of the Turner Room*, about 1885
Bodycolour and wash on paper, 10.2 x 13.3 cm
City of London, London Metropolitan Archives

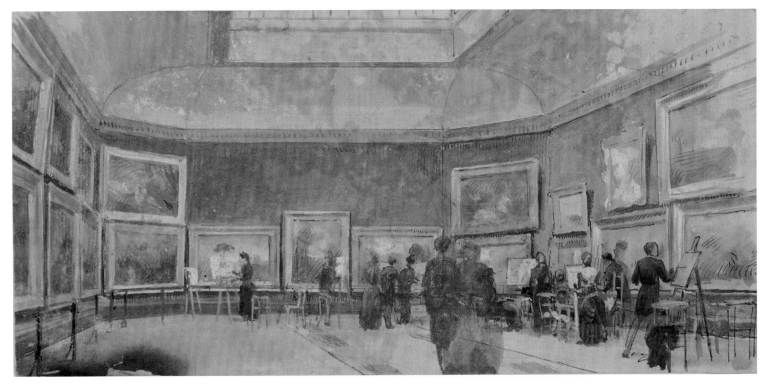

Fig. 39 Henry Tidmarsh
*Interior View of the National Gallery showing the Turner Room with
Students and Copyists at work*, about 1883
Bodycolour and wash on paper, 8.6 x 17.8 cm
City of London, London Metropolitan Archives

Fig. 40 Bertha Mary Garnett
A Corner of the Turner Room in the National Gallery, 1883,
1883
Oil on canvas, 25.5 x 35.8 cm
The National Gallery, London (History Collection)

been given subject to the condition that they would be kept together, as was the case with the Turner bequest, the limit was set at twenty-five years. About forty of Turner's finished pictures were initially selected for loan to museums and galleries around the country, although *Dido building Carthage* and *Sun rising through Vapour* were not included among them.

A further extension to the Gallery in 1887 and the loan scheme helped relieve some of the pressure on display space while at the same time making the collection more accessible to a wider public. However, the issue of exhibition space once again came to the fore when, in 1889, Sir Henry Tate offered his collection of modern British art to the National Gallery provided it was housed in a separate suite of rooms. Without space available to display the gift according to Tate's wishes, the Trustees reluctantly turned down the offer. Undeterred, Tate returned with a new proposal to present not only his collection to the nation but also a gallery in which to house it. This new gallery, which would come under the jurisdiction of the National Gallery Trustees and was known initially as the National Gallery of British Art, was sited at Millbank and opened to the public on 16 August 1897. Popularly renamed the Tate Gallery, its remit covered works by British artists born after 1790, while those artists born before that date, such as Turner, remained at Trafalgar Square.

The situation changed when, in May 1905, the Trustees acceded to a suggestion from a member of the public, Alfred Forman, for the display of the four pictures that had formed Turner's last exhibits at the Royal Academy in 1850 (see fig. 31, p. 47) . With no Director in post at that time, they instructed the Keeper of the Tate Gallery, Charles Holroyd, to exhibit the pictures at Millbank. That same year the Gallery reviewed a number of Turner's unfinished paintings that had not been formally accessioned into the national collection in 1856 due to the belief that their unfinished condition made them unsuitable for exhibition. The Trustees decided to accession these pictures and, without any available space at Trafalgar Square, placed them on public display at Millbank with the four Turners already there. Together with a number of Turner's other paintings not normally on public view, between 1905 and 1906 a total of forty-four paintings from the bequest were transferred to the Tate. The display of the unfinished pictures not only excited the public's interest but also prompted Lionel Cust, the Director of the National Portrait Gallery and a highly influential figure in the art world, to call for the establishment of a Turner Gallery at Millbank. A certain momentum was now building towards using the space available at the Tate to display the Turner bequest and when the National Gallery's annual report for 1907 noted that the Gallery's Turner Room was 'insufficient for the proper exhibition of this great Bequest', it was with the knowledge that an anonymous donor (later revealed as Sir Joseph Duveen) had come forward with an offer to construct a new Turner Gallery at the rear of the Millbank site. The Trustees were broadly in favour of the scheme, with the exception of Alfred de Rothschild who questioned the legality of the move under the

terms of Turner's will. The matter was resolved in August 1907 when it was decided not to transfer the bequest to the new Turner Gallery but only to lend it for an indefinite period of time. This was agreed with the proviso that 'a selection of typical pictures adequately representing Turner in his various manners should be retained at Trafalgar Square'; this selection to be made by Holroyd, who by now had become Director of the National Gallery. The bulk of the Turner bequest was lent to the new Turner Gallery at the Tate, which opened on 20 July 1910. Nineteen paintings by Turner, including fifteen from the bequest and both *Dido building Carthage* and *Sun rising through Vapour*, were retained at Trafalgar Square along with some watercolours.[5]

The realisation of the Turner Gallery anticipated a major review of the national collections conducted by a committee under the chairmanship of Lord Curzon, the former Viceroy of India and a leading figure among the Board of Trustees. The committee was formed in 1911 'to enquire into the Retention of Important Pictures in this Country, and other matters connected with the National Art Collections'. During the autumn and winter of 1912 it collected evidence from numerous prominent figures in the art world and deliberated on a wide range of issues, including the funding of acquisitions and the boundaries of the various national collections. When Curzon finally published his report in 1915, its recommendations included the establishment of a separate Board of Trustees for the Tate (a proposal which was brought into effect in 1917) and an expanded collecting remit for

the Gallery to include historic British art, i.e. works by artists born before 1790. Despite the new Tate Board, all the works in both Galleries would remain officially vested in the Trustees of the National Gallery. The Curzon Report drew on the example of the existing division of the Turner bequest between the two Galleries to establish the principle that the Tate would hold the majority of the British school paintings while the National Gallery would display a select number of masterpieces.

Curzon's committee had also considered an extension to the powers of sale granted to the Trustees under the National Gallery Act of 1856, which enabled them to sell paintings provided that they had not been given or bequeathed to the nation. The specific question of seeking legislation to sell part of the Turner bequest as a means of funding new acquisitions was raised during the committee's deliberations but was rejected in favour of a recommendation to encourage long-term reciprocal loans. The committee reasoned that such loans would enable the National Gallery to fill gaps in its collection at the same time as promoting the work of Turner overseas, and the report concluded that 'the Louvre is admirably supplied with the works of the French school, so that the exchange of a picture, say, by Turner for a picture by Chardin or Fragonard would be an apparent advantage to both institutions'. The necessary legislation to bring about this proposal was never enacted. Instead, on 13 September 1916, Curzon reported to the Board that he and his fellow Trustee Lord Lansdowne had approached the Government to ascertain whether they would support 'a Bill for the sale of superfluous Turners, or

other paintings belonging to the National Gallery'. This apparent volte-face had been caused by the news that Lord Ellesmere was considering selling one or more of his outstanding paintings by Titian (known as the Bridgewater Titians) to the American collector Henry Clay Frick. Consequently, during the summer of 1916, Curzon and Lansdowne had entered into negotiations with Lord Ellesmere with a view to purchasing three of his Titians, namely *Venus Anadyomene, Diana and Actaeon* and *Diana and Callisto*. The purchase price was estimated at between £300,000 and £360,000, a sum far beyond the Gallery's financial capabilities and one that was unlikely to be provided by the Government at any time and certainly not in the midst of the First World War. Curzon's solution was twofold: firstly, to purchase all three Titians but immediately to sell on *Diana and Callisto* to a syndicate of dealers and at a profit to the National Gallery, thereby sacrificing one Titian in order to secure the other two; and secondly, to raise the remainder of the necessary funds by pursuing legislation to sell off part of the Turner bequest, arguing that 'there seems something eminently absurd in keeping stored away thousands of the productions of an artist, for which the whole world is hankering, and which are worth much more than their weight in gold, at the very moment when the greatest masterpieces by other and even more famous artists are slipping away for lack of funds'. Curzon reckoned that some forty of Turner's oil paintings could be sold for an estimated price of £150,000, and the sale of a further 200 watercolours would bring in between £150,000 and £200,000. The Trustees gave their assent to Curzon's proposals and two alternative bills were drawn up, one to enable the sale of part of the Turner bequest and the other for a more comprehensive bill to sell off not only the Turners but also other 'superfluous' paintings in the collection (mostly Dutch pictures). It was this latter bill that was introduced into the House of Lords in November 1916. However, in the months that followed, the bill suffered from a lack of Government support. It was at first postponed and then quietly dropped while the stimulus for this extraordinary measure, the threatened sale of Lord Ellesmere's Titians, also failed to come to pass.[6]

Once normal business was resumed following the end of the First World War, there was a large transfer of British paintings to the Tate in 1919, in accordance with the recommendations of the Curzon Report. As part of the process of reorganisation, the Director, Charles Holmes (who had been appointed in 1916), revisited the hang of the two Turners with the two Claudes. Although previous Directors had deferred to the Claudes and displayed all four paintings in the French School, Holmes appears to have considered them as part of his plans for a rearrangement of the British School. When he realised that these plans would be disrupted by the hang of the two Turners next to the two Claudes, he proposed that the paintings should be transferred to Millbank, despite the anomalous position that the Claudes would occupy there. The Trustees expressed concern at the public reaction to such a move and rejected Holmes's proposal. Instead he sought to accommodate the four pictures by hanging them in the entrance vestibule at Trafalgar Square, a location that they retained until the 1930s. While this might suggest a certain antipathy to Turner on the part of Holmes, this was certainly not the case. In his evidence to the Royal Commission on National Museums and Galleries in 1928, Holmes argued unsuccessfully for the retention of Turner's watercolours at Trafalgar Square and Millbank instead of their placement as a long-term loan at the British Museum (to where they were moved in 1932 along with Turner's other works on paper). He returned to the subject in his memoirs when he eulogised that 'not half-a-dozen of Turner's exhibited oil-paintings illustrate the quintessence of his genius – the supremely fascinating borderland where Painting touches the frontier of Music – as do these enchanting sketches'.

During the Second World War the collections of both the National Gallery and the Tate were evacuated from London, although two Turners did make a brief reappearance in Trafalgar Square in the monthly displays of single pictures organised by the Director, Kenneth Clark, who was a keen admirer of Turner. Known as the *Picture of the Month* exhibitions, they featured *Frosty Morning* in 1942 and *Crossing the Brook* (plate 27) in 1944.[7] When the collection returned to London in 1945, the new Director, Philip Hendy, was faced with the challenge of displaying the paintings in a Gallery partially closed due to bomb damage. Given the existence of a national collection of British art at the Tate, he gave priority to the display of the foreign schools and there was consequently a further diminution of the British pictures remaining at Trafalgar Square when the bulk of those that had hung there before the war were transferred to Millbank. *Dido building Carthage* and *Sun rising through Vapour* remained at the National Gallery but were separated both from each other and from Claude's *Landscape with the Marriage of Isaac and Rebecca* and *Seaport with the Embarkation of the Queen of Sheba*. In response to questions about this arrangement, the Gallery promised to review the situation once space became more freely available, although both the Director and senior staff were beginning to question whether a strict adherence to the conditions laid down by Turner was still necessary within

Fig. 42 Postcard from Noël Arnott, 18 October 1954
Paper, 8.5 x 14 cm
National Gallery Libraries and Archive, London

After the Second World War, the Gallery did not resume the display of the two Turners with the two Claudes. This was partly due to the reorganisation of the galleries, which had been damaged by bombing during the war, but it was also partly a re-consideration by the curatorial staff as to whether the display of the two Turners alongside the two Claudes was still necessary. This change did not go unnoticed by members of the public, as witnessed in this exchange of correspondence in 1954 between a Gallery visitor, Noël Arnott, and the Assistant Keeper, Cecil Gould.

Noël Arnott's postcard reads:
I had understood that "Claude's" Embarkation of the Queen of Sheba was hanging next to Turner's Dido Building Carthage. I visited the NG yesterday with the idea of having a good look at these two pictures but only discovered the "Claude". Can you enlighten me on this subject?

Fig. 43 Copy of letter from Cecil Gould to Noël Arnott, 21 October 1954
Paper, 20.3 x 16.5 cm
National Gallery Libraries and Archive, London

the context of a modern hang of the Gallery or in securing Turner's reputation by his juxtaposition with Claude (see figs 42 and 43).

The post-war period also witnessed negotiations between the National Gallery and the Tate regarding a formal separation of the two Galleries by Act of Parliament. The resulting National Gallery and Tate Gallery Act of 1954 vested the works of art held by each institution, including the Turners, in their respective Boards of Trustees. Given that the distillation of the British School at Trafalgar Square had been occasioned by constraints on display space, the two Galleries also signed an agreement to facilitate the transfer of British pictures once space became available after the Act became law in 1955. The Turners were a case in point. A proposal by Hendy to rationalise the display of the Turners at Trafalgar Square in 1952 had been abandoned due to the ongoing reconstruction work. Therefore, instead of a fixed display of Turners at either Gallery, between 1954 and 1968 there was in effect a pool of eighteen paintings from the bequest that spent time either at Trafalgar Square or Millbank.[8] A more settled situation began to emerge in the mid-1960s and by 1967 the Tate decided that it was time to allow the agreement regarding the transfer of British pictures to lapse. At the same time the National Gallery decided that it should retain only a core collection of British masterpieces and would not seek to restore its representation of the British School to its pre-war levels. The consequence for the Turners was that in 1968 the National Gallery's Director, Martin Davies, and its Keeper, Michael Levey, made a final selection of seven paintings that would have the necessary merit and significance to represent Turner within the National Gallery. All but one of the seven were chosen from the eighteen paintings that had spent at least some time at Trafalgar Square since 1954.[9] Levey in particular was closely involved in the new hang and his choices were as much about aesthetics as representation, bargaining a number of Turners and other British pictures for

Overleaf:
Fig. 44 Claudes and Turners in Room 15 of the National Gallery, London, 2011
The National Gallery, London

WAY OUT
TRAFALGAR SQUARE

WAY OUT
SAINSBURY WING

15

THE PIE BERGÉ RO

Fig. 45 Claudes and Turners in Room 32 of the National Gallery, 1977
National Gallery Libraries and Archive, London

the return of *Calais Pier* to Trafalgar Square which he felt was necessary 'to juxtapose harmoniously to three Constables and yet also be capable of holding its own on a single wall'. When the selection was debated by the Trustees, only the inclusion of *The Parting of Hero and Leander* instead of *A Disaster at Sea* was questioned, although ultimately it was decided that the National Gallery only required 'one large, violent Turner' and that *The Parting of Hero and Leander* was more suitable for historic and aesthetic reasons.

The seven paintings selected were in addition to *Dido building Carthage* and *Sun rising through Vapour*, which had themselves been subject to recent scrutiny. A flurry of letters to *The Times* in early 1966 had once again raised the question of the hang of the two Turners with the two Claudes and had prompted Hendy and the Trustees to reconsider the issue. While there was still some reluctance to disrupt the hang of the Gallery and resume the display of the four paintings together, it was agreed that the conditions of the will regarding their display were legally binding. The moral argument was even more convincing and consequently, in May 1968, *Dido building Carthage* and *Sun rising through Vapour* were reunited with *Landscape with the Marriage of Isaac and Rebecca* and *Seaport with the Embarkation of the Queen of Sheba* (figs 44 and 45).[10]

There was one final part of the bequest that had yet to be resolved. In 1932 the Gallery had agreed to place Turner's sketches and drawings on long loan at the British Museum, following the flood at the Tate in the winter of 1929. When the National Gallery and Tate Gallery Act of 1954 had formally separated the two Galleries, the sketches and drawings had remained vested in the Trustees of the National Gallery. However, the construction of the Clore Gallery in the 1980s as the new home of the Turner bequest offered the opportunity to reunite the paintings with the sketches and drawings and in 1984 the Trustees duly agreed to transfer the latter to Millbank. Furthermore, when the Clore Gallery opened in 1987, the National Gallery lent the seven paintings it had selected from the Turner bequest in 1968 for the first six months of the opening display. Only *Dido building Carthage* and *Sun rising through Vapour* remained at Trafalgar Square, hanging between the two Claudes as Turner had intended and as they continue to hang to the present day.

NOTES

1 Tate, N00499.

2 For an analysis of Turner's will see Robert Cumming, 'The Greatest Studio Sale That Christie's Never Held?', *Turner Studies*, vol. 6, no. 2, 1986.

3 The National Gallery's Annual Report of 1857 gives the total number of works as 100 finished pictures, 182 unfinished pictures and 19,049 sketches and drawings.

4 The finished pictures of the Turner bequest were located in the following rooms: Rooms 7 and 8: 1861–9; Rooms 4 and 6: 1869–76; Pennethorne's Gallery (now the Entrance Vestibule): 1876–84; Room 8: 1884–1910.

5 For a comprehensive account of the display of the Turner bequest at the Tate, see Sam Smiles, *J.M.W. Turner: The Making of a Modern Artist*, Manchester 2007.

6 *Venus Anadyomene* was purchased by the National Galleries of Scotland in 2003; *Diana and Actaeon* was purchased jointly by the National Gallery (London) and the National Galleries of Scotland in 2009; both Galleries have an option to purchase *Diana and Callisto* in the near future.

7 Tate, N00492 and N00497.

8 In addition to *Dido building Carthage* (NG 498) and *Sun rising through Vapour* (NG 479), the eighteen paintings were: *Calais Pier* (NG 472), *Crossing the Brook* (Tate, N00497), *Ulysses deriding Polyphemus – Homer's Odyssey* (NG 508), *The Fighting Temeraire* (NG 524), *The Parting of Hero and Leander* (NG 521), *Venice, The Bridge of Sighs* (Tate, N00527), *Snow Storm – Steam-Boat off a Harbour's Mouth* (Tate, N00530), *St Benedetto, Looking towards Fusina* (Tate, N00534), *Rain, Steam, and Speed – The Great Western Railway* (NG 538), *A Disaster at Sea* (Tate, N00558), *Chichester Canal* (Tate, N00560), *Interior of a Great House: The Drawing Room, East Cowes Castle* (Tate, N01988; then known as *Interior at Petworth*), *The Evening Star* (NG 1991), *Godalming from the South* (Tate, N02304), *On the Thames (?)* (Tate, N02307), *The Thames near Walton Bridges* (Tate, N02680), *Walton Reach* (Tate, N02681) and *The Lake, Petworth, Sunset; Sample Study* (Tate, N02701).

9 *Margate (?), from the Sea* (NG 1984) was the only painting to be selected that had not been on display at the National Gallery in the previous fourteen years.

10 The four paintings were displayed with the British School initially, then with the French seventeenth-century paintings, and finally in a room of their own: Room 35: 1968–76; Room 32: 1976–91; Room 15: 1991–present.

Further reading about the Turner Bequest includes:

I. Warrell, *Through Switzerland with Turner: Ruskin's First Selection from the Turner Bequest*, London 1995

I. Warrell, 'R.N. Wornum and the First Three Loan Collections: A History of the Early Display of the Turner Bequest Outside London', *Turner Studies*, vol. II, no. 1, summer 1991, pp. 36–49

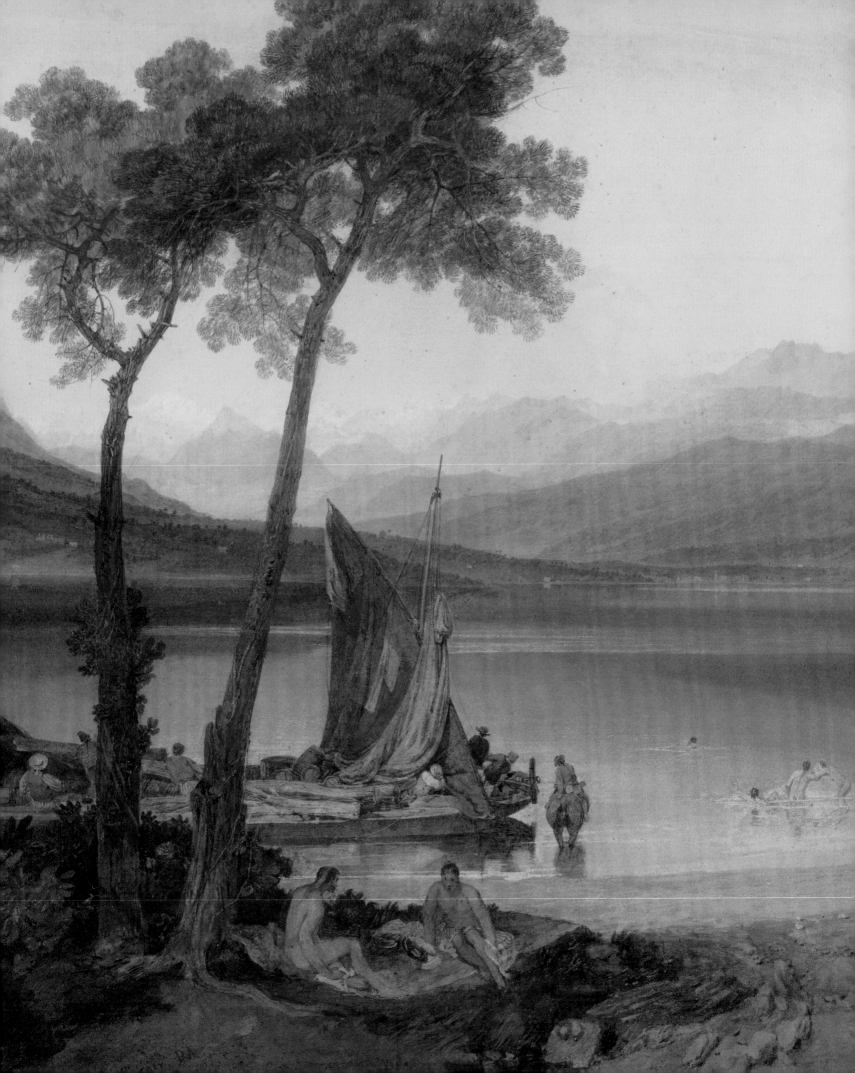

ENCOUNTERING CLAUDE'S IDEAL LANDSCAPES

Turner's early knowledge of Claude was founded largely on engravings of works in private collections, or Richard Earlom's sepia mezzotints after Claude's *Liber Veritatis* (plates 16 and 17), which could be seen in the Royal Academy's library. In 1799, however, two works by Claude of international repute arrived in London – *Landscape with the Father of Psyche sacrificing at the Temple of Apollo* and *Landscape with the Arrival of Aeneas before the City of Pallanteum* – the so-called 'Altieri Claudes' (plates 1 and 2). Following their highly publicised purchase, William Beckford, their owner, exhibited them privately in his London home before sending them to his country residence, Fonthill Abbey in Wiltshire. Turner was among those who visited Beckford's town house, but he also had ample opportunity to study the works when he was invited to stay at Fonthill later that year.

While the Altieri Claudes were on display in London, Turner's *Caernarvon Castle* (plate 5) and *Harlech Castle* (Yale Center for British Art, New Haven) were on show at the Royal Academy, prompting reviewers to comment on the relationship between the two artists. A journalist in the *True Briton* claimed that *Harlech*, 'though it combines the style of Claude and of our excellent Wilson, yet wears an aspect of originality, which shews the Painter looks at Nature with his own eyes'. It was the Claudian quality of Turner's works, though, that most appealed to collectors at this time: in 1803 Lord Yarborough, who was also present at the same viewing of the Altieri pictures, bought Turner's *The Festival upon the Opening of the Vintage of Mâcon* (plate 13), a work clearly modelled on examples such as *Landscape with the Father of Psyche sacrificing at the Temple of Apollo*.

From this point onwards Turner's attempts to ally himself to (and assert parity with) Claude became more strategic. At the Academy in 1804, and again at the British Institution in 1806, Turner showed his *Narcissus and Echo* (plate 8), which recalled both in style and title one of the most renowned works by the French artist – *Landscape with Narcissus and Echo* (plate 7), then in the London town house of Sir George Beaumont, the eminent collector, amateur painter and self-styled arbiter of taste. However, Turner's free interpretation of Claude's model did not suit Beaumont's more conventional tastes, and in 1806 he claimed Turner's exhibits 'appeared to him to be like the works of an old man who had ideas but who had lost his powers of execution'. Subsequently the collector waged a personal battle against the artist, criticising his high tonality and loose brushwork.

Individuals such as Beaumont became increasingly powerful during the early decades of the nineteenth century, both as connoisseurs and potential patrons.

Just as significantly, British artists – prevented from travel to the Continent by the wars with France – were also largely reliant on their collections for access to Old Master models. One collection in particular – that of John Julius Angerstein – offered an especially rich selection, including some outstanding paintings by Claude that were later to become centre-pieces of the National Gallery Collection (see plates 20 and 48, and NG 2, NG 5 and NG 30). Following the Battle of Waterloo, however, artists once again had the opportunity to travel abroad and to explore not only unfamiliar landscapes but galleries and museums of legendary reputation. In 1819, Turner visited Italy for the first time, and while the impression made on his palette by the light and the scenery can be clearly traced, equally obvious is the impact of the pictures he viewed there, particularly those in the galleries of Venice, Rome and Florence. It was in the Uffizi in Florence that Turner sketched Claude's *Seaport with the Villa Medici* (plate 10), which would later be poignantly recalled in *Regulus* (plate 47), painted and exhibited in Rome during Turner's second Italian trip.

Although Turner's techniques appear to have grown increasingly innovative and idiosyncratic during these later years, his dedication to the study of Claude's works continued unabated. In 1821 he returned to the Louvre, which he had first visited in 1802. Instead of neglecting Claude, as he had on that occasion, this time he sketched most of the major works by the seventeenth-century master in the collection, including a number of *Seaport* subjects (plate 11). Similarly, in 1835, during a stop in Dresden, Turner took time to make partial pencil copies of Claude's *Landscape with the Flight into Egypt* and *Landscape with Acis and Galatea*. These later drawings are evidence of Turner's lifelong admiration for Claude, and of his relentless determination to learn all he could from his artistic hero. Despite all his travels, however, it transpired that the best resources were to be found on home ground: 'In no country but England can the merits of Claude be so justly appreciated,' Turner declared in a lecture at the Royal Academy, 'for the choicest of his works are with us, and may they always remain with us in this country.'

PS

1　Claude
Landscape with the Father of Psyche sacrificing at the Temple of Apollo, 1662
Oil on canvas, 174 x 221 cm
Anglesey Abbey, The Fairhaven Collection (The National Trust)

An apocryphal story relates that the 'very young Turner' stood weeping before one of the *Seaports* belonging to John Julius Angerstein (all three of which are now in the National Gallery). Turner was allegedly daunted by Claude's achievement, identifying it as his standard of excellence. But since none of the relevant pictures owned by Angerstein was in his Pall Mall home until after November 1802, when Turner was already twenty-seven, this story evidently got muddled in the retelling. Turner's formative experience seems to have been his profoundly emotional response to these, the Altieri Claudes, in May 1799, which he described as 'beyond the power of imitation'. It was just a couple of weeks later that he sold his watercolour of *Caernarvon* (plate 5) to Angerstein for an unprecedented sum. The anecdote, though flawed, usefully underscores the significance of Claude's harbours as a formative influence, and a model against which Turner periodically measured his progress as an artist.

2 Claude
Landscape with the Arrival of Aeneas before the City of Pallanteum, 1675
Oil on canvas, 174 x 221 cm
Anglesey Abbey, The Fairhaven Collection (The National Trust)

3 J.M.W. Turner
Copy of the Composition of Claude's 'Landscape with the Arrival of Aeneas',
from *Studies for Pictures* sketchbook, about 1799
Watercolour on blue paper, 13.8 x 21.5 cm
Tate, London

4 J.M.W. Turner
Copies of Five Paintings by Claude: (1) 'Landscape with David at the Cave of Adullam'; (2) Landscape with Christ appearing to Mary Magdalen'; (3) 'Landscape with Philip baptising the Eunuch'; (4) 'Parnassus'; (5) 'Landscape with Hagar and the Angel', from the *Fonthill* sketchbook, 1804
Ink and pencil on paper, 47 x 33.5 cm
Tate, London

The five compositions that Turner transcribed on this sheet are of paintings by Claude that were sold at an auction in London on 2 June 1804. The largest here, recorded in watercolour, reproduces the *Landscape with David at the Cave of Adullam*, now in the National Gallery (NG 6).

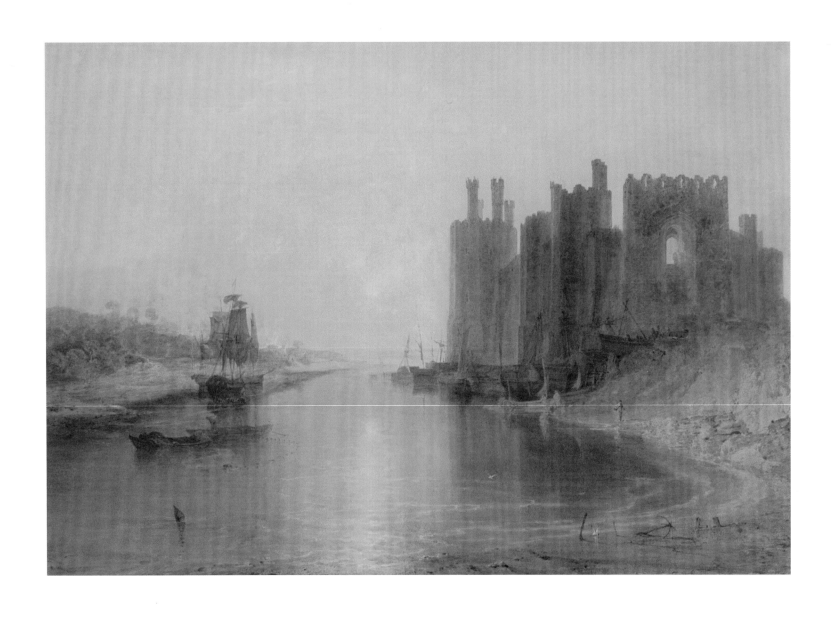

Caernarvon Castle was an important transitional work for Turner, demonstrating his admiration for the home-grown achievements of the Welsh landscape painter Richard Wilson, while also signifying his ambition to confront the greater renown of Claude. Contemporary connoisseurs would have recognised that the dazzling effect of almost molten sunlight was derived from Claude, but the implicit comparison evidently worked to Turner's advantage. This explains the comparatively inflated price that he charged, and which he secured from John Julius Angerstein for this large watercolour. Another patron was the Earl of Yarborough, who supported the tour Turner made of the Alps during the Peace of Amiens in 1802. As well as recording sublime peaks and vertiginous passes, Turner studied the idyllic shores of Lake Geneva, finding a Swiss equivalent for Claude's bucolic landscapes. He developed this composition through various studies in his *Calais Pier* sketchbook at the same time that he was working on *Sun rising through Vapour* (plate 21); and the two works have some elements in common.

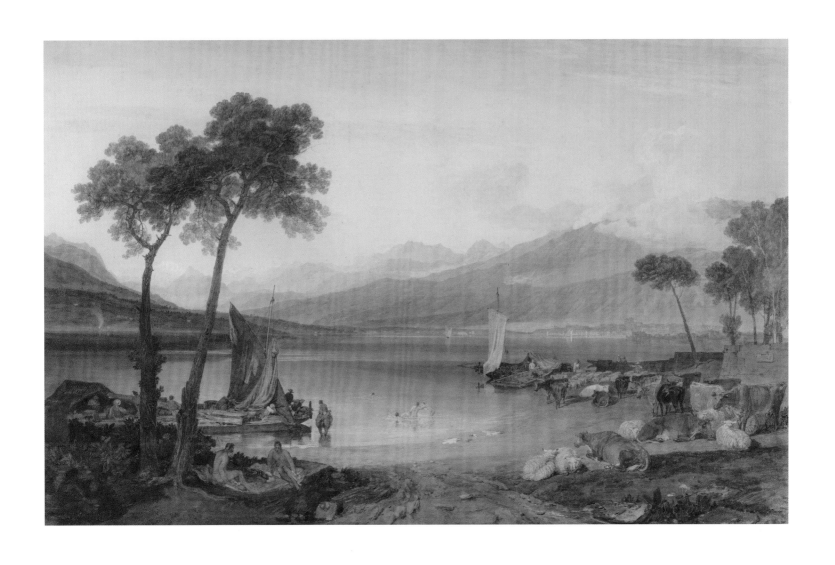

6 J.M.W. Turner
Lake Geneva and Mount Blanc, about 1804
Watercolour, pen and black ink, pen and brown ink and scraping out,
on cream wove paper, 73.3 x 113.3 cm
Yale Center for British Art, Paul Mellon Collection, New Haven

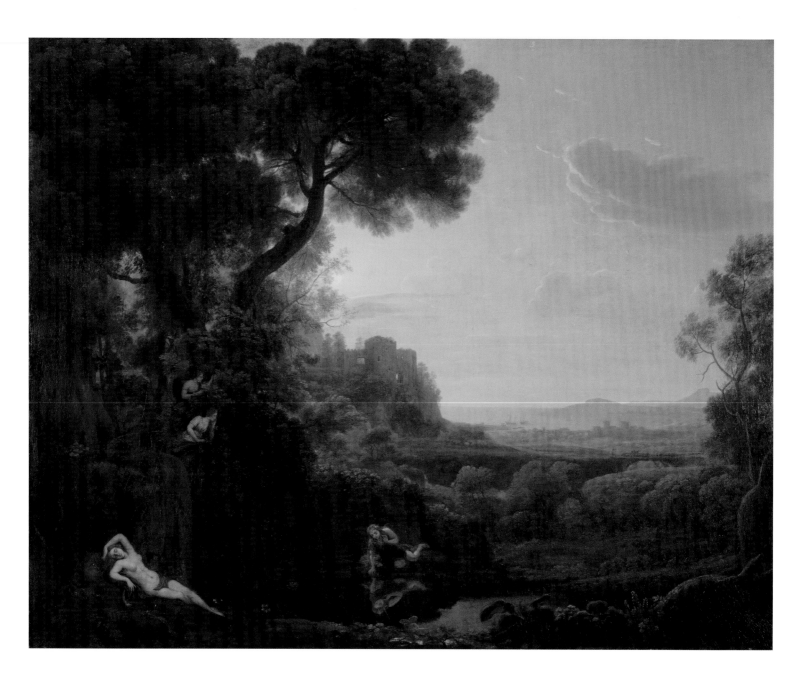

Claude's painting is primarily an exquisite, idealised rendering of the Italian landscape, suffused by a soft, clear light that encourages the eye to wander pleasurably ever further towards the boats and mountains beyond the distant coast. The foreground is inhabited by a young man totally enraptured by his own reflection, who is spied on by two nymphs (the prominent reclining nude is a personification of the stream). Claude was here illustrating Ovid's tale of the nymph Echo, and her unrequited love for Narcissus, one of many stories in the *Metamorphoses*.

The painting had been commissioned by an unknown English patron, but by the 1790s it belonged to the influential connoisseur, Sir George Beaumont. Turner would have seen it at Beaumont's house in Grosvenor Square before embarking on his own version of the subject (plate 8). Effectively a pendant to the Claude, it borrows many of the same components, but rearranges them in the confines of an autumnal glade, lit by long shadows: an evening scene to contrast with Claude's brilliant morning.

7 Claude
Landscape with Narcissus and Echo, 1644
Oil on canvas, 94.6 x 118.7 cm
The National Gallery, London

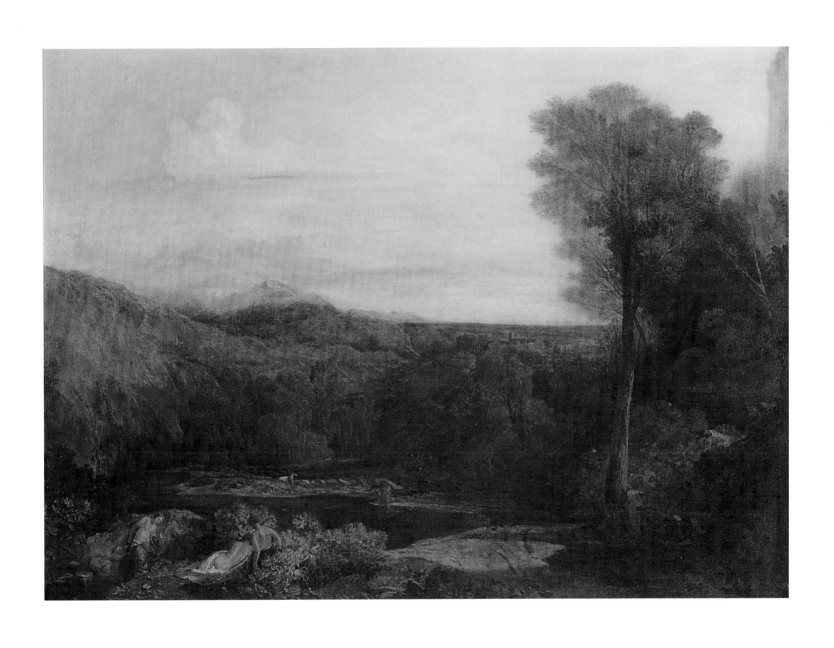

8 J.M.W. Turner
Narcissus and Echo, exhibited 1804
Oil on canvas, 86.5 x 117 cm
Tate, London (in situ at Petworth House)

9 J.M.W. Turner
 Study for 'Appulia in Search of Appulus, vide Ovid', from the *Woodcock Shooting* sketchbook,
 about 1812–13
 Pencil on paper, 11 x 17.8 cm
 Tate, London

10 J.M.W. Turner
 Copy of 'Seaport with the Villa Medici' by Claude, from the *Rome and Florence* sketchbook, 1819
 Pencil on paper, 11.3 x 18.9 cm
 Tate, London

11 J.M.W. Turner
Copies of Three Paintings by Claude in the Louvre: (1) Landscape with Rural Dance, 1639; (2) Seaport,
1639; (3) Seaport with Ulysses restituting Chryseis to her Father Chryses, 1644, from the *Dieppe, Rouen*
and Paris sketchbook, 1821
Pencil on paper, 23.1 x 11.8 cm
Tate, London

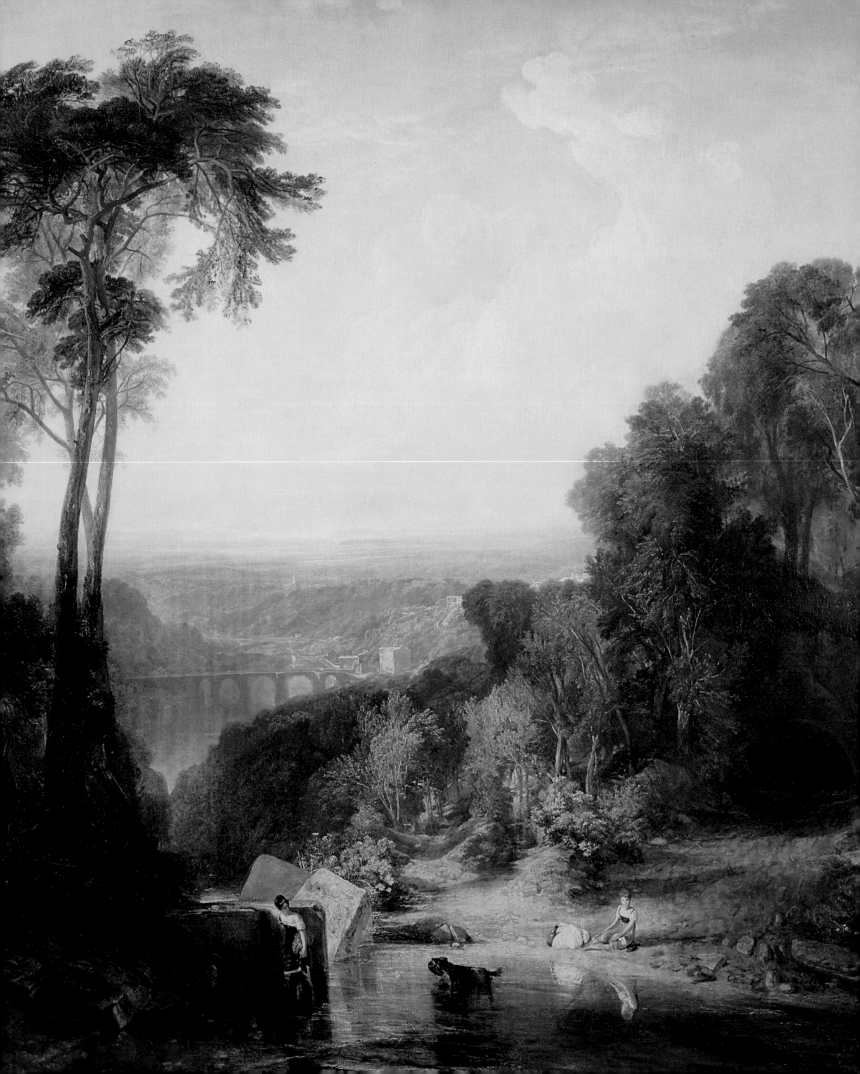

CLAUDE TRANSPLANTED
TO THE BRITISH SCENE

Confined to Britain for almost the whole of the Napoleonic Wars, Turner was unable to undertake the traditional Grand Tour of Italy until 1819. Far from neglecting the classical themes and subject matter he would have exploited in Rome, he spent these years dreamily inhabiting the narratives of ancient myth and history, filtering them through his response to the British landscape. His crucial guide and inspiration was of course Claude. Like Sir Joshua Reynolds before him, Turner relied on Claude to transport him to the 'tranquility of Arcadian scenes and fairy land'. In notes to himself, Turner contemplated the potential for a distinctive British type of landscape art. This, he felt, must combine unique native factors, such as the changeable climate, with an appreciation of the work of earlier artists: 'An endless variety is on our side and opens a new field of novelty, if we use the deep instructing tool of Salvator, the higher style of Poussin or the milder solar of Claude, the soil is British and so should be the harvest.'

By the time Turner made these comments, he had already painted a sequence of works that demonstrated the validity of the direction he was advocating. The first of these followed his brief trip to Paris in 1802, though on that visit he appears not to have been impressed by the Claudes in the Louvre, if he saw them at all. Consequently, the inspiration for his spectacularly panoramic evocation of the river Saône (plate 13) came from a painting (*Landscape with the Metamorphosis of the Apulian Shepherd*, 1657, The Duke of Sutherland) he would have known well in the collection of the Duke of Bridgewater, one of his important early patrons. The group of trees in the Claude painting is reprised in a general way on the right of Turner's picture. The image was also a key source for Turner's *Appulia in Search of Appulus, vide Ovid* (fig. 7, p. 20).

Throughout the 1800s Turner persisted in his determination to confer the distinctions of idealised landscape on British subjects. This approach is most evident in his views of the Thames, but can also be repeatedly discerned in the plates of his *Liber Studiorum*, the ambitious engraving project that pre-occupied him until around 1820, and which ultimately amounted to seventy mezzotint images (see plates 18 and 19).

During the same period Turner depicted aspects of contemporary British life in his series of *Picturesque Views on the Southern Coast of England* and other sets of topographical designs. The expansion of industry is hinted at in images such as *Sunshine on the Tamar* (plate 25), where smoke from a lime-kiln pollutes an otherwise beautifully pristine morning. Not for the last time, the scene is structured like one of Claude's port subjects.

The importance of the sea to Britain's identity is one of the crucial themes of Turner's work, acting as an important leitmotif throughout his career. This enduring fascination for all matters maritime helps to explain why Claude's harbours exerted such a powerful hold on his imagination. By March 1805 Angerstein's collection featured all three of the great harbour scenes by Claude now in the National Gallery, and it was after this date that Turner came to know them well. Their impact can be discerned in the sketchbooks he used on the Thames that summer, but two years later he exhibited *Sun rising through Vapour* (plate 21), a serene blending of Claude's example with the Dutch marine tradition in a uniquely northern seaport. The picture marks the culmination of Turner's first enthusiasm for Claude in a remarkably subtle way: its positioning of the sun, with its suffused radiance, is directly derived from the effect in Claude's *Seaport with the Embarkation of the Queen of Sheba* (plate 20). This was also the image he sought to emulate when he started work, eight years later, on *Dido building Carthage* (plate 22). Whereas Claude had favoured classical and biblical stories, or the lives of the saints, as the subjects for his embarkation scenes, Turner explored the origins of empire. Presumably he anticipated that this theme would appeal to potential patrons in the London of 1815, as had the religious topics Claude had developed for his clients in Rome. Turner had already been drawn to the meeting and subsequent romance of Dido and Aeneas in Carthage, which was presented by both Virgil and Ovid as a potential distraction from the founding of Rome. But while Turner's painting of 1815 also featured the interplay of personal and public duty, he was here addressing the bigger theme of the course of nations. As a fallen empire, Carthage offered a warning that fate could overturn even the wealthiest and most successful civilisations. Whether he was thinking of Britain or recent events in France is a moot point. Perhaps significantly, Turner's choice of classical architecture not only echoed Claude, but also evoked his native London, in which the most prestigious streets were increasingly ornamented with classical porticoes and pediments.

IW

12 J.M.W. Turner
*Two Composition Studies for 'The Festival upon the Opening of the
Vintage of Mâcon'*, from the *Calais Pier* sketchbook, about 1802–3
Pen and ink with chalk highlights on blue paper,
43.3 x 27.2 cm (each page)
Tate, London

Turner had developed his ideas for *Mâcon* in his *Calais Pier* sketchbook, where it is also
possible to observe how the studies for the view of *Lake Geneva* (plate 6) and *Sun rising
through Vapour* (plate 21) evolved through the same process of creating variations on
received ideas of classical landscape. In each case, having decided on a unifying lighting
effect, Turner moved around the components of trees, boats and human figures until he
was satisfied he had achieved a harmonious arrangement of the whole.

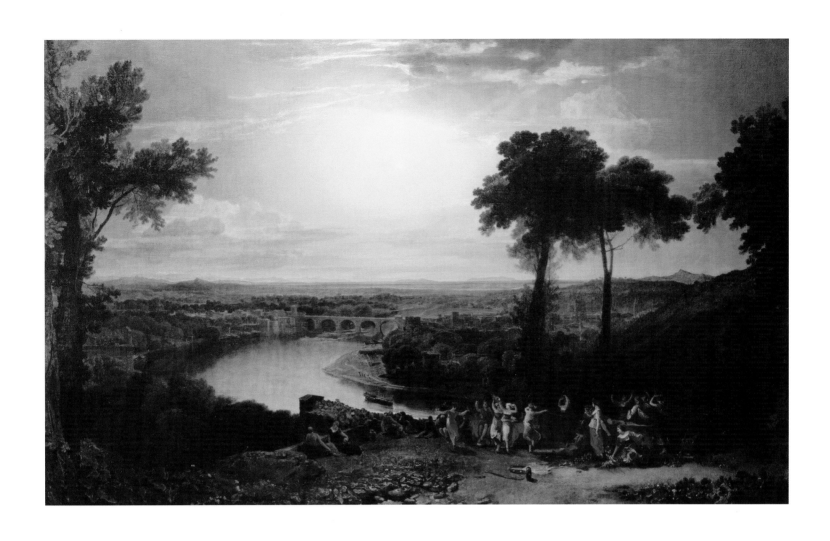

13 J.M.W. Turner
The Festival upon the Opening of the Vintage of Mâcon, 1803
Oil on canvas, 146 x 237.5 cm
Museums Sheffield

Turner's *Mâcon*, with its skilfully diffused outburst of sunlight, has been aptly described by art historian Kathleen Nicholson as the sort of picture Claude might have painted had he lived in 'northern climes'. And in fact the essence of the view can be traced as readily to the Thames at Richmond as to the French river Saône that it purports to show.

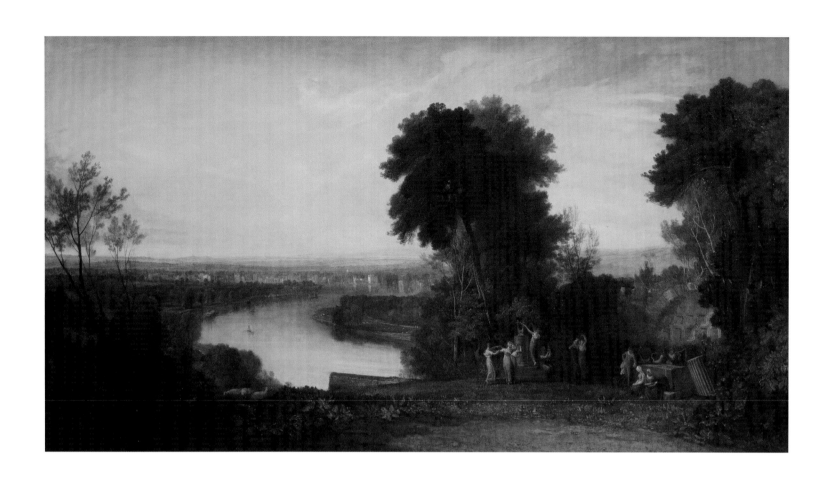

14 J.M.W. Turner
Thomson's Aeolian Harp, 1809
Oil on canvas, 166.7 x 306 cm
Manchester Art Gallery

15 J.M.W. Turner
The Thames near Windsor, about 1807
Oil on mahogany veneer, 18.7 x 26 cm
Tate, London

By the summer of 1805 Turner was making *plein-air* sketches of fragments, or 'bits', of landscape. It is likely that the process derived from an awareness that Claude and Poussin had undertaken similar exercises in the vicinity of Rome. Nevertheless, these studies appear to be very direct records of the natural world, uncluttered by conventional formulas in the way each scene is selected and composed. Turner only rarely painted oil sketches on the spot, so these Thames views represent a concerted attempt to train his eye to see the potential of even apparently ordinary material. Some of the *plein-air* studies may have been completed back in the studio, but for the most part they were important in grounding Turner in closely observed details when he came to work on his grander evocations of the same scenery, such as *Thomson's Aeolian Harp*.

Claude le Lorrain delint. Published Aug.t 1.st 1774, by John Boydell Engraver in Cheapside. R. Earlom feat.

N.o 53. From the Original Drawing in the Collection of the Duke of Devonshire.

16 Richard Earlom, after Claude
Landscape with a Country Dance; plate 53 in *Liber Veritatis*
Mezzotint on paper, 20.8 x 25.9 cm
Private collection

From 1635 Claude made drawings of each of his completed paintings, often annotating them with the name of the collector or the location to which they had been sent. The drawings were bound in an album of around 200 sheets, known as the *Libro di verità*, or *Libro d'invenzioni*. By the late 1720s the volume had arrived in England and been acquired by the 2nd Duke of Devonshire, in whose family collection it remained until 1957; it is now in the British Museum. During the 1770s the drawings were engraved by Richard Earlom and published by John Boydell in an influential two-volume set as the *Liber Veritatis* (a third volume based on miscellaneous sketches appeared in 1819). The copies of the book shown here are part of the Turner family library, but it is not known whether they were acquired by Turner himself. Nevertheless, this is the form in which he would have known many of Claude's images.

Claude le Lorrain delin. Published Dec.ʳ 3.ᵈ 1776 by John Boydell Engraver in Cheapside. R. Earlom fecit.

Nᵒ 164. From the Original Drawing, in the Collection of the Duke of Devonshire.

17 Richard Earlom, after Claude
Coast Scene with Apollo and the Cumaean Sibyl; plate 164 in *Liber Veritatis*
Mezzotint on paper, 20.5 x 26 cm
Private collection

18 J.M.W. Turner
The Junction of the Severn and the Wye; plate 28 in
Liber Studiorum, 1811
Etching, aquatint and mezzotint on paper, 18.1 x 26.5 cm
Royal Academy of Arts, London

Though the engraved version of Claude's *Liber Veritatis* clearly provided the impetus
for Turner's *Liber Studiorum*, this costly and impractical endeavour was more diverse in
its range, providing a showcase for his achievements. In each of the six landscape types
Turner devised, he demonstrated his allegiance to Claudian models, though it is
especially in the pastoral scenes that he was most effective in recreating Claude's mood
of bucolic languor. At a time of earnest progress and innovation in agricultural practices,
Turner chose, more often than not, to present the people farming as the counterparts of
Claude's shepherds and shepherdesses. While on one level he was suggesting a timeless
correspondence in the activities depicted, he may also have been tapping the underlying
mood of patriotism during this period, which took pride in the nation's ability to feed its
people through its own agricultural resources.

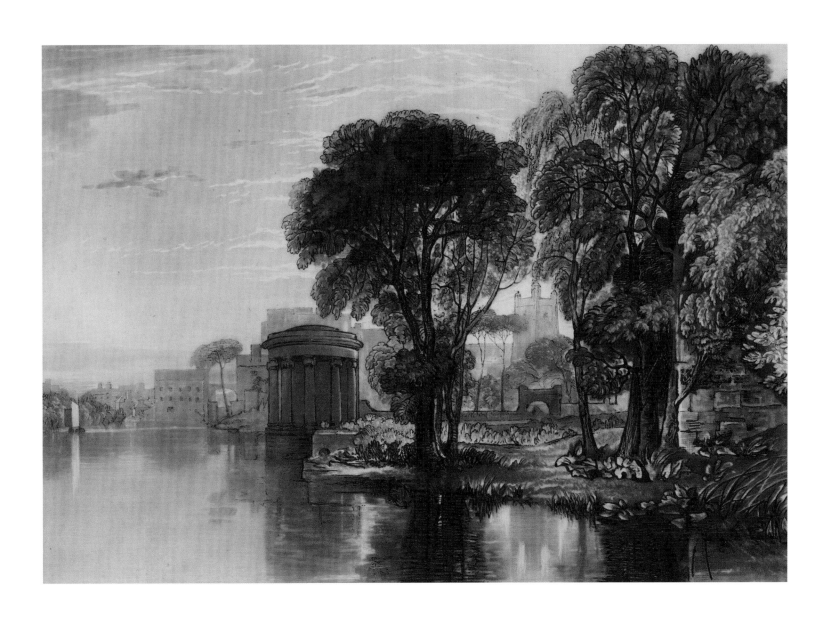

19 Henry Dawe, after J.M.W. Turner
Isleworth; plate 63 in *Liber Studiorum*, 1819
Etching and mezzotint on paper, 18.2 x 26 cm
Royal Academy of Arts, London

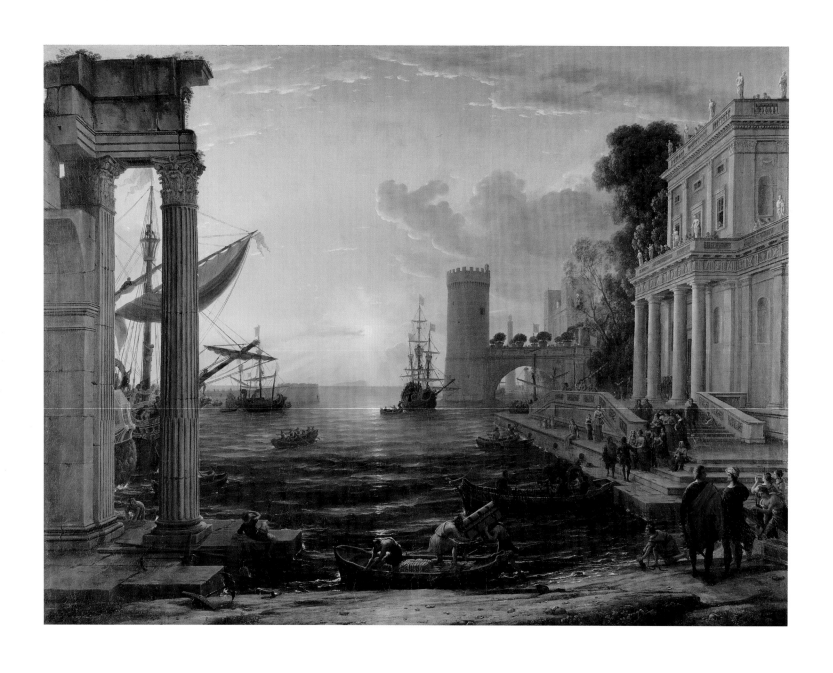

20 Claude
Seaport with the Embarkation of the Queen of Sheba, 1648
Oil on canvas, 149.1 x 196.7 cm
The National Gallery, London

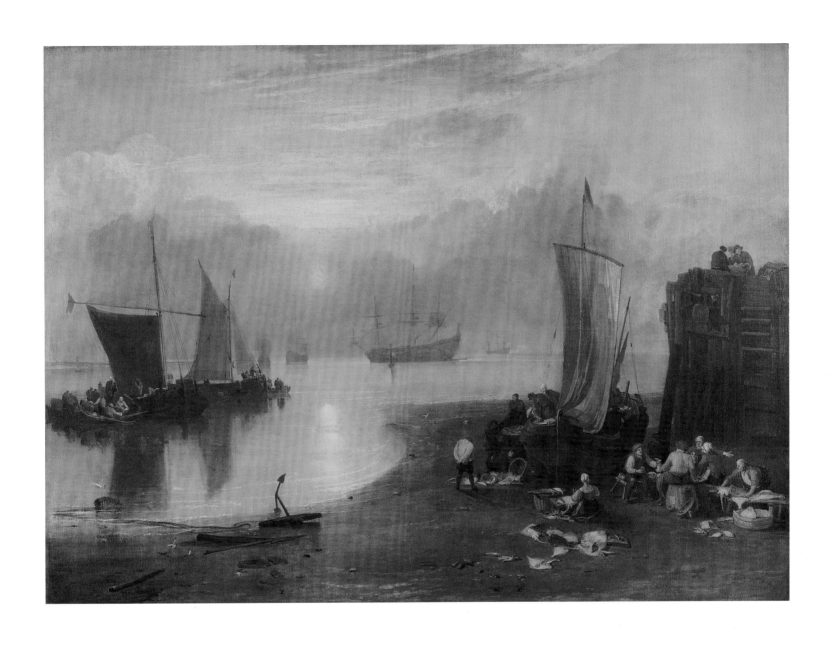

21 J.M.W. Turner
Sun rising through Vapour: Fishermen cleaning and selling Fish, before 1807
Oil on canvas, 134 x 179.5 cm
The National Gallery, London

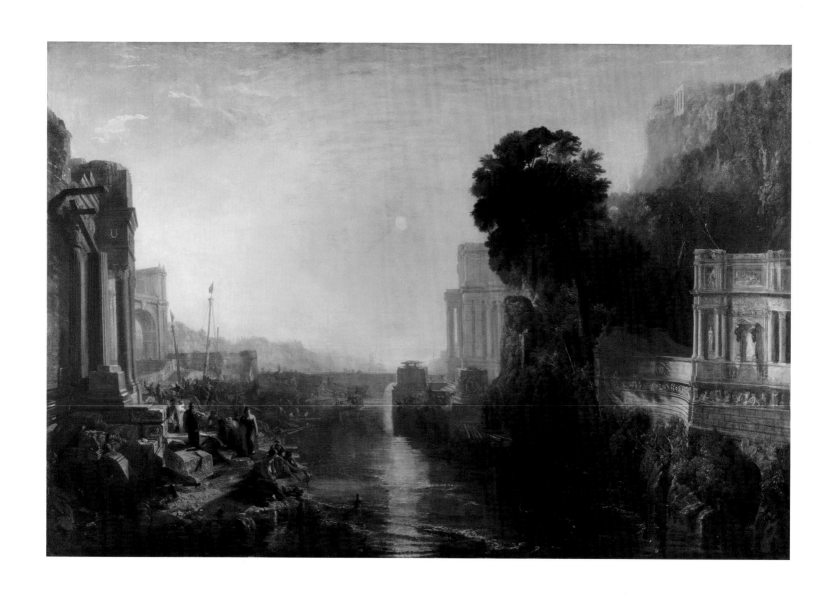

22 J.M.W. Turner
Dido building Carthage, or The Rise of the Carthaginian Empire, 1815
Oil on canvas, 155.5 x 230 cm
The National Gallery, London

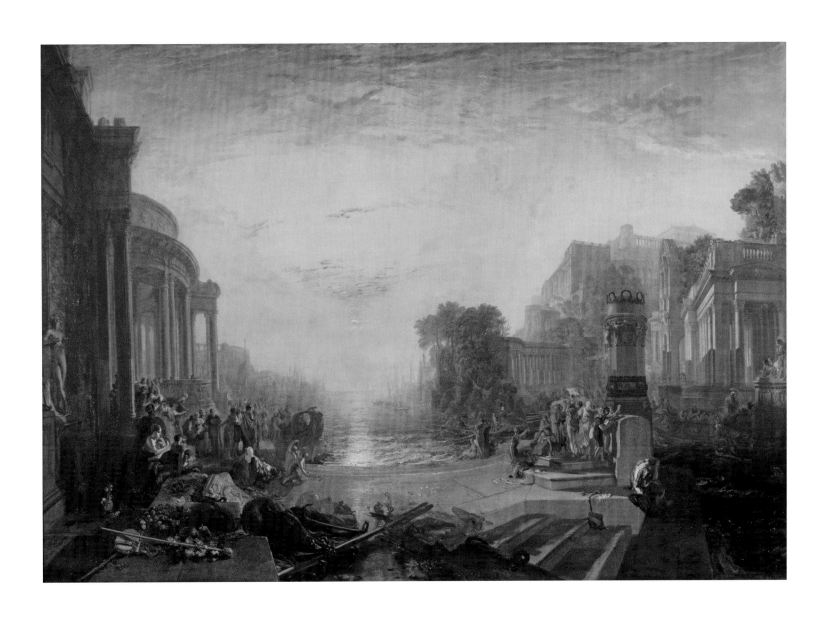

23 J.M.W. Turner
 The Decline of the Carthaginian Empire, exhibited 1817
 Oil on canvas, 170.2 x 238.8 cm
 Tate, London

Two years after *Dido building Carthage* was exhibited, Turner presented its pendant, *The Decline of the Carthaginian Empire*, a work deliberately conceived to address the ideas of the earlier image. Every detail offers a telling contrast. For example, the optimism of the sunrise in the first picture is answered with a portentous 'ensanguined' sunset (as Turner himself described it), symbolising the crushing defeat enacted on Carthage by Rome. Similarly, the fragile hopes epitomised by the toy boat being launched as Carthage puts down its foundations are shown to be delusive in the second painting, where the boat founders in the foreground shadows, its fate obscure and unremarked. Turner had originally intended the two paintings to remain together in the juxtaposition he requested of his own work with that of Claude, but later revised this wish in favour of *Sun rising through Vapour* (plate 21).

24 J.M.W. Turner
Linlithgow Palace, Scotland, exhibited 1810
Oil on canvas, 91.4 x 122 cm
National Museums Liverpool, Walker Art Gallery

25 J.M.W. Turner
Sunshine on the Tamar, about 1813
Watercolour over pencil, with some scratching out
and use of the brush handle, on wove paper, 21.7 x 36.7 cm
The Ashmolean Museum, Oxford

26 J.M.W. Turner
Plymouth Dock from Mount Edgcumbe, about 1814
Watercolour over pencil heightened with scratching out,
with touches of gum arabic, on wove paper, 15.6 x 24.1 cm
Plymouth City Museum and Art Gallery

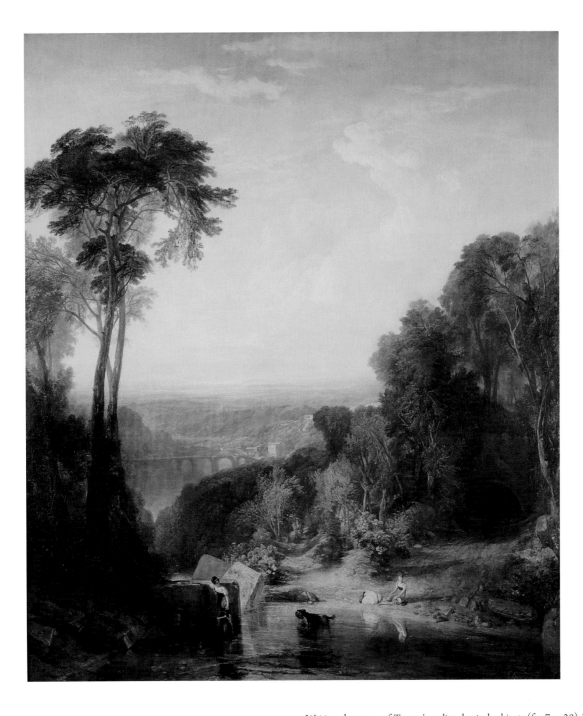

27 J.M.W. Turner
Crossing the Brook, exhibited 1815
Oil on canvas, 193 x 165 cm
Tate, London

Writing about one of Turner's earlier classical subjects (fig. 7, p. 20), William Hazlitt declared the result surprisingly satisfactory: 'we could almost wish that this gentlemen would always work in the trammels of Claude … All the taste and all the imagination being borrowed, his powers of eye, hand, and memory are equal to anything.' Hazlitt was not alone in detecting the ongoing influence of Claude in ambitious works like the Carthaginian scenes. Yet, in works like *Crossing the Brook*, which was exhibited in the same year as *Dido building Carthage* (plate 22), Turner created images that went far beyond their model, resulting in the kind of home-grown idealised landscape of which he had only dreamed just a few years earlier. This view of the Tamar Valley in Devon, framed by soaring Italianate ash trees, is beautifully lit by a softly glowing light, permitting the viewer's eye to ramble across the surface, counting the miles as it moves into the distance (as in a Claude landscape).

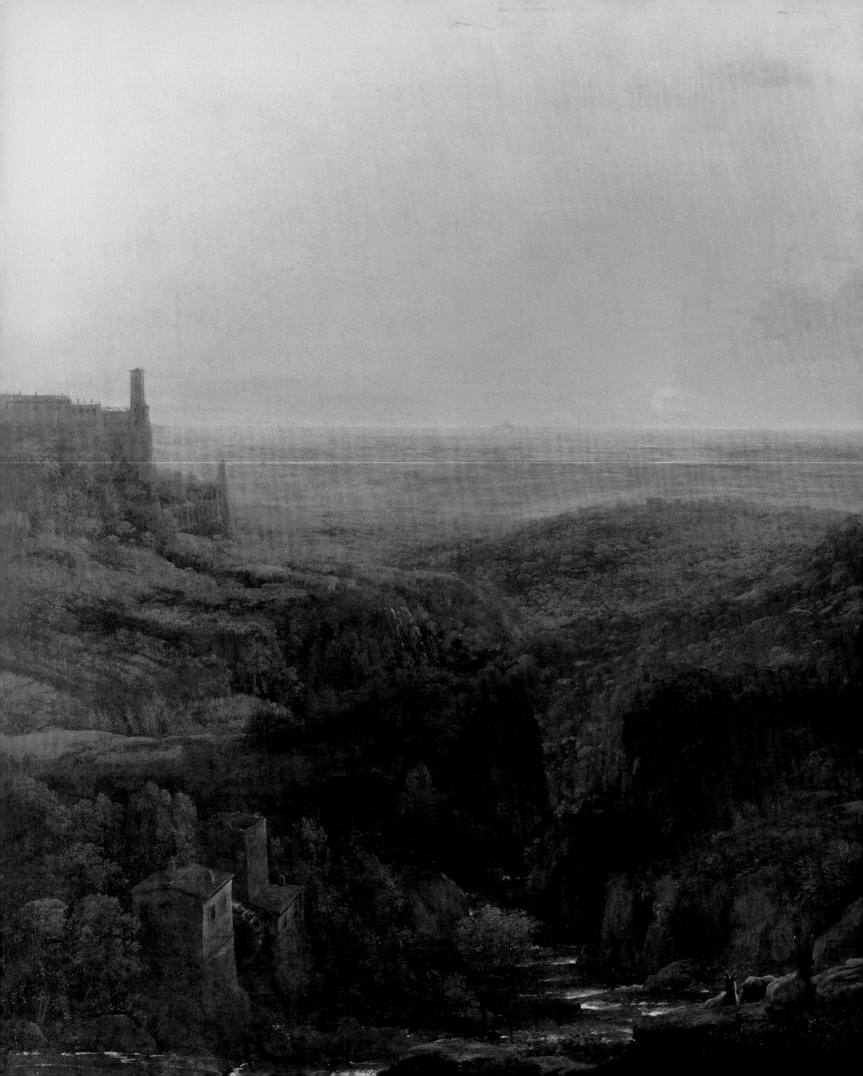

IMBIBING CLAUDE'S ITALY

Turner's reverence for Claude's art was nowhere more evident than in his approach to Italy, the country which had inspired the seventeenth-century master's most celebrated and alluring works. In a similar manner to the small black convex mirror known as a 'Claude glass', whose reflections helped amateur artists in the late eighteenth and early nineteenth centuries to emulate its namesake's style, Turner viewed Italy through 'Claude-tinted spectacles'. His concept of Italianate landscape was shaped by the visual language of Claude's paintings, which not only introduced him to a particular type of classical scenery, but also set up expectations regarding the natural beauties of the country. In a lecture first delivered in 1811 Turner outlined the fundamentals of Claude's vision, describing his works as 'pure as Italian air, calm, beautiful and serene', with views of the 'amber-coloured ether' that were 'rich, harmonious, true and clear'. Turner subsequently incorporated these elements into his own paintings, such as his large watercolour *Landscape: Composition of Tivoli* (plate 29). Dated 1817, two years before Turner actually saw Italy for himself, this work is a perfect distillation of the Claudian ideal, being an imagined composition dominated by golden light, rich colours, verdant trees and hazy distant 'aerial' forms.

First-hand experience of Italy came relatively late in Turner's life: it was not until 1819, when he was an established artist in his forties, that he finally set off on his first tour. That same year saw the publication of the third volume of Earlom's *Liber Veritatis*, which included engraved reproductions of some of Claude's most naturalistic-looking scenes (see plate 33). Although it is not known whether Turner saw these studies before his departure, Claude was certainly uppermost in his thoughts as he journeyed through Italy and he assiduously scanned the passing countryside for echoes of the French master's work. However, it was not until he reached Osimo, near Ancona, that the colouring and arrangement of the topography finally satisfied his preconceived notions, a moment which he joyfully noted in one of his sketchbooks as 'the first bit of Claude'. Further flashes of recognition occurred the further south he travelled, with Turner comparing the qualities of actual views to familiar and much loved paintings, such as that belonging to Lord Egremont at Petworth House (fig. 10, p. 21).

During his time in Italy, Turner consciously sought out sites that he already knew vicariously through Claude's works: for instance, Lake Albano or the Campagna north of Rome, where Claude had made a number of sketching trips along the river Tiber. One of the most aesthetically resonant places was Tivoli, famous for its beguiling combination of ancient ruins and breath-taking scenery. The town introduced Turner to a repertory of motifs that he could revisit and rework in endless idealised landscape variations. He deliberately sketched all the key classical sites familiar to him through Claude's paintings, such as the Temple of Vesta, a distinctive circular edifice dating from the first century BC and one of Tivoli's most famous landmarks (visible in plates 28, 32, 33 and 34). The spectacle that attracted him most, however, was the so-called Villa of Maecenas, a Roman temple now known as the Santuario di Ercole Vincitore, which stands above the steep ravine and cascades to the north-west of the town. Like Claude (see plate 37), Turner depicted the ruin from the north-east, silhouetted against the setting sun, with the Tiber winding its way towards distant Rome on the horizon. However, his watercolour studies (plates 35 and 36) exhibit a vitality and freshness that is entirely his own.

The legacy of 'Le Lorrain' remained potent for Turner throughout his life and the Claudian landscape prototype even pervaded his paintings where Italy was not the subject: see, for example, the oil painting entitled *Banks of the Loire* (plate 41). Turner painted this work, exhibited at the Royal Academy in 1829, immediately after his second tour of Italy and may even have conceived it in Rome. However, the clear point of reference is Claude's *Landscape with Hagar and the Angel* (plate 40), which had recently been presented to the National Gallery by the connoisseur and amateur painter Sir George Beaumont. Beaumont had been a severe critic of Turner's classical landscapes and it was therefore possibly a quiet revenge for Turner to create a pastiche based on the format and composition of Beaumont's own picture. (See also Turner's *Narcissus and Echo*, which reworks another painting by Claude in Beaumont's collection; plates 7 and 8.) A further interesting comparison is *The Vale of Dedham* by Turner's contemporary, John Constable, exhibited at the Royal Academy in 1828 (now in the National Gallery of Scotland), which also adopted *Hagar and the Angel* as its compositional source. However, where Constable's landscape is based upon close observation of nature, Turner perpetuates Claude's penchant for the ideal, transforming a recognisable, if obscure, French location into a radiant piece of Italianate perfection.

NM

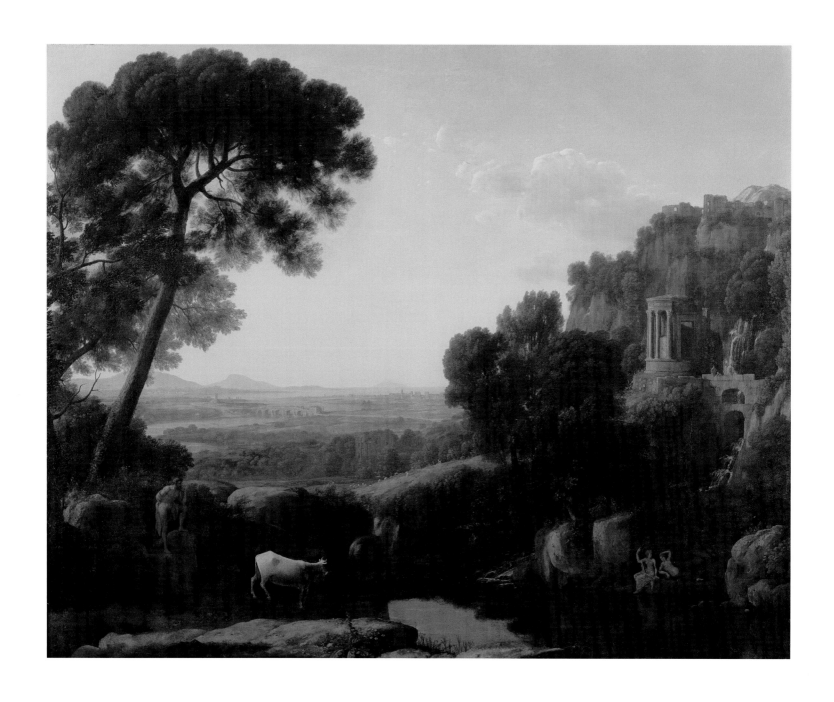

28 Claude
A Sunset or Landscape with Argus guarding Io, 1674
Oil on canvas, 99 x 123 cm
Viscount Coke and Trustees of the Holkham Estate

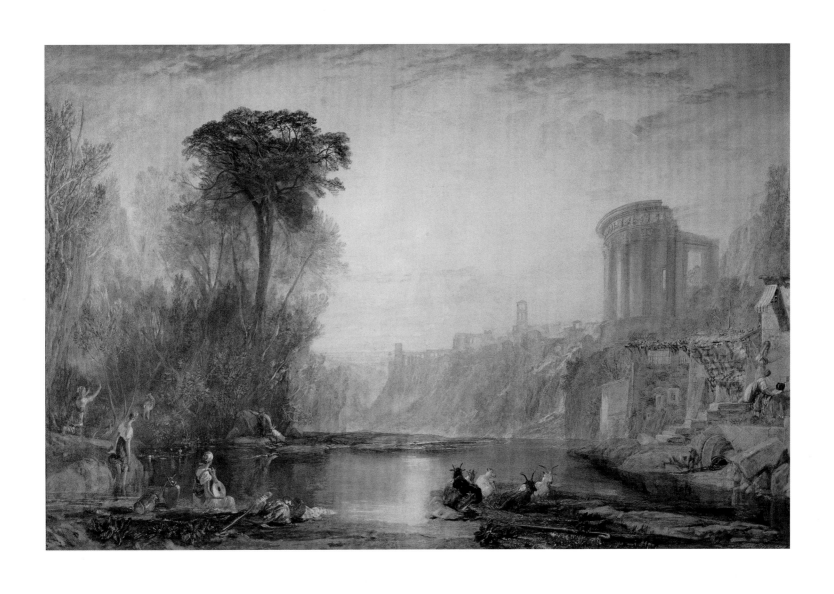

29 J.M.W. Turner
Landscape: Composition of Tivoli, 1817
Watercolour on paper, 67.6 x 102 cm
Private collection

30 J.M.W. Turner
Sunrise, 1825–30
Watercolour on paper, 33.8 x 47.2 cm
Tate, London

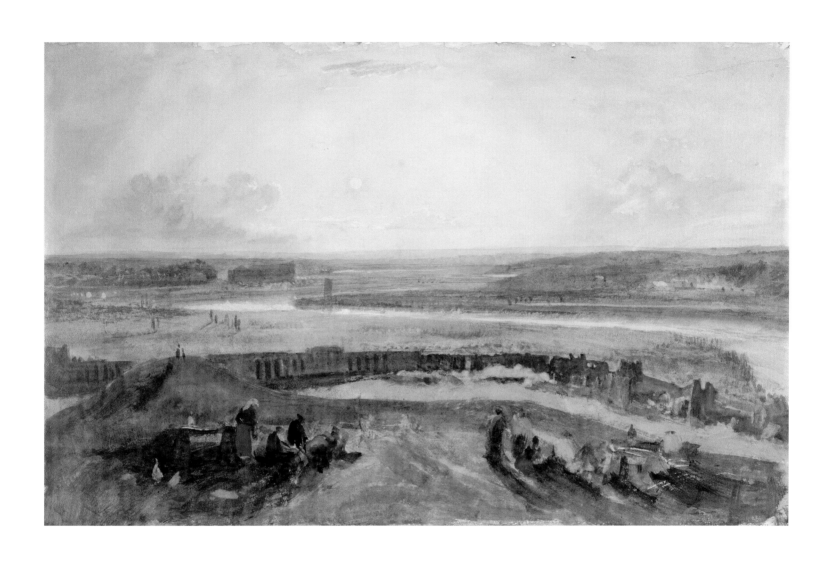

31 J.M.W. Turner
The Roman Campagna from Monte Testaccio, Sunset, from the *Naples, Rome C. Studies*
sketchbook, 1819
Gouache, pencil and watercolour on paper, 25.2 x 40.4 cm
Tate, London

32 J.M.W. Turner
Tivoli, from the North-East, with the Temple of Vesta, from the *Naples, Rome C. Studies* sketchbook, 1819
Pencil on paper, 25.7 x 40.5 cm
Tate, London

33 Claude
View of Tivoli, from Monte Catillo, with the Temple of Vesta, 1640–1
Pen and brown ink and brown wash, touched with watercolour, on paper, 21.5 x 31.6 cm
The British Museum, London

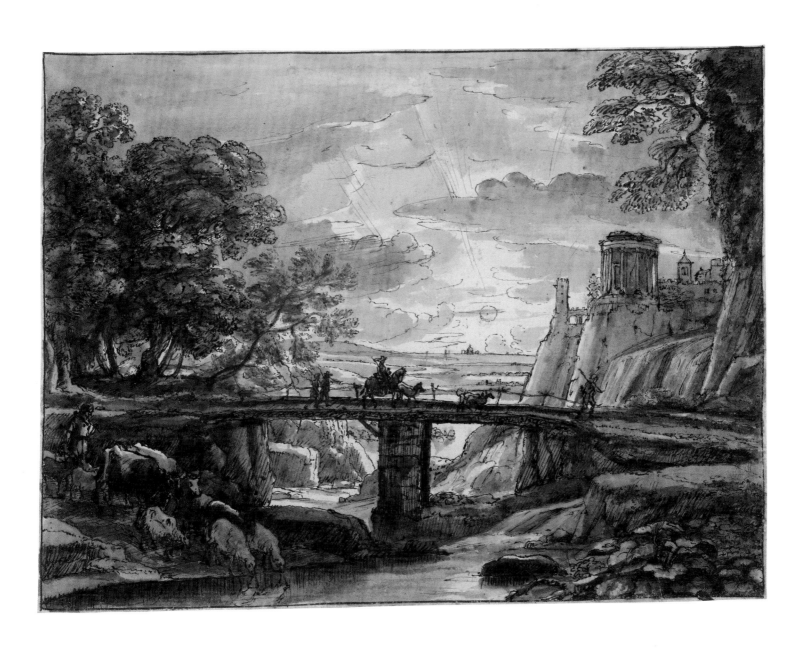

34 Claude
Landscape with a Rider and an Idealised View of Tivoli, 1642
Pen and brown ink and brown wash on paper, 19.6 x 26.4 cm
The British Museum, London

This is one of the 195 sheets that originally made up the album known as the *Liber Veritatis*, in which Claude recorded each of the paintings he sold, sometimes annotated with details of its first owner. The subject transcribed here is among the smallest of Claude's paintings, one of several works painted on copper (Courtauld Institute of Art, London). As the oil colours in the picture have now darkened considerably, the drawing better preserves the essence of Claude's original concept, and especially his glorious sunset effect, which was intended to draw the eye to the dome of St Peter's on the horizon. The composition is a capriccio that brings together fancifully the most famous topographical features of Tivoli: the Cascatelle, plunging beyond the bridge; the circular Temple of Vesta; the tower of the so-called Villa of Maecenas; and the campanile of Santa Maria Maggiore. Turner could have seen another of Claude's idealised views of Tivoli in the museum in Grenoble during his visit there in 1802.

35 J.M.W. Turner
Tivoli, from Monte Catillo, from the *Naples, Rome C. Studies* sketchbook, 1819
Pencil and watercolour on paper, 25.6 x 40.4 cm
Tate, London

36 J.M.W. Turner
Tivoli, from the Valley, with the Cascatelli and the Santuario di Ercole Vincitore,
from the *Naples, Rome C. Studies* sketchbook, 1819
Watercolour on paper, 25.2 x 40.4 cm
Tate, London

37 Claude
A View of the Roman Campagna from Tivoli, Evening, about 1644–5
Oil on canvas, 98.2 x 131.2 cm
Lent by Her Majesty The Queen

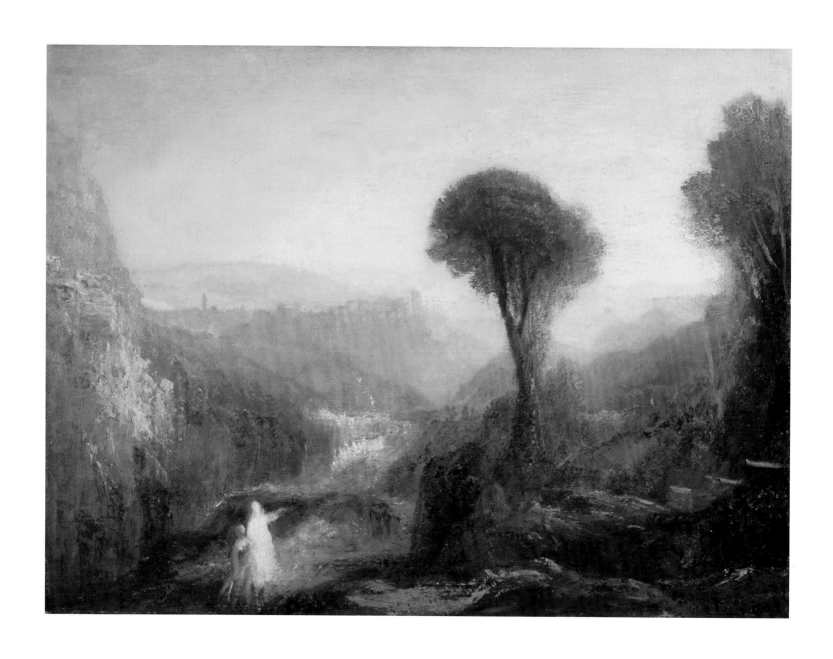

38 J.M.W. Turner
Tivoli: Tobias and the Angel, about 1835
Oil on canvas, 90.5 x 121 cm
Tate, London

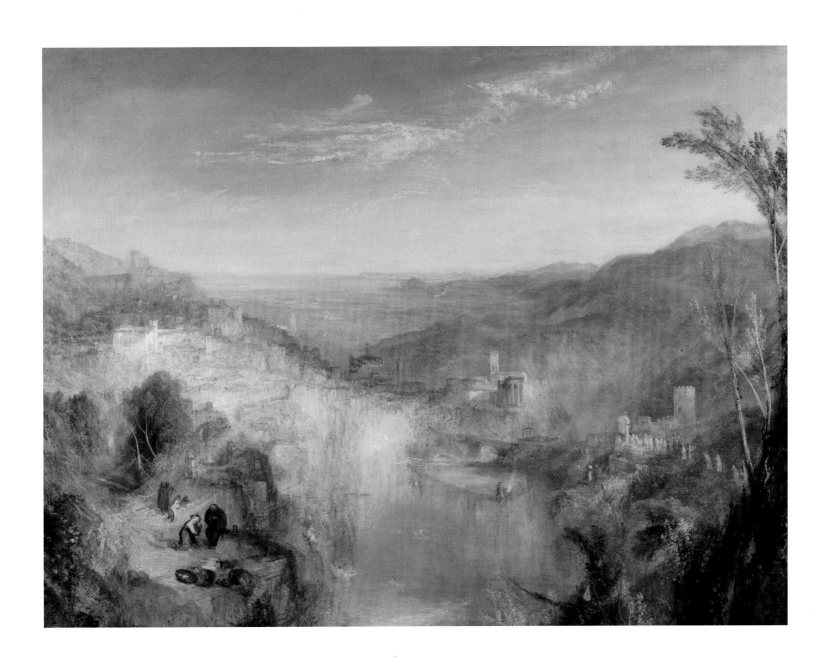

39 J.M.W. Turner
Modern Italy – the Pifferari, exhibited 1838
Oil on canvas, 92.6 x 123.2 cm
Glasgow Museums, Scotland

In the later 1830s, although he had not been to central Italy for about ten years, Turner continued to evoke Rome and the surrounding countryside in the paintings he sent for exhibition at the Royal Academy. This picture contains many recognisable features of the landscape at Tivoli, most noticeably the Temple of Vesta on the right. But instead of specifying the setting, Turner chose a title that embraces a much more expansive idea, presenting Tivoli as emblematic of the country as a whole. He paired it with a contrasting picture – *Ancient Italy – Ovid banished from Rome* (private collection) – the aim being to highlight the links between the past and continuing superstitious practices. Ovid was thought to have been the instigator of the local tradition of shepherd pipers (*pifferari*) playing lullabies to images of the Virgin each Christmas, one of many examples of the interconnected nature of pagan and Christian traditions in Italian life.

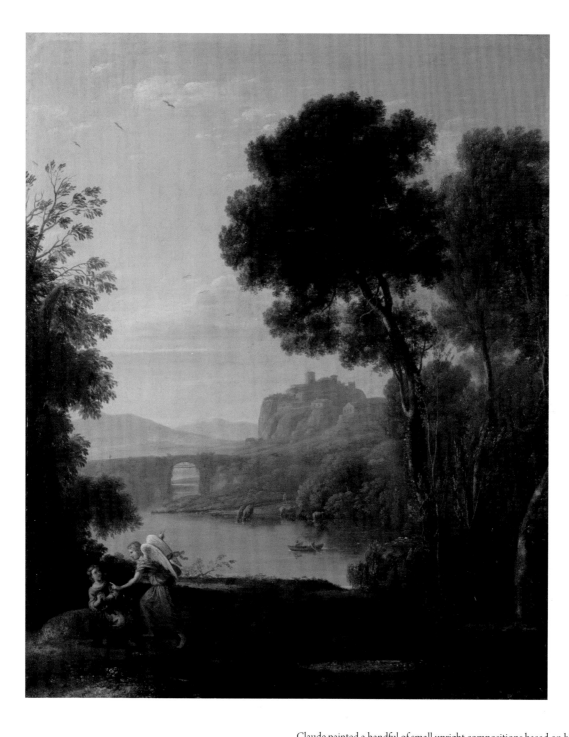

40 Claude
Landscape with Hagar and the Angel, 1646
Oil on canvas mounted on wood, 52.2 x 42.3 cm
The National Gallery, London

Claude painted a handful of small upright compositions based on his studies from nature in the Campagna, outside Rome. This painting had been promised to the National Gallery by Sir George Beaumont in 1826, just as Turner was about to embark on a tour of north-western France. Some of the sketches he made on the river Loire near Oudon afterwards served as the basis for an oil painting that he exhibited in the spring of 1829. Fresh from his second spell in Rome, he would then have spotted that Claude's picture had at last officially joined the collection. Although the subject of Claude's image is now known to depict the maidservant Hagar receiving the news that she will carry the children of Abraham, it was thought to represent 'The Annunciation' when first acquired. Turner's picture similarly includes a young woman, who stares towards the rising sun as if receiving some kind of benediction.

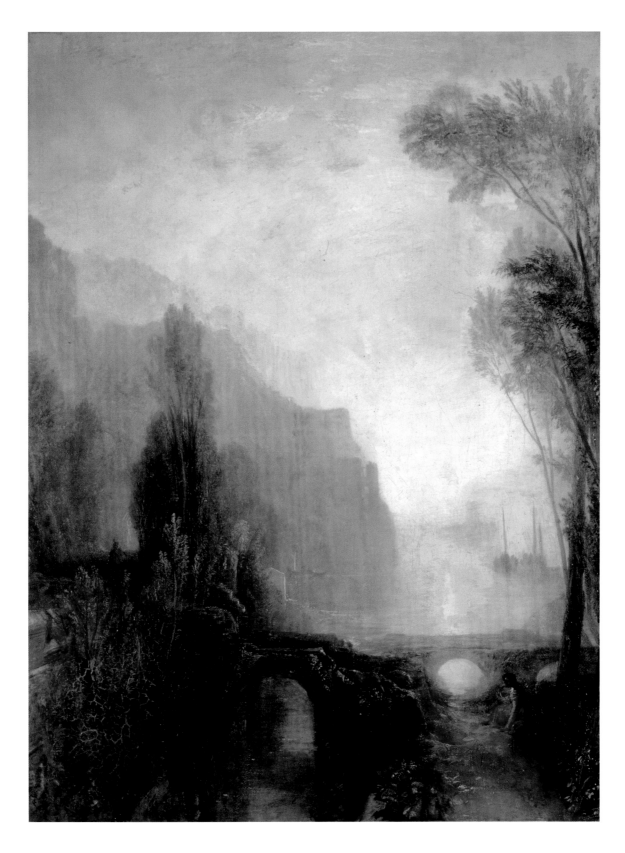

41 J.M.W. Turner
Banks of the Loire, 1829
Oil on canvas, 71.3 x 53.3 cm
Worcester Art Museum, Massachusetts

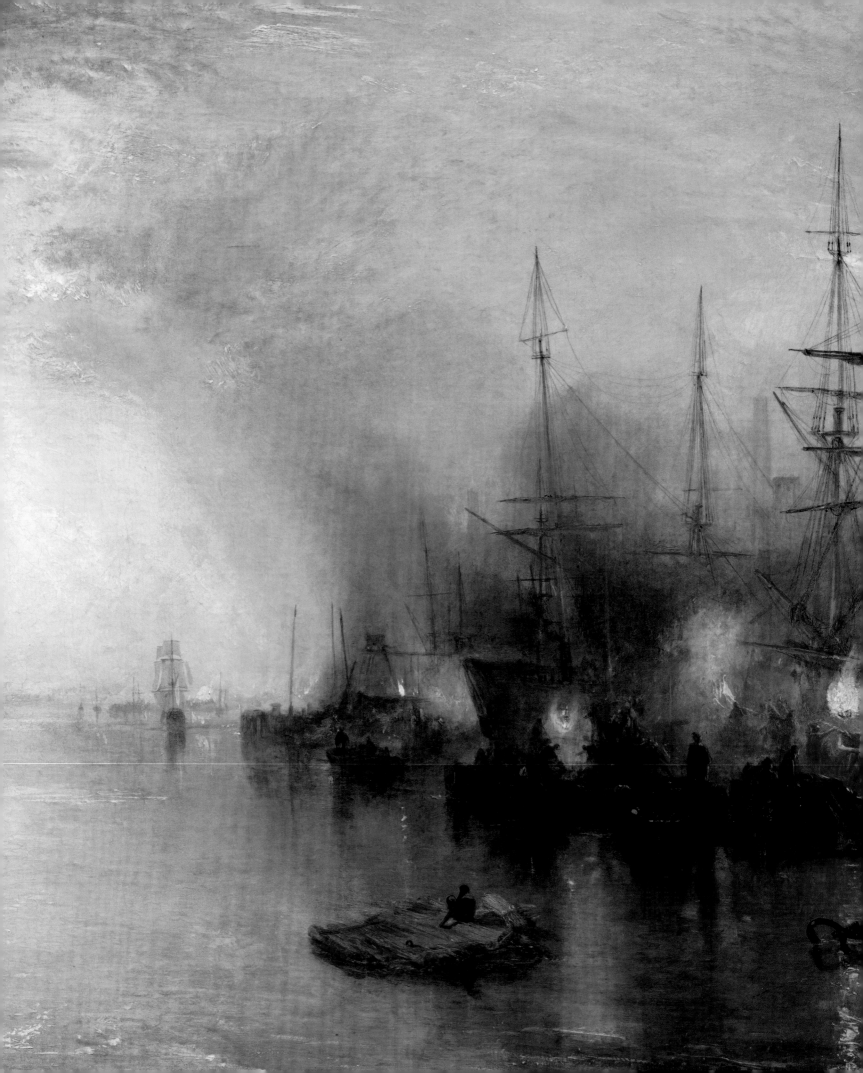

TURNER'S MODERN LANDSCAPES

Turner's enchantment with Claude's idealised version of Italy did not diminish in the 1820s, even though he increasingly experimented with new subject matter and new stylistic initiatives. Far from constituting a private, academic appreciation, Turner's love for Claude's images continued to inform and enrich his approach to landscape. This is most readily appreciable in the scenes inspired by his recent Italian travels. However, even where the influence was less overt the landscapes of Claude can be shown to have been just as significant for Turner in his treatment of British themes.

Britain was changing rapidly during this period. It was still ruled by the landed gentry, whose extensive parks must have seemed to the urban population as fantastical and remote as Claude's idylls (plate 44). By the 1830s, however, political reform was beginning to transform the nature of the voting class. During these years, Britain's network of roads and canals was steadily expanding, and was supplemented in the 1840s by the addition of railway lines. It is revealing, nevertheless, that Turner instinctively fell back on the borrowed formula of a Claudian port scene when recording the conjunction of road and canal at Kirkstall, near Leeds (plate 42).

Aspects of Claude's *Seaports* can also be discerned in Turner's depiction of other industrial settings. An unfinished view of Birmingham (plate 43), for instance, is a further adaptation of Claude's preference for *contre-jour* effects, where the viewer is dazzled by the glare of the sun, though here it struggles to penetrate the layers of pollution, producing extravagantly coloured swathes of mist. Another variant on the harbour formula can be found in the view of the canal at Dudley (Lady Lever Art Gallery, National Museums on Merseyside), where the moon replaces the sun, to create an unearthly contrast with the nocturnal fires of human industry.

Much the same effect can be found in the oil painting *Keelmen heaving in Coals by Night* (plate 55), an expansive reworking of a composition Turner had first realised in watercolour in 1823. The picture marks a highpoint in his use of Claude's *Seaports* as a prototype for contemporary settings. While his earlier evocations of ancient Carthage provoked meditations on the nature of empire that applied as much to France as to Britain, this view of the docks along the Tyne at South Shields addressed a more limited patriotic ambition. It had been commissioned by its first owner (a Manchester merchant) to be paired with a view of Venice, apparently in order to suggest the inevitable ebb and flow from one centre of power to another. The juxtaposition proposed that Britain stood as the rightful successor of Carthage and Venice. The engine fuelling this claim was Britain's prowess as a maritime and industrial power, evidence of which is shown in the ranks of ships moored alongside gantries and tramways.

A few years after he made the original watercolour view of Shields, Turner's interest in Claudian harbour subjects flourished yet again, no doubt inspired by the acquisition for the National Gallery in 1824 of the three *Seaport* canvases formerly in the Angerstein collection. Though Turner pursued his own variants of these in his private studies, and in the set of commissioned views he made at Petworth House, his most concentrated attempts to measure himself against these and other specific examples by Claude came in 1828. His exhibits that year at the Royal Academy included two pictures that grew directly from Claude's model: one was a further treatment of the story of Dido, painted on the same scale as the Carthaginian subjects of 1815 and 1817 (now in very poor condition; Tate, London); the second was a view of the recently inaugurated regatta at Cowes, on the Isle of Wight (plate 45). In this, Turner transformed his depiction of the festive scene into his own kind of Arcadia, a blending of Claude's golden light with the *fêtes-champêtres* of Watteau.

Turner also sought to pay homage to Claude's unifying light effects when painting *Regulus* (plate 47) just a few months later. By then he was temporarily established in Rome, where he eventually capitulated to local demands for him to exhibit his work. The pair of landscapes he created for this testimonial event were both conceived in relation to Claude: *Regulus* is well known as a reworking of Claude's *Seaport with the Villa Medici*; but it should also be noted that its pendant, the view of *View of Orvieto, painted in Rome* (plate 46) is an updating of Claude's topographical landscapes, such as those of Castel Gandolfo or the port of Santa Marinella, which Turner had transcribed in 1819. The conjunction of a seaport with a verdant landscape reproduced on a reduced scale the subject types of the celebrated pair of canvases by Claude, known as 'The Bouillon Claudes', which had recently joined the National Gallery (plates 20 and 48). Within a year, those works had been co-opted by Turner – in his will, if not yet in reality – to hang with his own pictures.

IW

42 J.M.W. Turner
Kirkstall Lock, on the River Aire, 1824–5, for *The Rivers of England*, 1827
Watercolour on paper, 15.9 x 23.5 cm
Tate, London

Turner composed his image so that the receding water channel leads the eye towards the setting sun as effortlessly as the underlying perspective lines in any of Claude's pictures. Relegated to the distance is the more obviously elegiac subject matter of the ruined Cistercian monastery. He painted a second, more classicised view of the abbey, its dilapidated form protected by the curved trunks of a group of trees (Tate, London; TB CCVIII M, D18146).

43 J.M.W. Turner
An Industrial Town, probably Birmingham at Sunset; Colour Study,
about 1830–2
Watercolour on paper, 34.8 x 48.2 cm
Tate, London

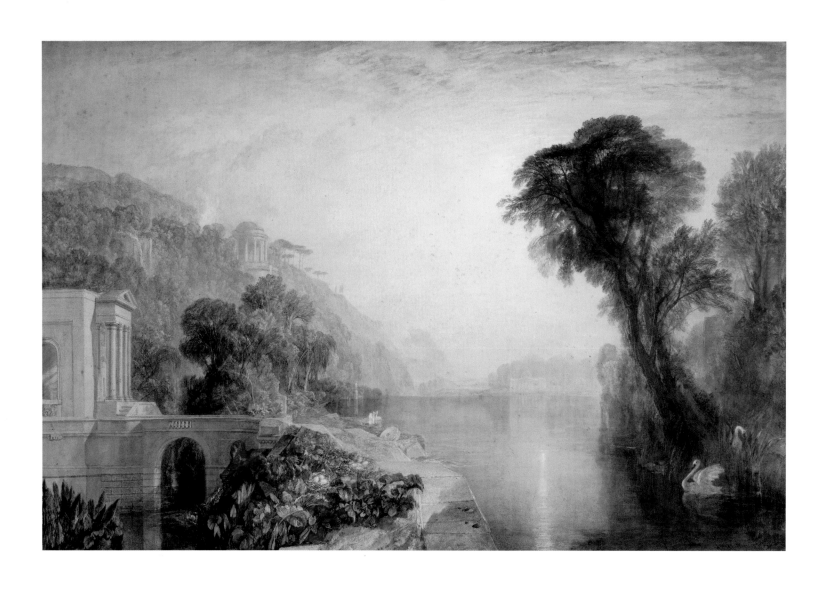

44 J.M.W. Turner
Rise of the River Stour at Stourhead (The Swan's Nest), about 1825
Watercolour on paper, 67.3 x 102.2 cm
Trustees of the Walter Morrison Collection, Sudeley Castle

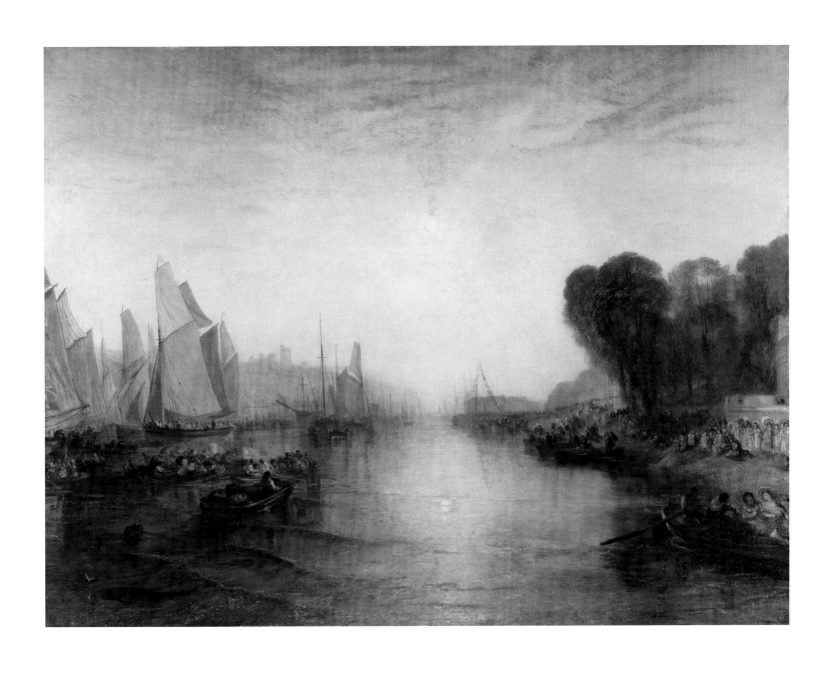

45 J.M.W. Turner
*East Cowes Castle, the Seat of J. Nash, Esq.; the Regatta starting for
their Moorings,* exhibited 1828
Oil on canvas, 91.4 x 123.2 cm
Victoria and Albert Museum, London

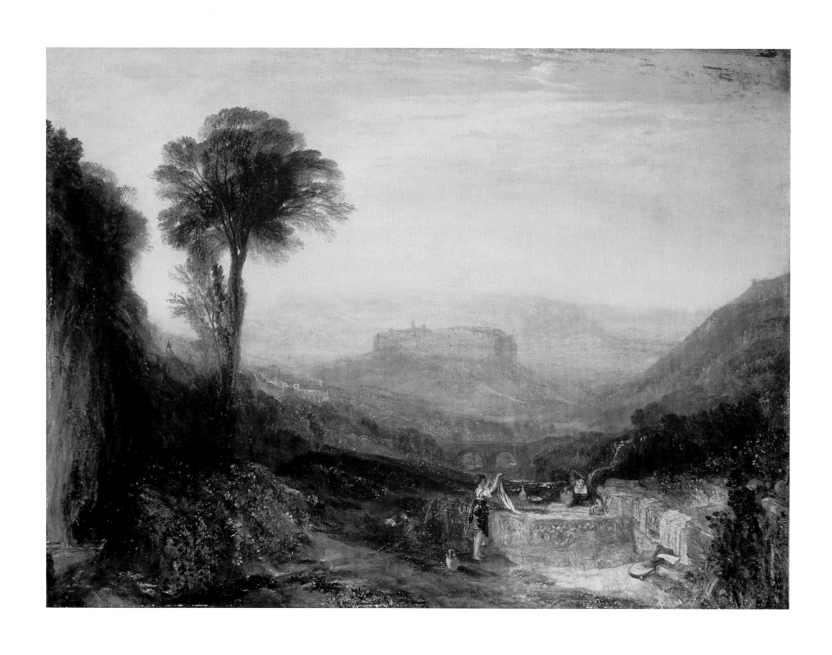

46 J.M.W. Turner
View of Orvieto, painted in Rome, 1828, reworked 1830
Oil on canvas, 91.4 x 123.2 cm
Tate, London

Turner knew that Claude had often created paired images, juxtaposing opposing lighting effects, or linking pastoral scenes with coast or harbour subjects. When he exhibited these two works in Rome in 1828, the painting *Regulus* evoked Claude very specifically by reworking the *Seaport, with the Villa Medici,* which he had studied in Florence in 1819. But he may also have been alluding to two of the Claudes bought by the National Gallery in 1824 (plates 20 and 48).

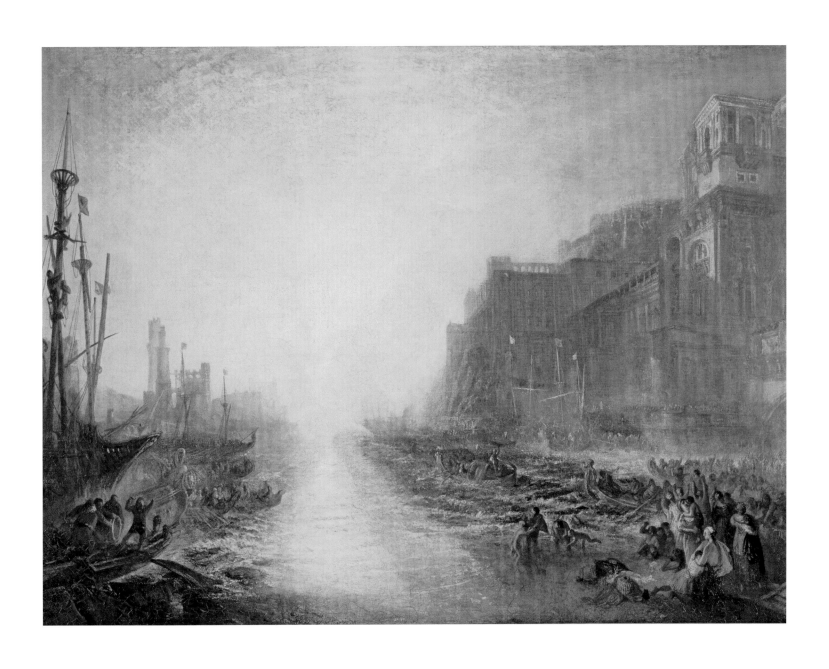

47 J.M.W. Turner
Regulus, 1828, reworked 1837
Oil on canvas, 89.5 x 123.8 cm
Tate, London

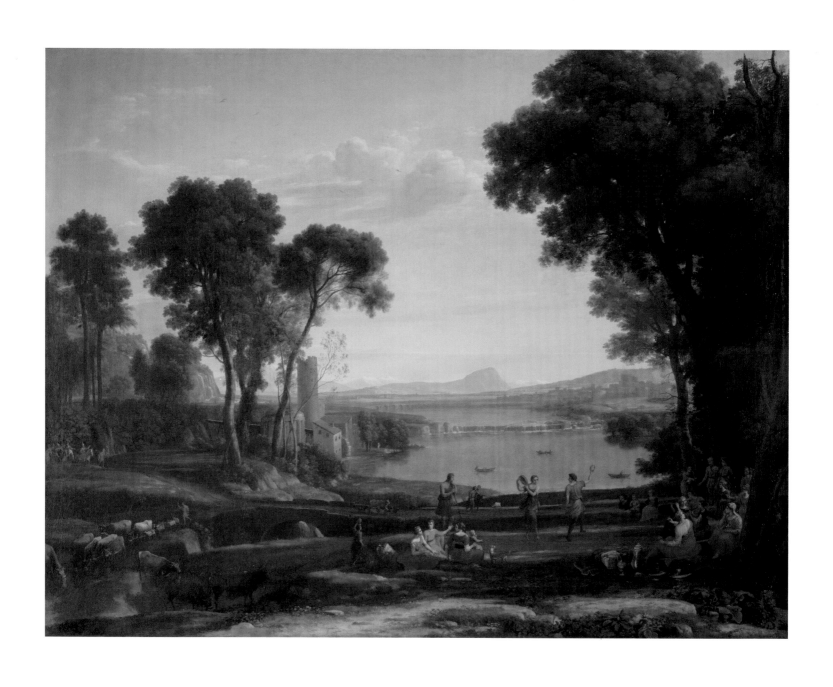

48 Claude
Landscape with the Marriage of Isaac and Rebecca, 1648
Oil on canvas, 152.3 x 200.6 cm
The National Gallery, London

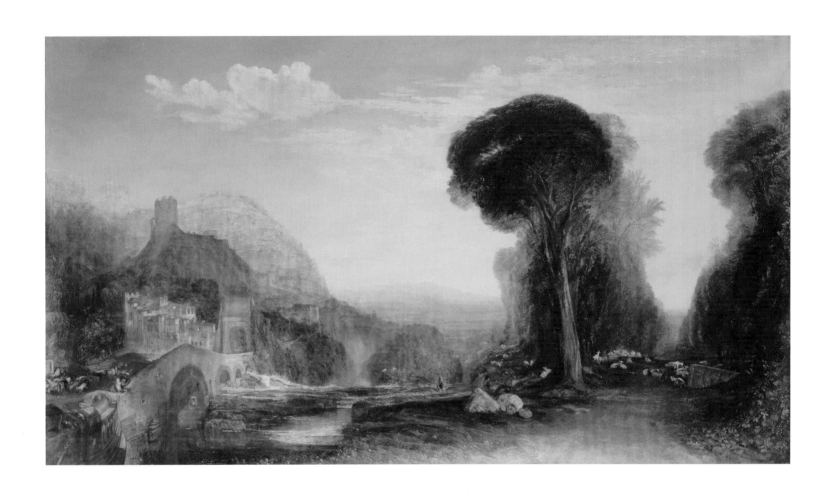

One of Turner's variations on the elements repeatedly found in Claude's compositions was conceived as a pair to the *Landscape with Jacob, Laban and his Daughters* (fig. 10, p. 21). When exhibited in London two years after Turner's return from Rome, it was given the suggestively topographical title *Palestrina – Composition*. However, the view represented cannot be related to the actual place to the south of Tivoli. As a result, the image is actually a skilled demonstration of 'Composition', the disparate elements brought together from Turner's travels in Italy, much as they are in the later *Childe Harold's Pilgrimage – Italy* (1832, Tate).

50 J.M.W. Turner
Sketch for 'Ulysses deriding Polyphemus', about 1827–8
Oil on canvas, 60 x 89.2 cm
Tate, London

This is one of sixteen oil sketches, painted sequentially on long strips of canvas, which were assumed to have been painted in Rome, during Turner's second stay there, at the end of 1828. Some of the images draw on sketches made in Italy in 1819 – or in France in 1821. So the oil studies seem more likely to predate the 1828 tour. Their existence in Turner's studio when he arrived back from Italy in 1829 proved to be crucial to his success at the Royal Academy that year. With the paintings he had recently completed in Rome still in transit, he had nothing ready to exhibit. Accordingly he looked back at this design and developed its composition on a large canvas as *Ulysses deriding Polyphemus – Homer's Odyssey* (1829, NG 508), one of his greatest achievements.

51 J.M.W. Turner
Southern Landscape with an Aqueduct and Waterfall, 1828?
Oil on canvas, 150.2 x 249.2 cm
Tate, London

52 J.M.W. Turner
Rocky Bay with Figures, about 1827–30
Oil on canvas, 90.2 x 123.2 cm
Tate, London

Where many of the artists based in Rome during this period hoped to arrive at a more literal representation of the natural world, Turner's renewed experience of the Campagna and its hill towns in 1828–9 confirmed his preference for a type of landscape painting that filtered and transformed prosaic realities through the artist's imagination. In short, his time in Rome reinforced his licence to invent. This is clear in paintings ranging from *Ulysses deriding Polyphemus – Homer's Odyssey* (1829, NG 508) to *Cicero at his Villa* (1839, private collection), as well as in unfinished designs that redeploy elements from Claude, such as the rock arch borrowed from the *Seacoast with Perseus and the Origin of Coral* (plate 53).

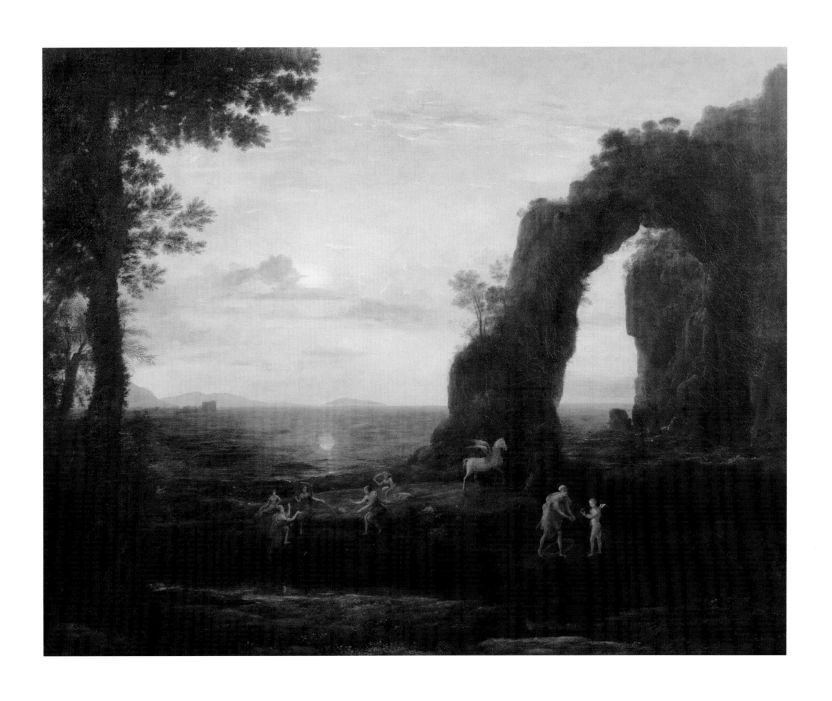

53 Claude
Seacoast with Perseus and the Origin of Coral, 1674
Oil on canvas, 104 x 129 cm
Viscount Coke and Trustees of the Holkham Estate

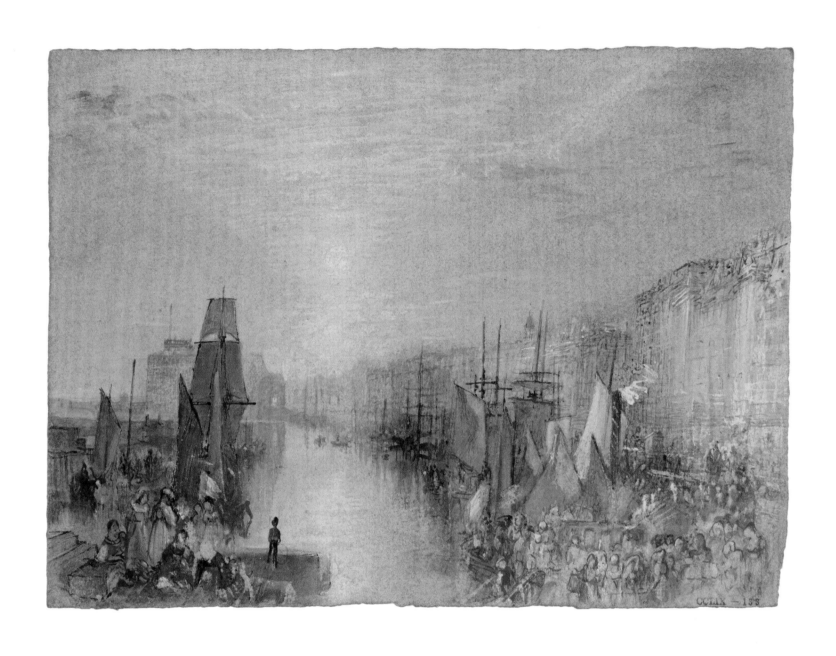

54 J.M.W. Turner
Le Havre: Sunset in the Port, about 1832, for *Turner's Annual Tour: The Seine,* 1834
Gouache and watercolour on blue paper, 14 x 19.2 cm
Tate, London

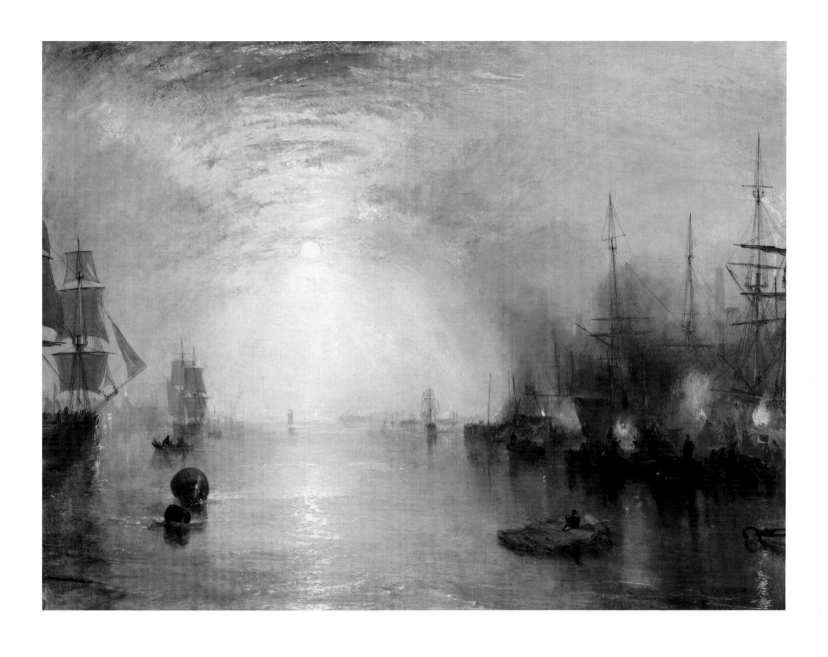

55 J.M.W. Turner
Keelmen heaving in Coals by Night, 1835
Oil on canvas, 92.3 x 122.8 cm
National Gallery of Art, Washington, DC

Such was the demand for the coal of Tyneside that the loading of the colliers continued throughout the night. Turner here depicts the unnatural glow of their flares competing even with the natural spectacle of the moonlit river. Once more he borrowed from Claude the structured perspective receding towards a distant point. Yet he subtly destabilised his model by moving the rising moon off-centre, so that his image seems less staged.

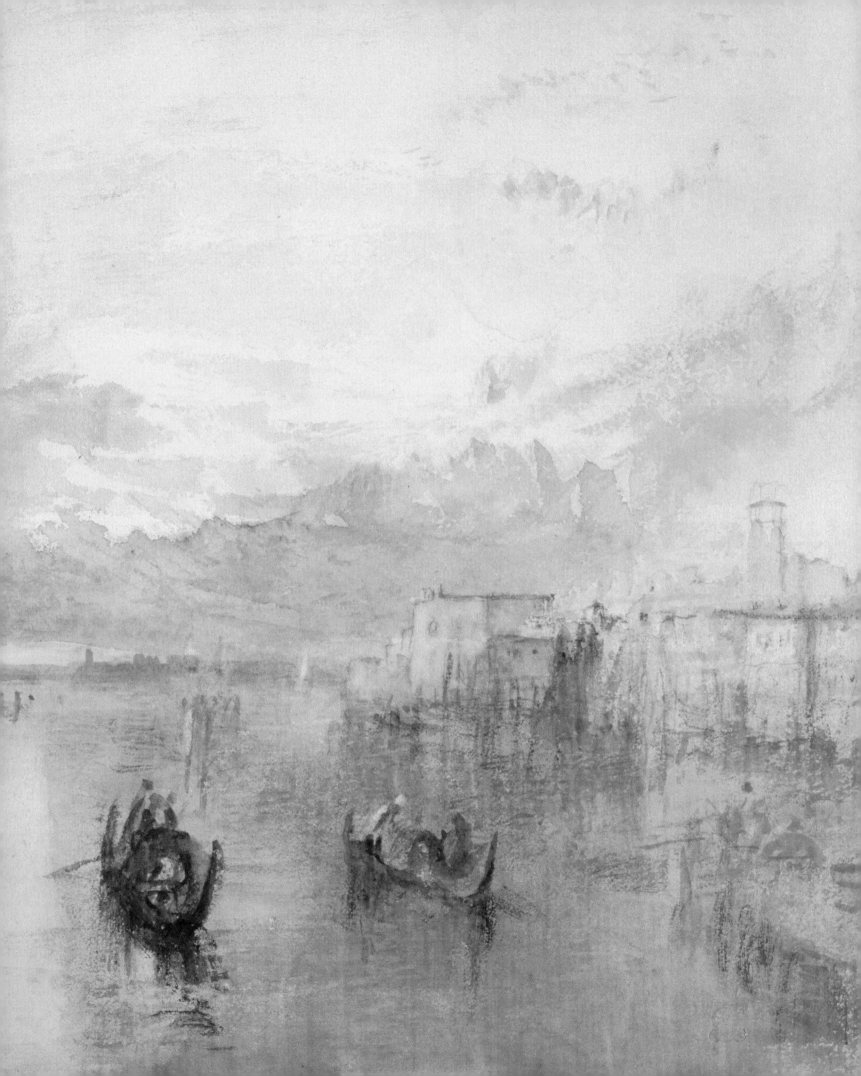

CLAUDE REVIVED: TURNER'S LATE SERIES

As the 1840s dawned, Turner remained one of the most prominent members of the Royal Academy, by then newly established in the eastern wing of the National Gallery building in Trafalgar Square. But, despite being one of the Academy's senior figures, Turner invariably failed to sell his contributions to its annual exhibitions. In fact, his work was no longer as widely acclaimed as it had been, and his paintings were instead routinely derided for their extravagant colours, or their mannered and indistinct application of paint.

Undaunted, Turner continued to aim at generating patronage from the highest quarters, whether in Britain, Germany or France. In 1841 he completed a view of the childhood home in Southern Germany of Prince Albert, who had married Queen Victoria just a year earlier. The subject was still opportune, even if Turner's depiction of the scene was too imprecise and romanticised to appeal to the Prince's taste, which favoured earlier Italian painters rather than those of the seventeenth century. Once again, Turner composed his view so that it fused Claudian fantasy with the topographical details he had studied during his visit to Coburg the previous summer.

Turner's journey to Germany in 1840 had also enabled him to visit Venice for his third and final time, resulting in a portfolio of some of his most spectacular watercolours (plates 56 and 57), as well as stimulating a sequence of lustrous oil paintings during the ensuing years. The pictures proved to be some of his most commercially successful works, their more compact format and Turner's enchanting recreation of this most appealing of topographical subjects resulting not only in numerous sales, but also in further commissions. Stylistically they are bolder and more atmospheric than his paintings of Venice from the 1830s, which had looked back to the crisp delineations of Canaletto.

From 1840 onwards Turner was also acquainted with the young John Ruskin, the son of a wealthy sherry merchant, and then a student at Oxford. During the following years, Ruskin and his father began to acquire Turner's works, but, like most contemporary collectors, they preferred his watercolours. This did not prevent Ruskin from appointing himself as the appropriate person to defend Turner from his critics, a mission that took the wide-ranging form of *Modern Painters*, a book published in five volumes between 1843 and 1860. In the first volume Ruskin made extravagant claims for Turner, proposing that he outstripped all earlier landscape artists. In answering objections about Turner's use of colour, he made comparisons with Claude, following the fashion among most arbiters of taste, who still adopted the seventeenth-century painter as the chief reference point in discussions on landscape. Having disparaged Claude's intellectual capabilities, Ruskin went on to belittle him by comparing him to a

'Sèvres china painter, [who] drags the laborious bramble leaves over his childish foreground'.

One of the few aspects of Claude's work that Ruskin was prepared to praise, with some qualifications, was his realisation of the sky in his paintings. Two works that he especially admired were the *Seaport with the Embarkation of the Queen of Sheba* (plate 20), and the picture then known (in its engraved form) as *The Enchanted Castle* (plate 61). Many years earlier, Turner had created an untitled design for his *Liber Studiorum*, generally known as 'Solitude', which was a reworking of Claude's *Enchanted Castle*.

Despite other instances of this kind, Ruskin somehow overlooked the significance of Turner's repeated demonstrations of his allegiance to Claude's example. Surprisingly, Ruskin's carping remarks towards Claude were not apparently sufficient in themselves to call forth some kind of defence from Turner (though the two men seem to have fallen out over something around 1845). Nevertheless, when Ruskin sought to acquire a set of the *Liber Studiorum* in 1845 he may unwittingly have provided the impetus for Turner to paint a set of ten canvases, each of which reworks one of the *Liber* subjects. The majority of the images selected for this group are of the most Claudian type, either in their presentation of classical scenes, or their realisation of British scenes according to idealised formulas. These were essentially a private tribute to Claude. With their luminous and pared-down forms, they resemble watercolour studies more than oil sketches. None of them was conventionally 'finished'; though Turner would presumably have applied further layers before exhibiting them. Indeed, none of them was exhibited until long after his death. Those in the artist's bequest, in fact, were among the first Turner canvases to be shown at the Tate Gallery in 1906, heralding the eventual movement of the collection to specially constructed galleries at Millbank. More than a hundred years after that revelatory debut, these works still reveal the extent to which the progressive character of Turner's art was founded on his deep-seated admiration for the transcendent qualities he found in Claude's paintings.

IW

56 J.M.W. Turner
Venice: The Punta della Dogana at Sunset, with the Domes of Santa Maria della Salute,
from the *Grand Canal and Giudecca* sketchbook, 1840
Watercolour on paper, 22.1 x 32.2 cm
Tate, London

57 J.M.W. Turner
Venice: The Giudecca Canal, looking towards Fusina at Sunset,
from the *Grand Canal and Giudecca* sketchbook, 1840
Pencil, watercolour and crayon on paper, 22.1 x 32.3 cm
Tate, London

Turner's watercolours of Venice engaged with the unique character of Venetian light, observing how it envelops the observer in its open spaces, and the ways in which it is intensified by being refracted on the surface of the lagoon. In studying this effect on the wide Giudecca Canal, Turner's natural reference point was the glaring light that pervades and gilds everything in Claude's *Seaports*.

58 J.M.W. Turner
Schloss Rosenau, Seat of HRH Prince Albert of Coburg, near Coburg, Germany,
exhibited 1841
Oil on canvas, 97 x 124.8 cm
National Museums Liverpool, Walker Art Gallery

The sun casts an amber glow across the whole canvas, and is positioned at the heart
of the image, so that the leaves of the tree on the left appear much darker, seen against
the light. It is an idyllic setting, into which Turner introduced the innocent flirtation of
a young angler boasting to his admirer. This playful echo of the amorous nymphs and
swains of classical legend may perhaps allude to the royal newly-weds, Victoria and
Albert, but more definitely testifies to the many contented hours Turner himself had
spent fishing, his favourite pastime.

59 J.M.W. Turner
The Château at Arques-la-Bataille, near Dieppe, 1845
Pencil and watercolour on paper, 24.3 x 30.3 cm
Tate, London

Turner revisited Arques-la-Bataille during his last journey to France in September 1845. The purpose of this channel crossing was an invitation to dine with his old acquaintance Louis-Philippe. At Arques, Turner made several watercolours of the picturesque ruins (Tate, London; CCCLXIV 15, 17, 126, 172, 393). While making his studies, Turner watched a ploughman tilling the soil, which may have stimulated the Claudian mood in this scene.

60 William Say, after J.M.W. Turner
Solitude; plate 53 in *Liber Studiorum*, 1814
Etching and mezzotint on paper, 17.7 x 25.7 cm
Tate, London

Instead of Claude's ornate realisation of Cupid's pleasure palace, Turner's castle is reminiscent of the fortresses he had studied during his survey of the picturesque ruins of England and Wales in the 1790s. It is, in any case, obscured by a clump of trees, placed towards the centre, which shelter a recumbent female figure. In Claude's painting the equivalent figure is Psyche, who meditates on the lover who pays her nocturnal visits that prevent her from seeing his immortal form. Without fixing his subject precisely, Turner left evidence that he had paid close attention to Claude's picture. He even introduced a grazing deer similar to those that surround the melancholy Psyche.

61 Claude
Landscape with Psyche outside the Palace of Cupid
('The Enchanted Castle'), 1664
Oil on canvas, 87.1 x 151.3 cm
The National Gallery, London

62 J.M.W. Turner
Landscape with Water: Tivoli, about 1840–5
Oil on canvas, 121.9 x 182.2 cm
Tate, London

63 J.M.W. Turner
Sunrise, a Castle on a Bay: Solitude, about 1845–50
Oil on canvas, 90.8 x 121.9 cm
Tate, London

TURNER INSPIRED: *SELECTED READING*

A. Bailey, *Standing in the Sun: A Life of J.M.W. Turner*, London 1997

M. Butlin and E. Joll, *The Paintings of J.M.W. Turner*, 2 vols, New Haven and London 1977 (revised edn 1984)

J. Egerton, *National Gallery Catalogues: The British Paintings*, London 1998

G. Forrester, *Turner's 'Drawing Book': The Liber Studiorum*, exh. cat., Tate Gallery, London 1996

J. Gage, *J.M.W. Turner: 'A Wonderful Range of Mind'*, New Haven and London 1987

J. Hamilton, N. Moorby, C. Baker and J. Ridge, *Turner and Italy*, exh. cat., National Galleries of Scotland, Edinburgh 2009

D. Hill, *Turner on the Thames: River Journeys in the Year 1805*, New Haven and London 1993

E. Joll, M. Butlin and L. Herrmann, *The Oxford Companion to J.M.W. Turner*, Oxford 2001

M. Kitson, *Claude Lorrain: Liber Veritatis*, London 1978

M. Kitson, *Studies on Claude and Poussin*, London 2000

M. Kitson, *The Seeing Eye: Critical Writings on Art: Renaissance to Romanticism*, London 2008

K. D. Kriz, 'Dido versus the Pirates: Turner's Carthaginian paintings and the Sublimation of Colonial Desire' in *Prospects for the Nation: Recent Essays in British Landscape, 1750–1880*, eds M. Rosenthal, C. Payne and S. Wilcox, New Haven and London 1997, pp. 281–60

H. Langdon, *Claude Lorrain*, Oxford 1989

H. Langdon, 'The Imaginative Geographies of Claude Lorrain' in *Transports: Travel, Pleasure and Imaginative Geography, 1600–1830* (Studies in British Art, no. 3), New Haven and London 1996, pp. 151–78

K. Nicholson, *Turner's Classical Landscapes: Myth and Meaning*, Princeton 1990

K. Nicholson, 'Turner, Claude and the Essence of Landscape' in *Turner and the Masters*, ed. D. Solkin, exh. cat., Tate Britain, London 2009

C. Powell, *Turner in the South: Rome, Naples, Florence*, New Haven and London 1987

C. Powell, *Italy in the Age of Turner: 'The Garden of the World'*, London 1998

R. Rand, *Claude Lorrain: The Painter as Draughtsman: Drawings from the British Museum*, New Haven and London 2006

M. Röthlisberger, *Claude Lorrain: The Paintings*, 2 vols, New Haven 1961

M. Röthlisberger, *Claude Lorrain: The Drawings*, 2 vols, Berkeley and Los Angeles 1968

S. Smiles, *The Turner Book*, London 2006

Turner and the Masters, ed. D. Solkin, exh. cat., Tate Britain, London 2009

J.M.W. Turner, ed. I. Warrell, exh. cat., National Gallery of Art, Washington DC 2007

B. Venning, *Turner, Art and Ideas*, London 2003

I. Warrell and M. Kitson, *Turner et Le Lorrain*, exh. cat., Musée des Beaux-Arts, Nancy 2002

J.J.L. Whiteley, *Claude Lorrain: Drawings from the Collections of the British Museum and the Ashmolean Museum*, exh. cat., British Museum, London 1998

M. Wilson, *Second Sight: Claude, The Embarkation of the Queen of Sheba, and Turner, Dido building Carthage*, exh. cat., National Gallery, London 1980

A. Wilton, *The Life and Work of J.M.W. Turner*, Fribourg 1979

A. Wilton and R.M. Turner, *Painting and Poetry: Turner's 'Verse Book' and his Work of 1804–12*, exh. cat., Tate Gallery, London 1990

H. Wine, *Claude: The Poetic Landscape*, exh. cat., National Gallery, London 1994

H. Wine, *National Gallery Catalogues: The Seventeenth-Century French Paintings*, London 2001

J. Ziff, '"Backgrounds: Introduction of Architecture and Landscape". A Lecture by J.M.W. Turner', *Journal of the Warburg and Courtauld Institutes*, 26 (1963), pp. 124–47

LIST OF WORKS

Claude
Portrait of Claude from *Liber Veritatis*, about 1636–40
Pen and brown ink and brown wash on paper, 26.5 x 32.3 cm
The British Museum, London (1957,1214.6)
[fig. 1]

Claude
A Sunset or Landscape with Argus guarding Io, 1674
Oil on canvas, 99 x 123 cm
Viscount Coke and Trustees of the Holkham Estate (53)
[plate 28]

Claude
A View of the Roman Campagna from Tivoli, Evening,
about 1644–5
Oil on canvas, 98.2 x 131.2 cm
Lent by Her Majesty The Queen (RCIN 404688)
[plate 37]

Claude
Landscape with a Rider and an Idealised View of Tivoli, 1642
Pen and brown ink and brown wash on paper, 19.6 x 26.4 cm
The British Museum, London (1957,1214.73)
[plate 34]

Claude
Landscape with Hagar and the Angel, 1646
Oil on canvas mounted on wood, 52.2 x 42.3 cm
The National Gallery, London (NG 61)
Presented by Sir George Beaumont, 1828
[plate 40]

Claude
Landscape with Narcissus and Echo, 1644
Oil on canvas, 94.6 x 118.7 cm
The National Gallery, London (NG 19)
Presented by Sir George Beaumont, 1826
[plate 7]

Claude
*Landscape with Psyche outside the Palace of Cupid
('The Enchanted Castle')*, 1664
Oil on canvas, 87.1 x 151.3 cm
The National Gallery, London (NG 6471)
Bought with contributions from the National Heritage
Memorial Fund and The Art Fund, 1981
[plate 61]

Claude
*Landscape with the Arrival of Aeneas before the City of
Pallanteum*, 1675
Oil on canvas, 174 x 221 cm
Anglesey Abbey, The Fairhaven Collection (The National
Trust) (NT/AA/P/217, CMS Inv. 515654)
[plate 2]

Claude
*Landscape with the Father of Psyche sacrificing at the Temple
of Apollo*, 1662
Oil on canvas, 174 x 221 cm
Anglesey Abbey, The Fairhaven Collection (The National
Trust) (NT/AA/P/219, CMS Inv. 515656)
[plate 1]

Claude
Landscape with the Marriage of Isaac and Rebecca, 1648
Oil on canvas, 152.3 x 200.6 cm
The National Gallery, London (NG 12)
Bought, 1824
[plate 48]

Claude
Seacoast with Perseus and the Origin of Coral, 1674
Oil on canvas, 104 x 129 cm
Viscount Coke and Trustees of the Holkham Estate (51)
[plate 53]

Claude
Seaport with the Embarkation of the Queen of Sheba, 1648
Oil on canvas, 149.1 x 196.7 cm
The National Gallery, London (NG 14)
Bought, 1824
[plate 20]

Claude
View of Tivoli, from Monte Catillo, with the Temple of Vesta,
1640–1
Pen and brown ink and brown wash, touched with watercolour,
on paper, 21.5 x 31.6 cm
The British Museum, London (Oo,6.77)
[plate 33]

Henry Dawe, after J.M.W. Turner
Isleworth; plate 63 in *Liber Studiorum*, 1819
Etching and mezzotint on paper, 18.2 x 26 cm
Royal Academy of Arts, London (03/5541)
[plate 19]

Richard Earlom, after Claude
Coast Scene with Apollo and the Cumaean Sibyl; plate 164
in *Liber Veritatis*
Mezzotint on paper, 20.5 x 26 cm
Private collection
[plate 17]

Richard Earlom, after Claude
Landscape with a Country Dance; plate 53 in *Liber Veritatis*
Mezzotint on paper, 20.8 x 25.9 cm
Private collection
[plate 16]

Bertha Mary Garnett
A Corner of the Turner Room in the National Gallery, 1883, 1883
Oil on canvas, 25.5 x 35.8 cm
The National Gallery, London (History Collection, H47)
[fig. 40]

Italian or German (?) School
Claudian Landscape, 17th century
Oil on wood, 26.7 x 26.7 cm
Tate, London (N05566)
Presented by Miss M.H. Turner 1944

Frederick Mackenzie
*The National Gallery when at Mr J.J. Angerstein's House,
Pall Mall*, 1824–34
Gouache on paper, 46.7 x 62.2 cm
Victoria and Albert Museum, London (40-1887)
[fig. 41]

William Say, after J.M.W. Turner
Solitude; plate 53 in *Liber Studiorum*, 1814
Etching and mezzotint on paper, 17.7 x 25.7 cm
Tate, London (A01113)
Presented by A. Acland Allen through The Art Fund 1925
[plate 60]

John Thomas Smith
Portrait of J.M.W. Turner, about 1829
Watercolour over pencil on paper, 22.2 x 18.2 cm
The British Museum, London (1885,0509.1648)
[fig. 2]

Henry Tidmarsh
*Interior View of the National Gallery showing the Turner Room
with Students and Copyists at work*, about 1883
Bodycolour and wash on paper, 8.6 x 17.8 cm
City of London, London Metropolitan Archives
(SC/GL/PR/W2/TRA/29385)
[fig. 39]

Henry Tidmarsh
*Interior View of the National Gallery showing Two Copyists at
work in the Basement of the Turner Room*, about 1885
Bodycolour and wash on paper, 10.2 x 13.3 cm
City of London, London Metropolitan Archives
(SC/GL/PR/W2/TRA/29380)
[fig. 38]

J.M.W. Turner
An Industrial Town, probably Birmingham at Sunset; Colour Study,
about 1830–2
Watercolour on paper, 34.8 x 48.2 cm
Tate, London (D25250; Turner Bequest CCLXIII 128)
Accepted by the nation as part of the Turner Bequest 1856
[plate 43]

J.M.W. Turner
Banks of the Loire, 1829
Oil on canvas, 71.3 x 53.3 cm
Worcester Art Museum, Massachusetts (1940.59)
Bequest of Theodore T. and Mary G. Ellis,
Worcester Art Museum, Worcester, Massachusetts
[plate 41]

J.M.W. Turner
Caernarvon Castle, 1799
Watercolour and pencil on paper, 57 x 82.5 cm
Private collection
[plate 5]

J.M.W. Turner
Copies of Five Paintings by Claude: (1) 'Landscape with David at the Cave of Adullam' [National Gallery, London]; *(2) 'Landscape with Christ appearing to Mary Magdalen'* [Städel Museum, Frankfurt]; *(3) 'Landscape with Philip baptising the Eunuch'* [National Museum of Wales, Cardiff]; *(4) 'Parnassus'* [Museum of Fine Arts, Boston]; *(5) 'Landscape with Hagar and the Angel'* [Private collection], from the *Fonthill* sketchbook, 1804
Ink and pencil on paper, 47 x 33.5 cm
Tate, London (D41265; Turner Bequest XLVII 19 verso)
Accepted by the nation as part of the Turner Bequest 1856
[plate 4]

J.M.W. Turner
Copies of Three Paintings by Claude in the Louvre: (1) Landscape with Rural Dance, 1639; (2) Seaport, 1639; (3) Seaport with Ulysses restituting Chryseis to her Father Chryses, 1644, from the *Dieppe, Rouen and Paris* sketchbook, 1821
Pencil on paper, 23.1 x 11.8 cm
Tate, London (D24561; Turner Bequest CCLVIII 32 a)
Accepted by the nation as part of the Turner Bequest 1856
[plate 11]

J.M.W. Turner
Copy of 'Seaport with the Villa Medici' by Claude, from the *Rome and Florence* sketchbook, 1819
Pencil on paper, 11.3 x 18.9 cm
Tate, London (D16585; Turner Bequest CXCI 60)
Accepted by the nation as part of the Turner Bequest 1856
[plate 10]

J.M.W. Turner
Copy of the Composition of Claude's 'Landscape with the Arrival of Aeneas', from *Studies for Pictures* sketchbook, about 1799
Watercolour on blue paper, 13.8 x 21.5 cm
Tate, London (D04139; Turner Bequest LXIX 122)
Accepted by the nation as part of the Turner Bequest 1856
[plate 3]

J.M.W. Turner
Crossing the Brook, exhibited 1815
Oil on canvas, 193 x 165 cm
Tate, London (N00497)
Accepted by the nation as part of the Turner Bequest 1856
[plate 27]

J.M.W. Turner
Dido building Carthage, or The Rise of the Carthaginian Empire, 1815
Oil on canvas, 155.5 x 230 cm
The National Gallery, London (NG 498)
Turner Bequest, 1856
[plate 22]

J.M.W. Turner
East Cowes Castle, the Seat of J. Nash, Esq.; the Regatta starting for their Moorings, exhibited 1828
Oil on canvas, 91.4 x 123.2 cm
Victoria and Albert Museum, London (FA.210[O])
Given by John Sheepshanks
[plate 45]

J.M.W. Turner
Keelmen heaving in Coals by Night, 1835
Oil on canvas, 92.3 x 122.8 cm
National Gallery of Art, Washington, DC (1942.9.86)
Widener Collection
[plate 55]

J.M.W. Turner
Kirkstall Lock, on the River Aire, 1824–5, for *The Rivers of England,* 1827
Watercolour on paper, 15.9 x 23.5 cm
Tate, London (D18145; Turner Bequest CCVIII L)
Accepted by the nation as part of the Turner Bequest 1856
[plate 42]

J.M.W. Turner
Lake Geneva and Mount Blanc, about 1804
Watercolour, pen and black ink, pen and brown ink and scraping out, on cream wove paper, 73.3 x 113.3 cm
Yale Center for British Art, Paul Mellon Collection, New Haven (B1977.14.6301)
[plate 6]

J.M.W. Turner
Landscape: Composition of Tivoli, 1817
Watercolour on paper, 67.6 x 102 cm
Private collection
[plate 29]

J.M.W. Turner
Landscape with Water: Tivoli, about 1840–5
Oil on canvas, 121.9 x 182.2 cm
Tate, London (N05513)
Accepted by the nation as part of the Turner Bequest 1856
[plate 62]

J.M.W. Turner
Le Havre: Sunset in the Port, about 1832, for *Turner's Annual Tour: The Seine,* 1834
Gouache and watercolour on blue paper, 14 x 19.2 cm
Tate, London (D24698; Turner Bequest CCLIX 133)
Accepted by the nation as part of the Turner Bequest 1856
[plate 54]

J.M.W. Turner
Linlithgow Palace, Scotland, exhibited 1810
Oil on canvas, 91.4 x 122 cm
National Museums Liverpool, Walker Art Gallery (WAG 2583)
Presented by F.J. Nettlefold 1948
[plate 24]

J.M.W. Turner
Modern Italy – the Pifferari, exhibited 1838
Oil on canvas, 92.6 x 123.2 cm
Glasgow Museums, Scotland (733)
Lent by Culture and Sport Glasgow on behalf of Glasgow City Council, Given by the Sons of James Reid of Auchterarder, 1896
[plate 39]

J.M.W. Turner
Narcissus and Echo, exhibited 1804
Oil on canvas, 86.5 x 117 cm
Tate, London (T03869)
Accepted by HM Government in lieu of tax and allocated to the Tate Gallery 1984. In situ at Petworth House
[plate 8]

J.M.W. Turner
Palestrina – Composition, 1828, exhibited 1830
Oil on canvas, 140.3 x 248.9 cm
Tate, London (N06283)
Bequeathed by C.W. Dyson Perrins 1958
[plate 49]

J.M.W. Turner
Plymouth Dock from Mount Edgcumbe, about 1814
Watercolour over pencil heightened with scratching out, with touches of gum arabic, on wove paper, 15.6 x 24.1 cm
Plymouth City Museum and Art Gallery (PLYMG:2006.8)
On loan from Plymouth City Council (Museums and Archives). Purchased with the assistance of The Art Fund and supported by the National Lottery through the Heritage Lottery Fund
[plate 26]

J.M.W. Turner
Regulus, 1828, reworked 1837
Oil on canvas, 89.5 x 123.8 cm
Tate, London (N00519)
Accepted by the nation as part of the Turner Bequest 1856
[plate 47]

J.M.W. Turner
Rise of the River Stour at Stourhead (The Swan's Nest), about 1825
Watercolour on paper, 67.3 x 102.2 cm
Trustees of the Walter Morrison Collection, Sudeley Castle (148 0007)
[plate 44]

J.M.W. Turner
Rocky Bay with Figures, about 1827–30
Oil on canvas, 90.2 x 123.2 cm
Tate, London (N01989)
Accepted by the nation as part of the Turner Bequest 1856
[plate 52]

J.M.W. Turner
Schloss Rosenau, Seat of HRH Prince Albert of Coburg, near Coburg, Germany, exhibited 1841
Oil on canvas, 97 x 124.8 cm
National Museums Liverpool, Walker Art Gallery (WAG 309)
Bequeathed by Emma Holt 1944
[plate 58]

J.M.W. Turner
Sketch for 'Ulysses deriding Polyphemus', about 1827–8
Oil on canvas, 60 x 89.2 cm
Tate, London (N02958)
Accepted by the nation as part of the Turner Bequest 1856
[plate 50]

J.M.W. Turner
Southern Landscape with an Aqueduct and Waterfall, 1828?
Oil on canvas, 150.2 x 249.2 cm
Tate, London (N05506)
Accepted by the nation as part of the Turner Bequest 1856
[plate 51]

J.M.W. Turner
Study for 'Appulia in Search of Appulus, vide Ovid', from the *Woodcock Shooting* sketchbook, about 1812–13
Pencil on paper, 11 x 17.8 cm
Tate, London (D09116; Turner Bequest CXXIX 41)
Accepted by the nation as part of the Turner Bequest 1856
[plate 9]

J.M.W. Turner
Sun rising through Vapour: Fishermen cleaning and selling Fish, before 1807
Oil on canvas, 134 x 179.5 cm
The National Gallery, London (NG 479)
Turner Bequest, 1856
[plate 21]

J.M.W. Turner
Sunrise, 1825–30
Watercolour on paper, 33.8 x 47.2 cm
Tate, London (D25186; Turner Bequest CCLXIII 64)
Accepted by the nation as part of the Turner Bequest 1856
[plate 30]

J.M.W. Turner
Sunrise, a Castle on a Bay: Solitude, about 1845–50
Oil on canvas, 90.8 x 121.9 cm
Tate, London (N01985)
Accepted by the nation as part of the Turner Bequest 1856
[plate 63]

J.M.W. Turner
Sunshine on the Tamar, about 1813
Watercolour over pencil, with some scratching out and use of
the brush handle, on wove paper, 21.7 x 36.7 cm
The Ashmolean Museum, Oxford (WA.RS.REF.168)
[plate 25]

J.M.W. Turner
The Château at Arques-la-Bataille, near Dieppe, 1845
Pencil and watercolour on paper, 24.3 x 30.3 cm
Tate, London (D35885; Turner Bequest CCCLXIV 46)
Accepted by the nation as part of the Turner Bequest 1856
[plate 59]

J.M.W. Turner
The Decline of the Carthaginian Empire, exhibited 1817
Oil on canvas, 170.2 x 238.8 cm
Tate, London (N00499)
Accepted by the nation as part of the Turner Bequest 1856
[plate 23]

J.M.W. Turner
The Festival upon the Opening of the Vintage of Mâcon, 1803
Oil on canvas, 146 x 237.5 cm
Museums Sheffield (VIS.3129)
Ernest Cook Bequest, 1955. Presented by The Art Fund.
[plate 13]

J.M.W. Turner
The Junction of the Severn and the Wye; plate 28 in *Liber
Studiorum*, 1811
Etching, aquatint and mezzotint on paper, 18.1 x 26.5 cm
Royal Academy of Arts, London (03/3204)
[plate 18]

J.M.W. Turner
The Roman Campagna from Monte Testaccio, Sunset, from the
Naples, Rome C. Studies sketchbook, 1819
Gouache, pencil and watercolour on paper, 25.2 x 40.4 cm
Tate, London (D16131; Turner Bequest CLXXXVII 43)
Accepted by the nation as part of the Turner Bequest 1856
[plate 31]

J.M.W. Turner
The Thames near Windsor, about 1807
Oil on mahogany veneer, 18.7 x 26 cm
Tate, London (N02305)
Accepted by the nation as part of the Turner Bequest 1856
[plate 15]

J.M.W. Turner
Thomson's Aeolian Harp, 1809
Oil on canvas, 166.7 x 306 cm
Manchester Art Gallery
[plate 14, not exhibited]

J.M.W. Turner
Tivoli, from Monte Catillo, from the *Naples, Rome C. Studies*
sketchbook, 1819
Pencil and watercolour on paper, 25.6 x 40.4 cm
Tate, London (D16116; Turner Bequest CLXXXVII 28)
Accepted by the nation as part of the Turner Bequest 1856
[plate 35]

J.M.W. Turner
Tivoli, from the North-East, with the Temple of Vesta, from the
Naples, Rome C. Studies sketchbook, 1819
Pencil on paper, 25.7 x 40.5 cm
Tate, London (D16118; Turner Bequest CLXXXVII 30)
Accepted by the nation as part of the Turner Bequest 1856
[plate 32]

J.M.W. Turner
*Tivoli, from the Valley, with the Cascatelli and the Santuario di
Ercole Vincitore*, from the *Naples, Rome C. Studies* sketchbook,
1819
Watercolour on paper, 25.2 x 40.4 cm
Tate, London (D16120; Turner Bequest CLXXXVII 32)
[plate 36]

J.M.W. Turner
Tivoli: Tobias and the Angel, about 1835
Oil on canvas, 90.5 x 121 cm
Tate, London (N02067)
Accepted by the nation as part of the Turner Bequest 1856
[plate 38]

J.M.W. Turner
*Two Composition Studies for 'The Festival upon the Opening of
the Vintage of Mâcon'*, from the *Calais Pier* sketchbook, about
1802–3
Pen and ink with chalk highlights on blue paper,
43.3 x 27.2 cm (each page)
Tate, London (D05018–D05019; Turner Bequest LXXXI 116–117)
Accepted by the nation as part of the Turner Bequest 1856
[plate 12]

J.M.W. Turner
Venice: The Giudecca Canal, looking towards Fusina at Sunset,
from the *Grand Canal and Giudecca* sketchbook, 1840
Pencil, watercolour and crayon on paper, 22.1 x 32.3 cm
Tate, London (D32129; Turner Bequest CCCXV 13)
Accepted by the nation as part of the Turner Bequest 1856
[plate 57]

J.M.W. Turner
*Venice: The Punta della Dogana at Sunset, with the Domes of
Santa Maria della Salute*, from the *Grand Canal and Giudecca*
sketchbook, 1840
Watercolour on paper, 22.1 x 32.2 cm
Tate, London (D32133; Turner Bequest CCCXV 17)
Accepted by the nation as part of the Turner Bequest 1856
[plate 56]

J.M.W. Turner
View of Orvieto, painted in Rome, 1828, reworked 1830
Oil on canvas, 91.4 x 123.2 cm
Tate, London
[plate 46, not exhibited]

Copy of letter from Cecil Gould to Noël Arnott,
21 October 1954
Paper, 20.3 x 16.5 cm
National Gallery Libraries and Archive, London
[fig. 43]

Copy of letter from Michael Levey to Martin Butlin asking for
Calais Pier, 29 April 1968
Paper, 28.5 x 20 cm
National Gallery Libraries and Archive, London

Copy of Turner's will, annotated by R.N. Wornum, about 1852–6
Paper, 30.5 x 12 cm (folded)
National Gallery Libraries and Archive, London
[fig. 32]

Illustrated Catalogue to the National Gallery (Foreign Schools)
by Henry Blackburn, 1878
Book, 21 x 14.5 cm (closed)
National Gallery Libraries and Archive, London

Letter from Jabez Tepper regarding the Turner Bequest,
24 September 1856
Paper, 25 x 20 cm
National Gallery Libraries and Archive, London

Letter from Jabez Tepper to Thomas Uwins regarding the
deposit of Turner's paintings at the National Gallery pending
the outcome of court proceedings, 29 July 1854
Paper, 24.5 x 20 cm
National Gallery Libraries and Archive, London
[figs 35 and 36]

Letter from Martin Butlin to Michael Levey, 1 May 1968
Paper, 24 x 19 cm
National Gallery Libraries and Archive, London

Letter from P. Hardwick to the National Gallery's Keeper,
Thomas Uwins, respecting the transfer of *Dido building
Carthage* and *Sun rising through Vapour*, 18 October 1852
Paper, 18 x 11 cm
National Gallery Libraries and Archive, London
[figs 33 and 34]

Looking at Turner's Pictures; plate from the book *Living London.
Its work and play, its humour and its pathos, its sights and its
scenes*, volume III, edited by George R. Sims, 1902
Book, 29 x 22.4 cm (closed)
City of London, Guildhall Library

Postcard from Noël Arnott, 18 October 1954
Paper, 8.5 x 14 cm
National Gallery Libraries and Archive, London
[fig. 42]

R.N. Wornum's diary entry for October 1861
Bound volume, 37.5 x 26 cm (closed)
National Gallery Libraries and Archive, London
[fig. 37]

LIST OF LENDERS

This exhibition has been made possible by the provision of insurance through the Government Indemnity Scheme. The National Gallery would like to thank HM Government for providing Government Indemnity and the Department for Culture, Media and Sport and Arts Council England for arranging the indemnity.

PHOTOGRAPHIC CREDITS

ACKNOWLEDGEMENTS

It's now more than ten years since I curated the exhibition *Pure as Italian Air* in the Clore Gallery, Tate Britain. Made up mainly of works on paper, supplemented with generous loans from the British Museum and Petworth House, the exhibition charted Turner's responses to the art of Claude Lorrain. Created in a matter of months to fill a sudden hole in the programme, that project suggested the potential for a much larger exhibition that would bring together the finest paintings of both artists, as well as a selection of their innovative sketches. It was, therefore, a great pleasure to be invited to contribute to the present project by Nicholas Penny, as part of the on-going exploration of the shared history of the National Gallery and the Tate.

The eventual structure and content of the exhibition has benefited greatly from stimulating discussions with Dr Penny and Susan Foister (Director of Collections and Deputy Director). Susan has worked closely with Jo Kent in the Exhibition department to oversee the staging of the show, overcoming many potential difficulties along the way. Many others at the National Gallery have also contributed to the success of this project: Alan Crookham; Belinda Phillpot; Cathy Putz; Eloise Stewart; and further assistance has been provided by Philippa Stephenson and Henrietta Ward. The exhibition has been designed by Calum Storrie and Tim Harvey. This beautiful book, which accompanies the exhibition, has been produced by a team led by Giselle Sonnenschein, with Jan Green: Suzanne Bosman; Lise Connellan; Joe Ewart; Jane Hyne; Sara Purdy; Penny Le Tissier.

My colleagues in many departments at Tate Britain also deserve recognition for their support for this project: Julia Beaumont-Jones; Helen Brett; Caroline Collier; Rachel Crome; Christine Kurpiel; Anne Lyles; Nicola Moorby; Kate Parsons; Katharine Richmond; Nicole Simoes da Silva; Philippa Simpson (now at the National Maritime Museum). But, crucially, Penelope Curtis first sanctioned my participation soon after her arrival as Director of Tate Britain, with an aspiration for other fruitful collaborations with the National Gallery in the future.

The exhibition is greatly enriched by the loan of several key items from other galleries or from private collections, and we are grateful to all of those who have either helped facilitate this, or who have selflessly parted with treasured pictures: Her Majesty The Queen; Sebastien Allard; The Lady Ashcombe and Trustees of the Walter Morrison Collection, Sudeley Castle; Lisa Beauchamp; Alexander Bell; Christopher Brown; Sian Brown; Hugo Chapman; the Rt Hon the Viscount Coke and Trustees of the Holkham Estate; Alison Cooper; Harriet Drummond; The Lord Egremont, Mark Evans; Guillaume Faroult; Helen Fothergill; Antony Griffiths; Sir Nicholas Grimshaw; Emmeline Hallmark; Colin Harrison; Franklin Kelly; Alastair Laing; Andrew Loukes; Jonathan Marsden; Ellen McAdam; Amy Meyers; Alice Murray; Hilary Ordman; Sandra Penketh; Karina Marotta Peramos; Emma Philip; Earl A.Powell III; Janice Reading; Martin Roth; Desmond Shawe-Taylor; Philippa Smith; MaryAnne Stevens; Dodge Thompson; Rosalind Mallord Turner; James Welu; Scott Wilcox; Timothy Wilson.

Finally, I should like to thank the various scholars whose work on Claude or Turner has provided the reliable bedrock on which to develop the exhibition: Martin Butlin; Judy Egerton; Gillian Forrester; John Gage; David Hill; Evelyn Joll; Helen Langdon; Cecilia Powell; Richard Rand; Marcel Röthlisberger; Eric Shanes; Sam Smiles; David Solkin; Jon Whiteley; Andrew Wilton; and, of course, Humphrey Wine, who has done so much to document the paintings by Claude in the National Gallery. In addition to the late Michael Kitson, who notably addressed the art of both painters, I should especially like to mention Kathleen Nicholson, who writes so beautifully on the intricate links between the two artists, and from whom I have gained countless insights into their work.

Finally, I should like to pay tribute to the late Andrew Wyld, who supported my Turner enterprises over the last twenty years with his tenacious energy, his wide-ranging knowledge and his enthusiasm.

IW